Studies in the History of Art
Published by the National Gallery of Art,
Washington

This series includes: Studies in the History of
Art, collected papers on objects in the Gallery's
collections and other art historical studies
(formerly *Report and Studies in the History of
Art*); Monograph Series I, a catalogue of stained
glass in the United States; Monograph Series II,
on conservation topics; and Symposium Papers
(formerly Symposium Series), the proceedings
of symposia sponsored by the Center for
Advanced Study in the Visual Arts at the
National Gallery of Art.

*Forthcoming

Winslow Homer

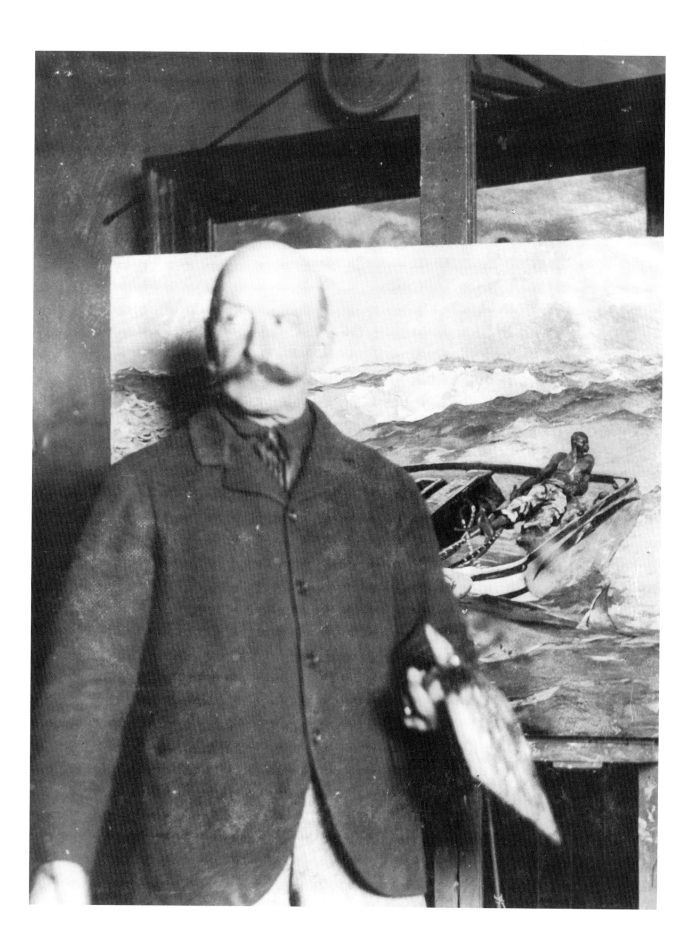

STUDIES IN THE HISTORY OF ART · 26 ·

Center for Advanced Study in the Visual Arts

Symposium Papers XI

Winslow Homer

A Symposium

Edited by Nicolai Cikovsky, Jr.

National Gallery of Art, Washington

Distributed by the University Press of New England

Hanover and London 1990

Editorial Board
DAVID A. BROWN, *Chairman*
DAVID BULL
NICOLAI CIKOVSKY, JR.
HENRY A. MILLON
CHARLES S. MOFFETT

Series Editor
CAROL ERON

Editor
TAM L. CURRY

Designer
CYNTHIA HOTVEDT

Editorial Assistant
ULRIKE MILLS

Copyright © 1990 Trustees of the National Gallery of Art, Washington

This publication was produced by the Editors Office, National Gallery of Art, Washington Editor-in-chief, Frances P. Smyth
Printed by Ameriprint, Inc., Vienna, Virginia
The text paper is 80 pound LOE Dull text
The type is Trump Medieval, set by
BG Composition, Baltimore, Maryland

Distributed by the University Press of New England, 17¹/₂ Lebanon Street, Hanover, New Hampshire 03755

Abstracted by RILA (International Repertory of the Literature of Art), Williamstown, Massachusetts 01267

Proceedings of the symposium "Winslow Homer" sponsored by the Center for Advanced Study in the Visual Arts, National Gallery of Art, 18 April 1986

ISSN 0091-7338
ISBN 0-89468-132-X

Cover: Winslow Homer, *Searchlight, Harbor Entrance, Santiago de Cuba* (detail), 1901, The Metropolitan Museum of Art, Gift of George A. Hearn

Frontispiece: Homer in his Prout's Neck studio, about 1899, Bowdoin College Museum of Art, Gift of the Homer Family

Contents

Preface

The Center for Advanced Study in the Visual Arts was founded in 1979 as part of the National Gallery of Art to promote the study of history, theory, and criticism of art, architecture, and urbanism through the formation of a community of scholars. The activities of the Center for Advanced Study include a fellowship program, meetings, research, and publication.

In April 1986 the Center for Advanced Study sponsored a symposium on "Winslow Homer" in conjunction with an exhibition of Homer watercolors at the National Gallery. Six papers on diverse themes, including specific works by Homer and various moments in the development of his artistic career, were presented by specialists in American art. The program was planned in consultation with Nicolai Cikovsky, Jr., curator of American art at the National Gallery, who also generously agreed to edit the papers and write an introduction, as well as present a paper at the symposium. The Center for Advanced Study is also grateful to John Wilmerding, formerly deputy director of the National Gallery and now professor of art history at Princeton University, for advice during the planning process and for introducing the symposium, and especially to Helen A. Cooper, curator of American paintings and sculpture at the Yale University Art Gallery and guest curator of the Homer exhibition, for moderating the symposium sessions. The symposium was made possible through the support of the IBM Corporation.

This publication is the eleventh in the symposium series of *Studies in the History of Art*, intended to document such gatherings and stimulate further research. Future volumes will chronicle additional symposia held under the sponsorship of the Center for Advanced Study.

HENRY A. MILLON
Dean, Center for Advanced Study
in the Visual Arts

Introduction

The articles published herein were originally delivered as papers at a day-long symposium on Winslow Homer held at the National Gallery of Art in April 1986. The occasion for the symposium—though not exclusively the subject of its concern—was the splendid exhibition, *Winslow Homer Watercolors*, organized for the Gallery by Helen A. Cooper, curator of American Paintings and Sculpture at the Yale University Art Gallery, who also moderated the symposium. Six scholars actively and currently engaged in Homer studies were invited to present their findings. The result was a comprehensive view, not only of recent work on Homer, but of the different ways in which that work was being undertaken.

Winslow Homer was something of a puzzle to his contemporaries. They recognized his singularity, acknowledged his greatness, and admired his art from the first. But they were not always sure exactly why. It has been more than three-quarters of a century since Homer's death. During that time there has been an industrious, one might almost say industrial, production of exhibitions, catalogues, articles, and books about him. Despite this quantity of explanation, and despite the clarifying distance of time, Homer is still in many ways a puzzle. Like his contemporaries, we irresistably admire the truth and power of his art. But like them, too, we are not always

sure just why and how it exerts its special power. Perhaps that is why he has had a renewed fascination for successive generations of scholars.

Homer is one of the most American artists—a New Englander by birth, descended on both sides of his family from a long line of New Englanders, a painter of iconic images of American life who embodied the qualities of simplicity, blunt honesty, and independent self-reliance that, as many once believed (and some still do), are special to the American national character. He seems to enact the American type more clearly and completely than any other American artist.

Homer's "Americanness" has attracted most of those who have written about him. Since his death particularly, when Americans became concerned about the possibility and authenticity of American artistic expression, Homer (with Ryder and Eakins, but Homer most of all) was a reassuring example of that possibility. But it is a different and more difficult matter to speak of Homer now than it was as recently as fifteen or twenty years ago, when the last wave of important books on him appeared. We know more about Homer now than we did then—more about certain aspects of his life (his English period, for example), more about aspects of his art (his Civil War paintings), more about his technique (watercolor), and more about the meaning of

particular pictures (*Prisoners from the Front*, *Veteran in a New Field*, *Cotton Pickers*, *Right and Left*). What has changed most is not the quantity but the *quality* of what we know, or would like to know, about Homer. We are concerned now less to classify him (as an American, or a realist) than to understand him, to know what he might have thought, or believed, and to think about his psychology, or sexuality, or politics—things, not too terribly long ago, that were not thought of, or were to a great extent unthinkable. As a result, Homer has become a more complicated artist than he once seemed to be, one who demands more subtle and, perhaps, more complicated explanation.

Of all the American artists we now regard as important, Homer is the one whose importance we have not had to rediscover or invent. He was admired from the beginning of his career in the early 1860s, consistently throughout the remainder of his life, and without diminishment since his death in 1910. If Homer has suffered at all it has been from being admired too much, because adulation feeds on and is easily satisfied by myths, legends, and simple truths. Without admiring Homer less— profound admiration, after all, is what nourishes an interest in him more widespread now than it has ever been—recent scholarship has looked at him more broadly and deeply, and has posed new questions and pursued their answers with a new discipline, learning, subtlety, refinement, and inventiveness.

The papers in the symposium ranged widely in their scope and method. Lucretia Giese, drawing on her doctoral dissertation on Homer's Civil War paintings, analyzed the assumptions and premises, often unspoken, in the criticism of two of Homer's most copiously discussed Civil War paintings, *The Bright Side* of 1865 and *Prisoners from the Front* of 1866. Roger Stein considered Homer's relationship to his literary contemporaries, his literary context, and the interplay in his early graphic work between the visual and the verbal. Henry Adams examined Homer's trip to Paris in 1866–1867 and the extremely important, much debated, and unsettled issue of its effect on the formation of Homer's early style. David Curry discussed the meaning and historical setting of one of Homer's greatest depictions of blacks, *Dressing for the Carnival* of 1877. David Tatham brought a combination of fresh archival research and imaginative speculation to bear on one of Homer's richest subjects, the Adirondacks. And I discussed the sources and meanings of two of Homer's late paintings, *The Gulf Stream* of 1899 and *Searchlight* of 1901, in an attempt to add a bit more to the understanding of two of Homer's most enigmatic works, and, more generally, the nature of Homer's late style.

The papers are published here substantially as they were given. They are by no means verbatim, however. On the principle that the flavor of a transient occasion is less important than a lasting contribution to knowledge, their authors have, with editorial encouragement, in certain cases altered and amended their papers and in every case added scholarly apparatus.

NICOLAI CIKOVSKY, JR.
Washington, D.C., 1987

Winslow Homer

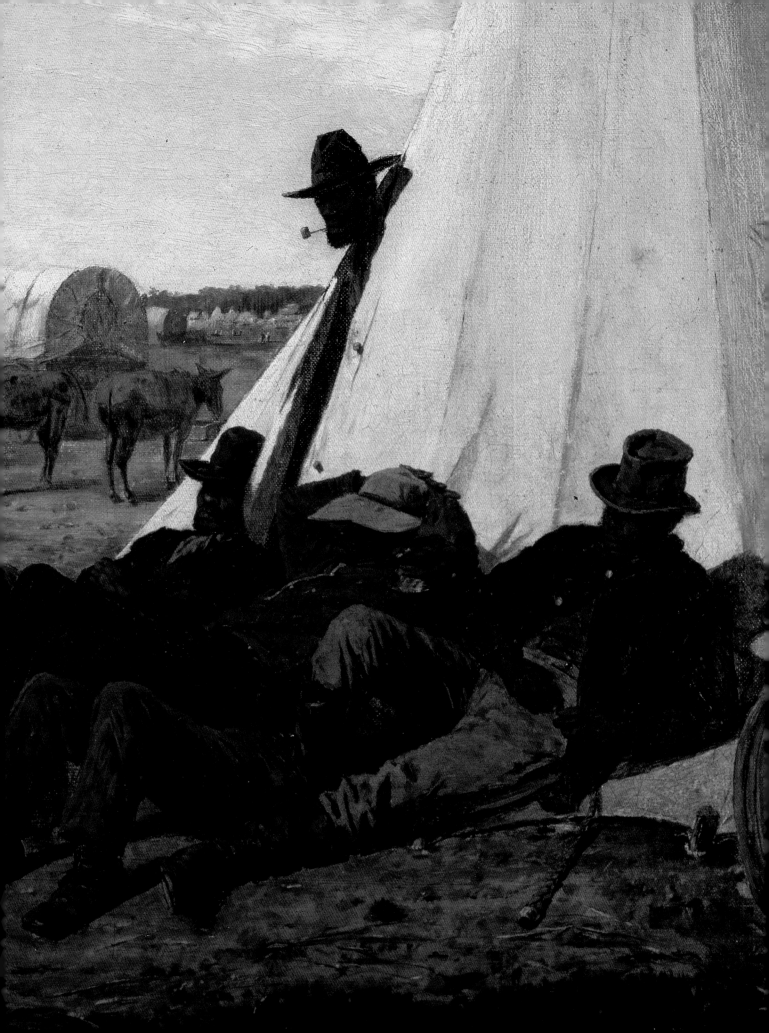

LUCRETIA GIESE
Lincoln, Massachusetts

Winslow Homer:

"Best Chronicler of the War"

Winslow Homer was consistent in exhibiting paintings of Civil War subjects after 1862 when he began to work seriously in oils.[1] Yet contemporary commentary on his work of 1863–1865 and 1866, immediately after the war, is disappointingly rare and insubstantial. Two paintings, however, became lightning rods for critical attention: *The Bright Side* of 1865 (fig. 1) and *Prisoners from the Front* of 1866 (fig. 13).[2] The extent of the contemporary writing on these paintings provides a perspective on their specific meaning at the time and their role in forming Homer's reputation.[3] Of the two, *The Bright Side* is less well known today; important studies have appeared in recent years on *Prisoners from the Front*.[4] Nevertheless, only when considered together do the two paintings illuminate important aspects of Homer's early career.

The Bright Side (fig. 1) depicts five black teamsters in camp relaxing in bright sunlight. Of the four who are stretched out on the ground leaning against a tent, three men are asleep, while their companion at the far right is propped up on one elbow and holds the end of his whip in his hands. A fifth man looks out between the tent flaps, a pipe gripped in his teeth. One of the men wears a military fatigue cap, the others some blue clothing and broad-brimmed hats similar to those worn in the Union Army, but the clothing does not appear to be regulation. To the left, mules before the camp wagons share their drivers' rest and waiting.

The man who sticks his head out of the tent opening presents an unsettling contrast to the other teamsters, their lethargic bodies extended and their own heads partially concealed by headgear. His alert, confronting gaze is unsmiling and unabashed. He does not seem to be caught off guard but demands a response. The impact of this figure is somewhat diminished in *The Bright Side*'s near-twin, *Army Teamsters* of 1866 (fig. 2). This painting is slightly larger and adds a recumbent mule and a third wagon to the left and the peak of another tent to the right. *Pentimenti* indicate the head and neck of still another mule were once included at the far right. In all other respects, however, the compositions are identical.

The subject was repeated in a wood engraving for Thomas Bailey Aldrich's article on Homer published in *Our Young Folks* in 1866 (fig. 3.)[5] For that illustration, which Aldrich described as "copied by the artist," Homer concentrated on the teamsters in the foreground by cropping the composition on all sides. Most noticeably, the teamster at the tent opening was omitted. Perhaps it was simply a matter of fitting the image to the format of the page, or perhaps the image had to be adapted for Aldrich's audience. *Our Young Folks* was a children's magazine, though presumably

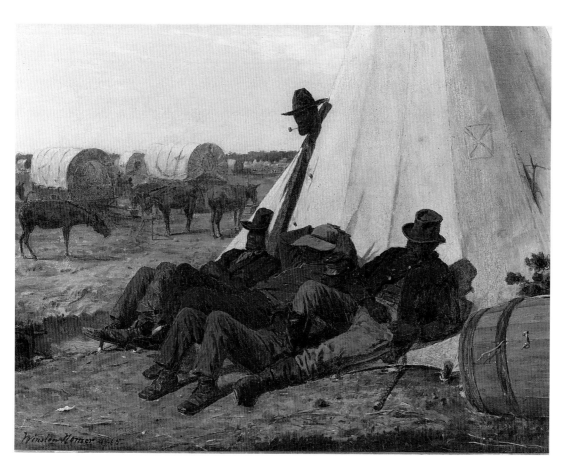

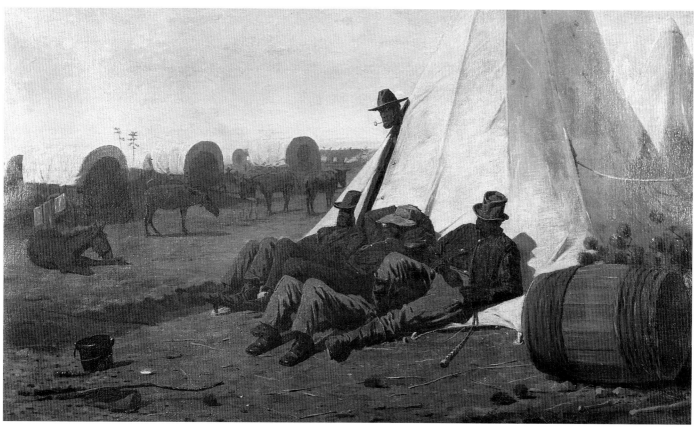

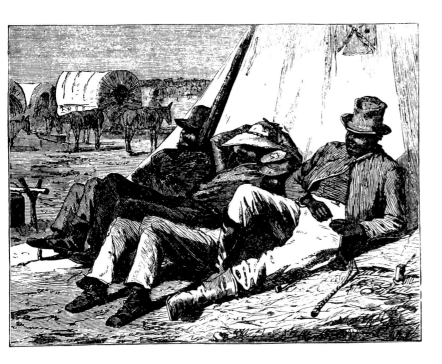

3. Winslow Homer, *The Bright Side*, wood engraving
In Thomas Baily Aldrich, "Among the Studios, III," *Our Young Folks* 7 (July 1866), 396

also read by parents.[6] Certainly tension was created by the inclusion of that figure, which led to an ambiguity of interpretation that might have been considered inappropriate for *Our Young Folks*.

The Bright Side attracted attention while still in Homer's studio, where critics reported seeing it in February and March of 1865.[7] Later in March the painting was shown at the Brooklyn Art Association, and in April it was shown at the National Academy of Design, along with *The Initials*, infrequently mentioned in reviews, and *Pitching Quoits*.[8] In *The Initials*, a woman traces with her fingers the initials of her soldier-beau inscribed in a tree; in *Pitching Quoits*, Zouaves while away time in camp playing this popular game. Commentary reveals a general preference for *The Bright Side*. Critics considered *"Sunny Side"* or *"Light and Shade,"* as the painting was alternatively called,

altogether the best thing he [Homer] has painted, and that is saying much, for, in many qualities, he is not excelled by any man among us. If he shall paint every picture with the loyalty to nature and the faithful study that marks this little square of canvas, he will become one

of the men we must have crowned when the Academy gets officers that have a right to bestow crowns.[9]

It was commended as "worth all the admiration it has received. The lazy sunlight, the lazy, nodding donkeys, the lazy lolling negroes, make a humorously conceived and truthfully executed picture." Other reviews called it "excellent" and "even better than 'Pitching Quoits.' It represents a group of negro teamsters lounging and dozing under the sunny wall of a Sibley tent. . . . No improvement could be suggested that would make this picture a more expressive work or more effective as a representation of the scene."[10] *The Bright Side*, according to Eugene Benson ("Sordello"), exemplified "boldness and truth" as opposed to the "trivial and false." He thought it the: "best example of Mr. Homer's talent. . . . frank in its characteristics, and happily fitted to express the subject. . . . [*Pitching Quoits*] is somewhat rudely painted."[11] In the opinion of another critic, *Pitching Quoits* was "less individual" than *The Bright Side*, which illustrated "an accurate knowledge of African habits and peculiarities." Still another asserted vaguely that Homer "is earning an honorable name. He sometimes makes us tremble a little, but such a picture as his 'Light and Shade' would seem to make permanent distrust ridiculous."[12]

By far the most intriguing contemporary review was written by the poet-critic George Arnold:

I saw a capital specimen in his [Homer's] studio, entitled 'The Bright Side.' A number of stalwart negroes are basking in the broad Southern sunlight against the side of a tent. Their faces are strikingly varied in character and expression, but they are all evidently choke-full of those two blessings—inseparable from the darky idea of what we call freedom— warmth and idleness.
I would recommend Mr. Homer to paint a companion-picture to this, showing the condition of the poor devils when they arrive here in the North, where they get no more army rations gratis, and find themselves condemned to saw wood and pile brick in the driving snow, in order to procure a somewhat more miserable subsistence than that of which a mistaken and ferocious philanthropy has deprived them.

The present work, however, has no political significance. It is simply a strikingly truthful delineation of Ethiopean comfort of the most characteristic, and therefore the most purely physical sort.[13]

The length and veiled intensity of Arnold's discussion of *The Bright Side* is noteworthy, for he alone of the many reviewers directly addressed the implications of its subject matter. His disclaimer seems itself an affirmation of the painting's distinctive and politically charged imagery.

Notices by Aldrich in 1866 and by Clarence Cook in 1888, concurred in favorable reviews of the painting. Aldrich, after all, chose to describe and illustrate (in somewhat altered form) *The Bright Side* and not another work that might have been in Homer's studio. He appreciated its "picturesque" characterization of blacks "loving sunshine as bees love honey. . . . Something to eat, nothing to do, and plenty of sunshine constitute a contraband's Paradise." The subject was of interest, he thought, being a scene "common enough in our camps down South during the war; but the art with which it is painted is not so common."[14] Clarence Cook asserted that the painting "enjoyed an almost equal popularity [to *Prisoners from the Front*], though not touching so tender a spot in the Nation's heart. It came at a time when there was much feeling as to the employment of Negro troops; and its punning title, with the good natured presentation of the subject, played its part in putting the question in the right light."[15] Cook did not explain the last point.

The attention given *The Bright Side* was presumably because of its unusual subject. Blacks were only infrequently included in paintings during most of the Civil War. When they were, by Eastman Johnson, for example, the works did not depict the blacks in a distinctly wartime environment.[16] Generally, it was not until late in the war that blacks were depicted as important in themselves, regardless of the situation. Earlier they had been given subservient roles or, when visually more prominent, were portrayed as picturesque figures, solitary brooders, or ineffectual children. Such images reinforced prevailing negative attitudes toward blacks. Most critics of *The Bright Side* made somewhat slurring remarks about the teamsters and generally, racial characteristics, not the problem of the blacks' current status, preoccupied the critics.

There can be no question that racial prejudice was "all but universal" in the United States at the middle of the nineteenth century.[17] In part this prejudice was based on the racial correspondence between the American slave and the "barbaric" black from Africa. The apparent backwardness of the African translated into beliefs about the inherent laziness and inferiority of his American counterpart.[18] That these opinions were repeatedly expressed, or implied, in New York newspaper reviews of *The Bright Side* in 1865, two years after the abolition of slavery, reflects the perpetuation of prejudice.

New York remained particularly intransigent, displaying strong "Copperhead" and anti-black sentiment. The free black was seen as jeopardizing the position of the poor white laborer, whose job was threatened by the numbers of "new" workingmen and by the subsidization of the unemployed black. One pro-Southern New York newspaper reported bitterly: "All persons of a 'loyal color' are now liberally provided for by Uncle Sam, not only with bread and dinner, but even clothes."[19] The basis for racial hatred was amplified in an address prepared by the Workingmen's United Political Association of New York in 1864: "the very object of arming the negroes is based on the instinctive idea of using them to *put down the white laboring classes.* That is its hidden meaning—that is why Fifth Avenue so gracefully leans upon Sambo."[20] Reference here is probably to the arming of black soldiers in the Union Army by official proclamation in 1862.

Use of blacks in the Union Army did indeed generate tension. Although General David Hunter had organized a black regiment in the spring of 1862, it was not until November that a black regiment was officially sanctioned by the Union and the Bureau of Colored Troops was formed. Controversy over the employment of black men as soldiers also involved the matter of equal pay. Blacks met with resistance even in the

capacity of simple army laborers, such as mule drivers. They were supervised by whites and mistreated, according to numerous accounts.[21] Thus in spite of blacks' connection with the Union Army, their subservient status had not changed.

What then does *The Bright Side* show? Arnold alone used the word "political" in his remarks on the painting, although dismissing the possibility. Yet the language of other reviews suggests the potential. Cook was probably correct about *The Bright Side*'s punning title. A newspaper article of 1863 entitled "Look on the Bright Side" points to a possible double meaning: "It is better to tread the path of life cheerfully, skipping lightly over all the obstacles in your way, rather than sit down and lament your hard fate. . . . The best thing to do when evil comes upon us is . . . not to sit and suffer, but to rise and make vigorous effort to seek a remedy."[22] No effort or cheerfulness is shown in Homer's painting (or despondency either). Instead, the men are apparently absorbing what Arnold called "those two blessings . . . warmth and idleness." Their perceived lazy contentment would have diminished the potential threat of the subject and perhaps suggested the teamsters' satisfaction with their lot. The presence of mules may further support such a reading. Comment was made, as noted, about "lazy, nodding donkeys" and "lazy, lolling negroes." Yet the black man at the tent opening cannot be overlooked. His visage gives teeth to the irony of the painting's title.

The situation of the blacks at the time of the Civil War had not aroused universal sympathy. At the time, as Arnold's comments indicate, there was a feeling that the condition of "wage slavery" of the Northern white worker could be as constricting as the total slavery of the black. As early as the middle of the nineteenth century, a New Hampshire labor newspaper commentator complained: "A great cry is raised in the Northern states against Southern slavery. The sin of slavery may be abominable there, but is it not equally so here? If they have black slaves, have we not white ones? Or how much better is the condition of some of our laborers here at the North, than the slaves of the South?"[23]

If the black was regarded as naturally passive and indolent, the fact of his slavery was defused.

Aside from the issue of the black as a laborer, the issue of integration seems tied up in the painting. Clarence Cook believed the infusion of blacks would enrich the United States. Opponents claimed Cook's "black broth" would never appeal to "delicate appetites." Cook attributed "high qualities" to the black race, believing it to be "faithful, earnest, deeply believing in God" and filled with "the seeds of a sweet and rich and generous culture."[24] This perspective has been called "romantic racialism."[25] To Cook and others like him, the fundamental differences that were assumed to exist between the white and black indicated the black's superiority, not his biological inferiority. The supposed childlike innocence of the black man was interpreted as an expression of the "ultimate in Christian virtue." Similar characteristics were assigned the black in a *Final Report of the American Freedmen's Inquiry Commission to the Secretary of War* of 1864, which, because it represents an official position, is worth quoting at length:

The African race is . . . Genial, lively, docile, emotional, the affections rule; the social instincts maintain the ascendent except under cruel repression, its cheerfulness and love of mirth overflow with the exuberance of childhood. It is devotional by feeling. It is a knowing rather than a thinking race. . . . As regards the virtues of humility, loving-kindness, resignation under adversity, reliance on Divine Providence, this race exhibits these, as a general rule, in a more marked manner than does the Anglo Saxon.[26]

These opinions may explain why some critics saw *The Bright Side* as comic, perhaps recognizing its irony, or "grotesque," presumably in the sense of its being a caricature or travesty. To one critic, "The idea [of *The Bright Side*] is almost grotesque." To George Arnold, "nearly all of his [Homer's] work contains a grotesque element; witness particularly the comic old darky with the pipe. . . . in fact, every one of these woolly-pated fellows is a study in grotesque in himself." Benson ("Sordello") described *The Bright Side* as having "dry, latent humor."[27]

4. Winslow Homer, *Army Teamsters*, 1880, chromo-lithograph
Colby College Museum of Art, The Harold T. Pulsifer Memorial Collection

Such statements indicate a patronizing attitude toward blacks and seem to ridicule the "romantic racialism" that attributed "superior" qualities to the black. A "travesty" burlesques a serious subject. In this way, Homer's painting was rendered inoffensive, seen to make light of the blacks' actual situation. A natural preference for warmth, presumed by such intellectuals of the era as Louis Agassiz,[28] was suggested by the blacks' basking in the sun in *The Bright Side*. Freed blacks, it was believed, would instinctively migrate from harsher northern climates to the South, even back to Africa. The black was thought to be too enamored of a mild climate, too docile and lazy, to be a serious threat to the white worker. Whatever problems might accompany the arrival of blacks in the North—their pressure on the labor market, difficulties of integration—need not be taken too seriously.

Although many responses to *The Bright Side* take the painting as a light-hearted piece, a later version of *Army Teamsters* supports another interpretation. A chromolithograph of *Army Teamsters* published in 1880 by Armstrong & Company of Cambridge, Massachusetts, is imprinted

with what may be a reference to General Hunter's regiment of blacks; the words "Hunter's Co. . . ." (other letters are illegible) appear at the bottom right of the margin (figs. 4 and 5).[29] The painting *Army Teamsters* was owned by Lawson Valentine, whom Homer knew from childhood. Valentine, a businessman of considerable means, in 1880 assumed a partnership in

5. Stamp of Armstrong & Co. on verso of chromolithograph in figure 4

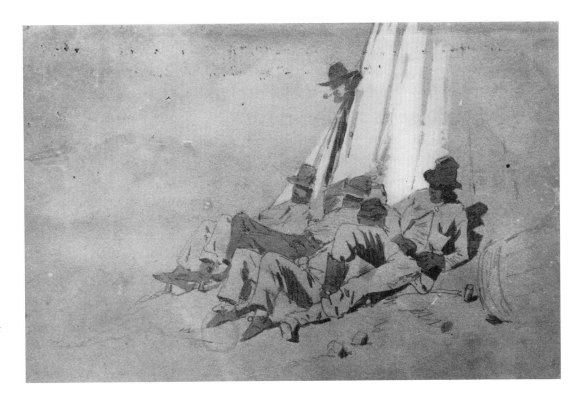

6. Winslow Homer, compositional study for *The Bright Side*, pencil and wash on paper
Colby College Museum of Art, The Harold T. Pulsifer Memorial Collection

7. Winslow Homer, study for *The Bright Side*, 1864, oil on paper mounted on board
Private collection

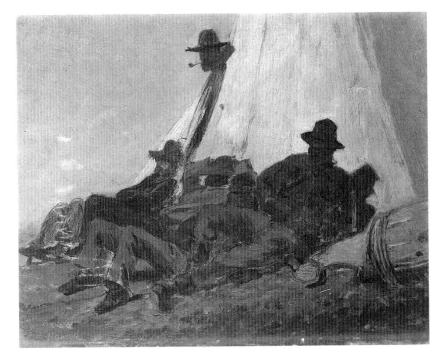

the firm of Houghton Mifflin Company, which controlled Armstrong & Company, and by 1885 was also president of the interdenominational periodical *The Christian Union*, a position he retained until his death in 1891.[30] The celebrated antislavery preacher Henry Ward Beecher was associated with the magazine by 1870.[31] Valentine himself was a concerned and charitable man; and he and Beecher were said to be "congenial spirits."[32] Another likeminded individual, Reverend Lyman Abbott, an editor of *The Christian Union* and long-time friend of Valentine, advocated the right of black and white workingmen to education and organization. The specific reason Valentine commissioned the chromolithograph is uncertain, although it seems to have coincided with his partnership in the firm that published it. Whether to celebrate that happening or not, *Army Teamsters* is not a surprising choice of image for Valentine to present to his colleagues in view of his sympathies.

And what of Homer's own sympathies? In the first place, Homer seems to have given considerable attention to the creation of *The Bright Side*. From what is known of surviving material, he made a tonal compositional sketch and an oil study dated 1864 (figs. 6 and 7), the two paintings of 1865 and 1866 (figs. 1 and 2), incorporating a pencil study of mules perhaps made as early as 1862 (fig. 8), and the wood-engraved version for Aldrich's article of 1866 (fig. 3). In the compositional study and "matching"

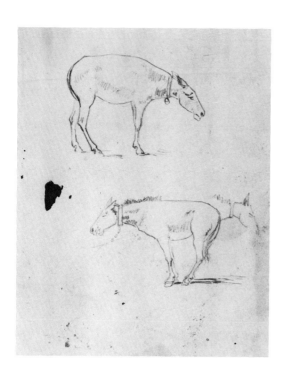

oil sketch, the five teamsters are dominant. Only part of a tent and staked barrel suggests the larger camp environment worked out in the paintings. Yet, other than a general indication of dark coloring, the blacks are not particularized. Of course, in these pieces Homer may have been concerned simply with blocking in form. Or it may be that only when the image was made "public" did Homer feel the need to define racial characteristics. This is not to say that Homer then lapsed into straight caricature, but only that he seems not to have been concerned, at least in the studies, with making racial distinctions.

Homer had included blacks in his work as early as 1856, according to David Tatham, although essentially only as staffage.[33] Whether he did so out of pictorial interest or journalistic accuracy is not clear. And the possibility of other reasons

8. Winslow Homer, study of mules for *The Bright Side,* c. 1862, pencil on paper
Collection Mrs. Lois Homer Graham

9. Winslow Homer, *Defiance: Inviting a Shot before Petersburg, Virginia,* 1864, oil on panel
The Detroit Institute of Arts, Gift of Dexter M. Ferry, Jr.

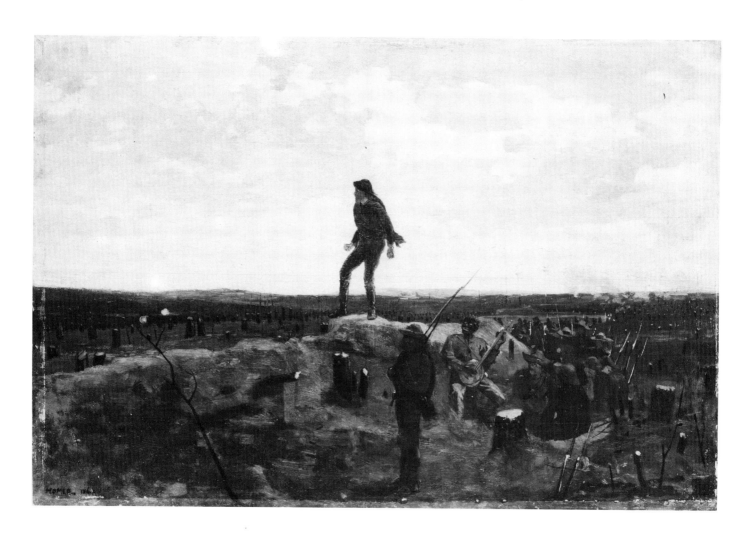

10. Winslow Homer, *Army Boots*, 1865, oil on canvas
The Hirshhorn Museum and Sculpture Garden, Smithsonian Institution, Washington, D.C.

11. Winslow Homer, *At the Cabin Door*, 1865–1866, oil on canvas
The Newark Museum, New Jersey, Gift of Mrs. Clementine Corbin Day, Mrs. Hannah Corbin Carter, Horace K. Corbin, Jr., Robert S. Corbin, and William O. Corbin in memory of their parents, Hannah Stockton Corbin and Horace Kellogg Corbin

is no more than conjecture; for Homer's position on racial issues is not known. There is, however, an unmistakable difference in the consideration Homer as a painter gave blacks after the start of the war. He can be said to have used the black as "color" in at least one painting—*Defiance: Inviting a Shot before Petersburg, Virginia*, of 1864 (fig. 9). The banjo-playing black man assumes the conventional role of witless entertainer, although it can be argued that he serves to cement the painting's topicality rather than its slander. In Homer's other paintings of blacks—*Army Boots*, 1865, *Near Andersonville* (formerly *At the Cabin Door*), 1865–1866, and *The Bright Side* (figs. 10, 11, and 1)—the figures dominate the compositions. Whatever hint of humor there may be in the paintings, it is not ridicule. The sensitive rendering of distinct individuals precludes such an interpretation.[34]

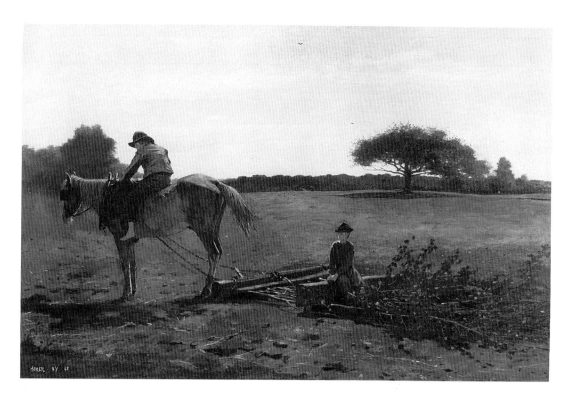

12. Winslow Homer, *The Brush Harrow*, 1865, oil on canvas
The Harvard University Museums, Fogg Art Museum, Cambridge, Massachusetts, Anonymous gift

Homer almost certainly did not intend his images of blacks in *The Bright Side* to have political significance. Even so, they could hardly escape being attributed such meaning by their first viewers. Racism was not articulated as an "issue" by *The Bright Side*; but critics inevitably construed the painting in racial terms. A "truthful" representation of the black in the Ruskinian sense would have been difficult to accept, and the other extreme, a blatantly biased image, would have had limited appeal. Yet Homer's mildly stereotypical *The Bright Side* was sufficiently ambiguous to be acceptable to either black sympathizers or supporters of slavery. Critical attention indicates Homer's success in finding an acceptable, yet not wholly innocuous, way to depict the black, a core element of the war.

In 1866 Homer submitted two more paintings about the Civil War to a National Academy of Design exhibition. *The Brush Harrow*'s reference was oblique (fig. 12).[35] Two children, in the absence of older brothers or fathers at the front, perform the normally adult task of smoothing a field after plowing. *Prisoners from the Front*, on which the critics focused, dealt pointedly with the war (fig. 13), depicting a group of soldiers in a war-ravaged landscape. A Union officer dispassionately regards three Confederate prisoners brought before him under light guard, who stand at ease awaiting their disposition. Their surrendered rifles lie on the ground in the foreground. A cavalry escort with a flag displaying the red trefoil of the 1st Division of the 2nd Corps is to the right.

Tension is generated by the opposition of the two protagonists, whose dress and stance are in marked contrast. Behind the Confederate is a desolate landscape, suggesting the wasted South or, perhaps in the eyes of a Union sympathizer, the entire country laid waste by the war brought on by the Confederacy. The watchful cavalry backing the Union general suggests the strength and resolve of the North. The space between the two officers is more than a physical separation. There is no proffering or joining of hands or passing of swords, as might be expected in such a subject, that would bridge the distance.

At the time of its exhibition, *Prisoners*

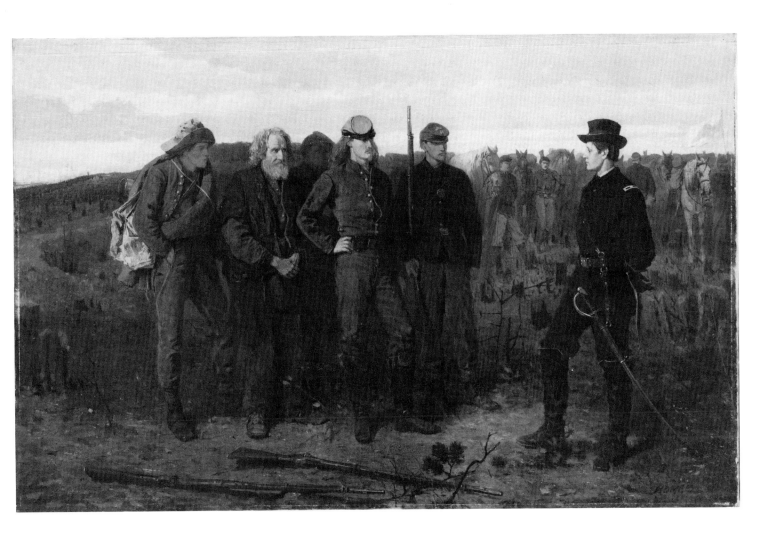

13. Winslow Homer, *Prisoners from the Front*, 1866, oil on canvas
The Metropolitan Museum of Art, New York, Gift of Mrs. Frank B. Porter

from the Front impressed everyone with its appropriateness and seriousness.[36] In addition, all of the critics remarked on Homer's admirable characterization of the participants. And nearly all, despite praise of the painting's honesty, described the soldiers in *Prisoners from the Front* in distinctly pro-Northern terms. A pointed comparison was drawn between the bearing of the Union general and that of the prisoners who represented the opposition. Eugene Benson described the prisoners most forcefully as an "audacious, reckless, impudent young Virginian, capable of heroism . . . the poor, bewildered old man, perhaps a spy, with his furtive look, and scarcely able to realize the new order of things about to sweep away the associations of his life . . . 'the poor white,' stu-

pid, stolid, helpless, yielding to the magnetism of superior nature and incapable of resisting authority. Mr. Homer shows us the North and South confronting each other. . . ." Benson went on to say that it was clear why the South was not successful against the North: "The basis of its resistance was ignorance, typified in the 'poor white'; its front was audacity and bluster, represented by the young Virginian;—two very poor things to confront the quiet, reserved, intelligent, slow, sure North, represented by the prosaic face and firm figure and unmoved look of the Union officer."[37] Clarence Cook, in the calmer atmosphere of 1888, considered the work "strong on the side of brotherly feeling, and of a broad humanity in the way of regarding the great struggle."[38]

Constant Mayer's *North and South: An Episode of the War*, shown in the 1865 Academy exhibition, provides a fruitful comparison with Homer's *Prisoners from the Front*. At least one reviewer interpreted Mayer's painting as illustrating the theme of brotherhood; his description is useful since the present location of the painting is not known:

Two soldiers are lying there; the one wearing the light uniform of the Confederate service, the other the true blue of the United States. The latter appears to be the more seriously wounded of the twain, being on the point of dissolution. His companion reaches over, we suppose to offer assistance, perhaps a grateful drop of moisture from his canteen. If the action be a kindly one, it is certainly inadequately expressed. The eager, hard glance of the rebel suggests anything but a good Samaritan. One is apt to suspect him of a design on the dying man's clothes and effects. The idea that Mr. MAYER wants to express is, of course, brotherhood.[39]

The reviewer seems to have objected to the painting's histrionics, its lack of plausibility. He had suspicions about the genuineness of the Confederate soldier's compassion. Perhaps it is worth recalling that Mayer was German. Whatever the reason, his image of the South was unclear.

The critic for another journal, on the other hand, praised Mayer's *North and South* not only on its merits as a painting but principally for its appropriateness: "at the present time, when reconciliation and reconstruction are the order of the day. We wish those scribblers for the press, who are doing everything in their power to stir up feelings of hate among the people, who are hounding on the Government to sully the grandeur of its triumph by base acts of revenge . . . could be touched by the noble sentiment of this picture."[40] Apparently this opinion of the painting prevailed, for a few months later an announcement appeared indicating photographic copies were available.[41]

Commentary on Mayer's painting suggests that the subject was timely, that the public was ready to accept a painting of the meeting of North and South. But it also suggests that Mayer's *North and South* was not immediately comprehensible.

There was confusion about the imagery.

On the surface, Mayer's painting and Homer's *Prisoners from the Front* have a related theme. A crucial difference, however, was Homer's apparently legible and comparatively matter-of-fact presentation of North-South relations. Reviewers remarked on the painting's "veracity" and "historical" aspect. Its hold, however indirect, on the facts of the war and its lack of sentimental glossing were surely important factors.

Homer drew on his topographical sketch of the area near Petersburg, where the 2nd Corps had been involved in intense fighting, and used his personal observations for the Union general.[42] The faces of the prisoners likewise seem individual, although no drawings are known. In fact, however, they characterize three different ranks, ages, and classes. This long-established formal convention is paralleled in an account by Oliver Wendell Holmes, who described Confederate prisoners he had encountered after the Battle of Antietam in September 1862 as: an elderly man with a beard, "drooping eyelid, and a black clay pipe in his mouth . . . [professing] to feel no interest in the cause for which he was fighting"; a "wild-haired, unsoaped boy, with pretty, foolish features . . . poor human weed . . . doomed by neglect to an existence but one degree above that of the idiot"; and "the true Southern type," college-educated, "a little over twenty, rather tall, slight, with a perfectly smooth, boyish cheek, delicate, somewhat high features, and a fine, almost feminine mouth" who spoke with a "pleasant, dangerous smile."[43] The critical commentary of 1866 on *Prisoners from the Front* contained comparable descriptions of the prisoners. Even the one apparent differentiation—some reviewers called the rebel officer a South Carolinian, some a Virginian—was only another generalization, because Virginia and the Carolinas were considered the chivalric strongholds of the South.[44] Homer's soldiers were nevertheless entirely convincing, although their specificity had symbolic purpose. They were recognized as epitomizing Northern victory and Southern resistance, which had taken various forms. In that way, the confronta-

tion of a few stood for many.

The relevance of Homer's painting may have been heightened by public awareness of the difficulties connected with the exchange of prisoners during the Civil War.[45] Problems had existed almost from the beginning. They were aggravated by the Emancipation Proclamation and acceptance of blacks into the Union Army and were never fully resolved. Reports of this issue—an aspect of Northern and Southern confrontation and eventual reconciliation—appeared frequently in newspapers and journals.[46] The public by the end of the war was also well aware of the horrific condition in which Union soldiers had been incarcerated in Confederate prisons at Andersonville, Georgia, and elsewhere. Accounts of deplorable treatment and its effects, often published with illustrations, gave a different dimension to existing tensions concerning the matter of prisoners of war and the relations between North and South.[47]

But clearly the larger issues of the treatment of the South and its restoration to the Union were the key factors in the critical reception of the painting. The surrender of the Confederacy in 1865 created a problem unique in the history of the United States. The South, which had been part of the original Union, was somehow to rejoin it and become again a functioning member but without the return to power of the parties who had initiated secession. The aristocratic, propertied (slave-owning) class was held primarily culpable for the war and had to be prevented from regaining political and social control. If that were not achieved, it was feared that the restoration of the Union and the emancipation of the blacks would be effectively negated.

Securing these achievements was of paramount importance. How to secure them was another matter. Retributive as well as magnanimous attitudes found expression in policies considered and carried out in the first year after the war. In late 1865, however, several former Confederate leaders were elected to the 39th Congress by newly reformed Southern states. It was clear that the old South was reasserting itself.[48]

Although impersonations of the South after the war ranged from bitter enemy to romantically attractive and wayward adversary, perhaps fueled by the myth of the so-called Lost Cause of the South,[49] an anxious, if not somewhat unfavorable, attitude was prevalent in 1865 and 1866.[50] Under the circumstances, it is tempting to dismiss the critics' comments on the Southerners in *Prisoners from the Front* as simply not objective. But something of their opinion is reflected in George Fredrickson's more considered essay on the reasons for Northern victory. In assessing the South, he stated that "Particularism, localism, and extreme individualism were the natural outgrowth of the South's economic and social system. So was resistance to any changes that posed a threat to slavery and racial domination."[51] These words closely resemble those used by critics to describe the three Confederates in *Prisoners from the Front*. The same conclusion seems to be expressed: that the South bred fierce individualism, a feeling of superiority, and provincialism; and that there was dependence on the past, resistance to innovation, and little cohesion among its parts. Without making too much of it, the apparent correspondence between Fredrickson's and the critics' reading in 1866 of the "conditions of character" of the South in comparison to the North gives fresh cogency to early commentary on Homer's painting.

Nicolai Cikovsky has rightly considered the painting to be an assessment of the Civil War, conveying the devastation and fundamental changes it wrought.[52] He unraveled the painting's historic associations, situating it within the events of the war and identifying the two generals who may have served Homer as representatives of Northern and Southern types. In addition to the portrait of the Union general, Francis Barlow, Cikovsky convincingly argued that there is a symbolic reference to the Confederate general J.E.B. Stuart in the captured young officer. Stuart was well-suited to exemplify the South. His chivalry and military successes had made him a virtual legend even in Northern journals by 1866, two years after he was killed. His personal qualities matched romantic notions of a Southern "aristocratic tradition."

Still, most of the New York critics stressed the divisiveness of the war.

Through harsh description Benson enunciated the need to explain, perhaps even deprecate, the rebels who had broken from the Union and to justify the bloody war and victory of the North.[53] Even more gentle comments were still clearly partisan in their favor of the North. In contrast, Cook's postwar review shows the mellowing effect of time. He was more charitable, seeing the painting as expressive of "brotherly feeling." Thus to contemporary critics the painting articulated Northern superiority and the stresses generated by the war; to Cook it spoke of compassion and the war's human drama.

On reexamination, it is not surprising that *Prisoners from the Front* prompted responses like Benson's. The rigidly upright "North" seems distant and unwelcoming; the proud, intransigent "South" seems unwilling to forgive or forget the humiliation of its surrender. Homer's patronizingly simple and standardized characterization of the South and somewhat congratulatory (though Northern critics saw it as objective) representation of the North convey a definite bias. Even the choice of subject— the punishing moment of defeat and the taking of prisoners—could be interpreted as a form of retribution. On the other hand, it is hard to read the painting as a punitive statement. Homer undoubtedly had Northern sympathies and he was, after all, painting for a Northern audience. But he gave nearly equal significance to both sides in *Prisoners from the Front*, pictorially and psychologically. His depiction could satisfy Northern viewers of various persuasions, as had *The Bright Side*.

In conclusion, then, it was the subject matter and the forceful, yet tactful, presentation that invited considerable interest in *Prisoners from the Front* and *The Bright Side*. One critic wrote in 1865 that the public had fittingly crowned Homer "the best chronicler of the war, with smiling eye and silent applause" on the basis of *The Bright Side*.[54] The following year, Benson described the pair of paintings as making "a comprehensive epitome of the leading facts of our war."[55] At the very least, *The Bright Side* did depict blacks in a wartime situation and *Prisoners from the Front* a tense encounter between North and South.

But it is the specific "leading facts" of the Civil War—slavery and the attendant problem of racism, and a fratricidal war— that seem encapsulated by Homer's *The Bright Side* and *Prisoners from the Front*. Their reference to those facts was unusual and unsettling at a time when, as one critic-collector of the period cynically claimed, American art was comprised of "ornaments, pictures, and sculptures made to gull and sell."[56] However muted their potential for controversy, Homer's two major early successes displayed more than journalistic directness and simple relevancy; they touched on the salient aspects of the war. In that sense, they chronicled the war. As the tenor of critics' remarks shows, the paintings could not be ignored. They placed Homer in the public arena, as Homer surely intended, and secured his early critical reputation. Sustaining that position after the Civil War was to prove a problem. It would be several years before Homer again found his center of gravity.

NOTES

For their assistance at various stages of this article or with my Ph.D. dissertation "Winslow Homer: Painter of the Civil War" (Harvard University, 1985), from which this article derives in part, I wish especially to thank T.J. Clark, Patricia Hills, Lloyd Goodrich, Abigail Booth Gerdts, Nicolai Cikovsky, Jr., Natalie Spassky, and Eric Rosenberg.

1. R.M. Shurtleff, *American Art News*, 29 October 1910, 4, discussed Homer's first oil paintings. William H. Downes, *The Life and Works of Winslow Homer* (Boston, 1911), 46–47, and the late Lloyd Goodrich *Winslow Homer* (New York, 1944), 18, agree on 1862 as the year Homer took up oils.

2. New York newspapers and periodicals provided the best coverage of the exhibitions of Homer's Civil War paintings. But even a cursory reading of the press during the war years reveals biases of one sort or another. Frank Luther Mott, *American Journalism: A History of Newspapers in the United States through 260 Years: 1690 to 1950* (New York, 1950) and *A History of American Magazines, Vol. 3, 1865–1885* (Cambridge, Mass., 1938) have been useful guides, revealing that the New York newspapers staunchly loyal to the Union were the *Times*, *Evening Post*, and *Daily Tribune*; the *New York World* was the leading "Peace Democrat" paper. According to one writer of the period, the *New York Leader* was also a Democratic weekly, a label that did not necessarily indicate a disloyal stand; I am grateful to Nicolai Cikovsky, Jr., for having brought this paper to my attention. *The Nation* upheld liberal, democratic principles. *Harper's New Monthly Magazine* and *The Round Table* were pro-Union, though the latter was often severely critical of the conduct of the war. *Watson's Weekly Art Journal* and *The New Path*, being devoted to artistic matters, were essentially nonpolitical.

3. Occasionally the short exhibition notes, reviews, or editorials about art were signed and information can sometimes be obtained about individual authors. More often the articles were not attributed. In those cases it is impossible to determine whether they reflect the journal's editorial policy or the writer's own opinion. Among acknowledged authors, George Arnold wrote several reviews for the *New York Leader* that appeared in 1864–1865; Eugene Benson ["Sardello"], was associated with the *New York Evening Post*; Thomas Bailey Aldrich contributed to many journals; and Clarence Cook was an art critic for the *New York Tribune*, 1863–1866, and an editor for *The New Path*.

Arnold trained as a painter but turned to a literary career. In *Vanity Fair* before the magazine's demise, Arnold satirized the war. He went to Staten Island "as one of the militia garrison of Fort Richmond" and belonged to the Thirty-Seventh New York National Guard, Company C, according to his obituary notice by Stephen R. Fisk in the *New York Leader*, 18 November 1865, 1. Benson, also a painter and man of letters, was a friend of Homer. They both maintained studios in the New York University Building and were fellow members of the Century Club. See

Aldrich, "Among the Studios, III," *Our Young Folks* 2, no. 7 (July 1866), 394, and *The Century: 1847–1946* (New York, 1947), 366, 384. Aldrich, a New-Englander, served briefly as a war-correspondent and devoted himself primarily to writing. Clarence Cook was a member of the Society for the Advancement of Truth in Art, founded in 1864. For his involvement with that movement and the *New York Daily Tribune*, see Linda S. Ferber, " 'Determined Realists': The American Pre-Raphaelites and the Association for the Advancement of Truth in Art," *The New Path: Ruskin and the American Pre-Raphaelites* [exh. cat., The Brooklyn Museum] (New York, 1985), 11–34.

4. Nicolai Cikovsky, Jr., "Winslow Homer's Prisoners from the Front," *Metropolitan Museum Journal* 12 (New York, 1977), 155–172; Natalie Spassky, *American Paintings in the Metropolitan Museum of Art* (New York, 1985), 2:437–445.

5. Aldrich 1866, 396.

6. Mott 1938, 3:175 n. 56, describes *Our Young Folks*, which was founded in 1865, as "a bright, amusing, literary magazine, with an excellent list of contributors." "Juveniles" were a popular form of periodical in the mid-nineteenth century.

7. *New York Evening Post*, 16 February 1865, 1; *New York Leader* 11, no. 10, 11 March 1865, 5.

8. Clark S. Marlor, *A History of The Brooklyn Art Association with an Index of Exhibitions* (New York, 1970), 230; *Catalogue of the Fortieth Annual Exhibition of the National Academy of Design* (New York, 1865), no. 190.

The Initials is the subject of my article, "Winslow Homer's Civil War Painting 'The Initials': A Little-Known Drawing and Related Works," *American Art Journal* 18, no. 3 (1986), 4–19.

9. *New York Daily Tribune*, 3 July 1865, 6.

10. *Watson's Weekly Art Journal* 3, no. 10, 1 July 1865, 148; *The New Path* 3, no. 6 (June 1865), 104; *The Nation* 1, no. 2, 13 July 1865, 58. The conical Sibley tent went out of field service by 1862 because it was so cumbersome and was used thereafter only in semi-permanent camps. See Francis A. Lord, *Civil War Collector's Encyclopedia: Arms, Uniforms, and Equipment of the Union and Confederacy* (Harrisburg, Pa., 1963), 280.

11. *New York Evening Post*, 31 May 1865, 1.

12. *New York Times*, 13 June 1865, 5, and 29 May 1865, 4; *The Round Table*, n.s. 3, 23 September 1865, 37.

13. *New York Leader*, 11 March 1865, 5.

14. Aldrich 1866, 397.

15. Clarence Cook, *Art and Artists of Our Times*, 3 vols. (New York, 1888), 3:257–258.

16. Eastman Johnson portrayed blacks chiefly in domestic situations. The notable exception is *A Ride for Liberty—The Fugitive Slaves*, 1863 (The Brooklyn Museum). A survey (by title) of National Academy of Design offerings during the Civil War years and the "Genre-Military" and "History-American Civil War" listings from the Inventory of American Paint-

ings Executed before 1914 (National Museum of American Art, Washington, D.C.), an examination of reviews of the period, and the scanty number of catalogues and books that include references to and photographs of paintings of the black in American art suggest a shying away from treatment of the black during the actual war years. See Hermann Williams, Jr., *The Civil War: The Artist's Record.* [exh. cat., The Corcoran Gallery of Art] (Washington, 1961); Sidney Kaplan, *The Portrayal of the Negro in American Art* [exh. cat., The Bowdoin College Museum of Fine Arts] (Brunswick, Me., 1964); Ellwood C. Parry, *The Image of the Indian and the Black Man in American Art, 1590–1900* (New York, 1974); Patricia Hills, *The Painters' America: Rural and Urban Life, 1810–1910* [exh. cat., The Whitney Museum of American Art] (New York, 1974); James Edward Fox, "Iconography of the Black in American Art, 1710–1900" (Ph.D. diss., The University of North Carolina at Chapel Hill, 1979); and Karen M. Adams, "Black Images in Nineteenth-Century American Painting and Literature: An Iconological Study of Mount, Melville, Homer and Mark Twain" (Ph.D. diss., Emory University, 1981). Blacks with the army, however, are visible in photographs of the period; see Alexander Gardner, *Gardner's Photographic Sketch Book of the War*, 2 vols. (Washington, D.C., 1866), plates 27, 63, 77, 94; and Roy Meredith, *Mr. Lincoln's Camera Man, Mathew B. Brady* (New York, 1974), Brady's Lantern Slide Lecture: nos. 1, 30, 35, 85.

17. Eric Foner, *Politics and Ideology in the Age of the Civil War* (New York, 1980), 77.

18. James M. McPherson, *The Struggle for Equality: Abolitionists and the Negro in the Civil War and Reconstruction* (Princeton, 1964), 139. Even a pastor from Deerfield, Mass., James K. Hosmer, who enlisted with the Union Army, spoke of slaves being not more harshly treated than "if they had remained in unenslaved barbarism." See Hosmer, *The Color-Guard, Being a Corporal's Notes of Military Service in the Nineteenth Army Corps* (Boston, 1864), 32.

19. *The Caucasian*, 15 March 1862; quoted in Basil Leo Lee, *Discontent in New York City, 1861–1865* (Washington, D.C., 1943), 145.

20. Lee 1943, 143.

21. According to official order (*The New York Times*, 15 February 1863, 3), blacks could be employed "As teamsters on Quarter Master's train, provided a sufficient number of white teamsters and wagon masters are retained to preserve order." See also *Boston Daily Evening Tribune*, 3 April 1863; *New York Daily Tribune*, 18 April 1863, 1; and *New York World*, 13 January 1864, 4, which published the statement by the president of the Western Sanitary Commission that the black "feels that he has exchanged one master for many masters."

22. *Boston Daily Evening Transcript*, 16 July 1863. The painting was exhibited at the National Academy of Design under the title *The Bright Side*. It may well have been Homer's choice, for he used the phrase "look on the *bright side*" in a letter, undated but of the war years, to his brother Arthur (private collection). The phrase seems to have had common currency.

23. Quoted in Foner 1980, 59–60.

24. Cook's views were quoted, and lambasted, in the *New York Leader*, 19 August 1865, 4.

25. George M. Fredrickson, *The Black Image in the White Mind: The Debate on Afro-American Character and Destiny, 1817–1914* (New York, 1972), 101–102, and 108–109, for reasons for the development of such an attitude.

26. Quoted in Fredrickson 1972, 124.

27. *New York Times*, 29 May 1865, 5; *New York Leader*, 3 June 1865, 1; *New York Evening Post*, 31 May 1865, 1.

28. Fredrickson 1972, 161.

29. Armstrong & Company was established in Boston in 1872 by Charles Armstrong, whose speciality was chromolithographs after paintings and drawings from books and folios. Marilee Wheeler and Leeds Armstrong Wheeler dated the print of *Army Teamsters* to 1880 (MS with checklist on "Armstrong & Company, Artistic Lithographers," 1944, with the Boston Public Library, Mass., published in part in 1982). The print in the library given by Leeds Wheeler has the lower edge cropped and partially painted over, which obscures the date. Even on the Colby print, and the third known copy, which recently surfaced through Goodspeed's Book Shop, Boston, the date is difficult to read. I am grateful to David Tatham for bringing Goodspeed's print to my attention.

30. Mott 1938, 422, claims Valentine became president in 1881; Lyman Abbott, *Reminiscences* (Boston, 1915), 346, gives the date as 1885.

31. Mott 1938, 76.

32. Abbott 1915, 344, 415.

33. Cited in Adams 1981, 112. Homer's lithographs illustrated the *Proceedings of the Reception and Dinner in Honor of George Peabody Esq. . . .* of London, who visited Danvers, Massachusetts, in 1856. A black next figures as a servant in Homer's *Harper's Weekly* illustration "Thanksgiving Day—The Dinner," 27 November 1858. The "Expulsion of Negroes and Abolitionists from Tremont Temple, Boston, Massachusetts, on December 3, 1860," in *Harper's Weekly* of 15 December 1860 necessarily included several blacks, yet the black on the stage about to be quieted and others in the audience resisting expulsion were given some prominence. Lastly, two engravings for the same magazine (16 March 1861) showed blacks as coachmen for the president's carriage in "The Inaugural Procession at Washington Passing the Gate of the Capitol Grounds" and as two separate foreground spectators of seemingly different social status in "The Inauguration of Abraham Lincoln as President of the U.S. at the Capitol, Washington, March 4, 1861."

34. A comparison of Homer's paintings of blacks with standard illustration fare—cartoon or otherwise—of 1865 points up Homer's restraint. See, for example, "Is all dem Yankees dat's Passing?" *Harper's Weekly*, 7 January 1865, 16, and "The Great Labor Question from a Southern Point of View," *Harper's Weekly*, 29 July 1865, 465.

35. Although the flank of the horse drawing the harrow was described in a review as branded with the abbreviation U.S. (*New York Leader*, 21 April 1866, 1), the painting had no such marking when examined by the conservation laboratory of the Fogg Art Museum.

36. For overviews of contemporary commentary on the painting, see Cikovsky 1977, 155–156, and Spassky et al. 1985, 440–441.

37. *New York Evening Post*, 28 April 1866, 1. The reviewer for *The Round Table*, 12 May 1866, 295, in similar fashion, characterized the South as "ardent and audacious at the front, . . . bound to the past, and bewildered by the threatened severance of that connection with the past, . . . resting on ignorance and servile habits," and the North as "unsympathetic, firm . . . reserved but persistent." *New York Leader*, 21 April 1866, 1, wrote further: "The contrast between the various slouching and insolent attitudes of the prisoners, and the erect and manly bearing of the Union officer, is admirably rendered by Mr. Homer." *Harper's New Monthly Magazine* 33 (June 1866), 117; described the Union officer's "certain grave and cheerful confidence of face, with an air of reserved and tranquil power . . . contrasted with the subdued eagerness of the foremost prisoner."

38. Cook 1888, 3:250.

39. *New York Times*, 12 May 1865, 4. A drawing by Homer of a similar subject, *Wounded Soldier Being Given a Drink from a Canteen*, signed and dated 1864 (The Cooper-Hewitt Museum, Smithsonian Institution's National Museum of Design), predates Mayer's painting. One soldier stands at the left watching as another gently cradles the head of a fallen colleague and holds a canteen to his lips. The drawing is pictorially complete, suggesting that Homer might have considered carrying it over into another medium.

40. *Watson's Weekly Art Journal*, 17 June 1865, 115.

41. *Watson's Weekly Art Journal*, 28 October 1865, 20.

42. Sketches for "Defiance," verso of portrait bust of General Francis Barlow (The Cooper-Hewitt Museum). For information about the friendship of Barlow and Homer, see Cikovsky 1977, 167–169.

43. Oliver Wendell Holmes, "My Hunt After 'The Captain,'" in *Pages from an Old Volume of Life: A Collection of Essays, 1857–1881* (Boston, 1883), 59–61; originally published in *The Atlantic Monthly* 10, no. 62 (December 1862).

44. For example, *Harper's New Monthly Magazine* 33 (June 1866), 117. In an article on "Southern Chivalry," a writer for the *New York Daily Tribune*, 19 September 1862, 2 wrote, "It has pleased the leading Rebel journals, especially those of Virginia and the Carolinas, to say much in invidious comparison of the lineage of the loyal and disloyal States respectively, and to boast of themselves as descended from the cavaliers of Old England." It was even said that the popular Confederate General J. E. B. Stuart was a descendent of Prince Rupert, nephew of Charles I, son of Elizabeth Stuart.

45. For an account of the handling of prisoners during the war, see Alfred H. Guernsey and Henry M. Alden, *Harper's Pictorial History of the Great Rebellion* (New York, 1868), 792, 794–795, 797.

46. See *New York Daily Tribune*, 18 November 1863, 4, and 8 January 1864, 4; *New York World*, 9 January 1864, 4; *New York Times*, 22 January 1865, 1, and 2 March 1865, 4; *Harper's Weekly*, 25 February 1865, 115, and 11 March 1865, 147.

47. See *Harper's Weekly*, 17 June 1865, 379–380.

48. One Southerner admitted "It is our duty to support the President of the United States so long as he manifests a disposition to restore all our rights as a sovereign State." Quoted in James M. McPherson, *Ordeal by Fire: The Civil War and Reconstruction* (New York, 1982), 502.

49. The phrase derived from Edward A. Pollard, *The Lost Cause: A New Southern History of the War of the Confederates* (1866). Pollard connected the South with the Lost Cause of Bonnie Prince Charlie of England in an attempt to ease the humiliation of defeat (n. 44). See also Rollin G. Osterweis, *The Myth of the Lost Cause, 1865–1900* (Hamden, Conn., 1973).

50. For a sampling of editorials noting the South's rebellious, haughty spirit, despite its crushing defeat, and expressing concern about the sincerity of the South's acceptance of Unionism, see: *New York Times*, 26 October 1865, 4, 19 January 1866, 4, and 13 April 1866, 4; *Harper's Weekly*, 16 September 1865, 578, and 30 September 1865, 611. See also government-sponsored reports such as Carl Schurz, *Report on the Condition of the South* (New York, 1969 [submitted 1865]); and accounts by journalists traveling in the South after the war such as Whitelaw Reid, *After the War: A Southern Tour, May 1, 1865–May 1, 1866* (New York, 1866); Sidney Andrews, *The South Since the War* (Boston, 1866); and John T. Trowbridge, *The South: A Tour of Its Battlefields and Ruined Cities* (Hartford, 1866).

51. George M. Fredrickson, "Blue over Gray: Sources of Success and Failure in the Civil War," in *A Nation Divided: Problems and Issues of the Civil War and Reconstruction* (Minneapolis, 1975), 77.

52. Cikovsky 1977, 171.

53. Benson (*New York Evening Post*, 31 May 1865, 1) had earlier excused artists who "made art a pleasant refuge from the toils and ardours of a sublime struggle . . . for the time is not one that asks art to stimulate patriotism with pictures of the heroic deeds of a noble cause." A year after the war, by the time of his review of *Prisoners from the Front* (*New York Times*, 28 April 1866, 1), Benson had evidently changed his mind or categorized *Prisoners from the Front* differently. He praised the painting's hold on "the most vital facts of our war" and accepted what he considered its awkward execution, claiming "we are neither introspective nor sentimental, nor much given to the delicacies of life" in the case of depictions of war.

54. *New York Daily Tribune*, 3 July 1865, 6.

55. *New York Evening Post*, 28 April 1866, 1.

56. James Jackson Jarves, quoted in Lewis Mumford, *The Brown Decades: A Study of the Arts in America, 1865–1895* (New York, 1971), 83.

ROGER B. STEIN
University of Virginia

Picture and Text:

The Literary World of Winslow Homer

To think of Winslow Homer in literary terms would seem at first to be flying in the face of the facts, for we know remarkably little about what Homer read and thought, and the Homer "library" we have recovered is pitifully small. His early friendships were especially with other artists, occasionally with critics and dealers. He had a studio in New York in the University Building and later in the famous Tenth Street Studio Building, and he was a member of the Century Association and the Tile Club. At least briefly during the 1870s Homer was also part of the aesthetic circle of Helena de Kay and her husband, the poet-editor of *Scribner's Monthly Magazine*, Richard Watson Gilder. Most of Homer's personal associations, however, especially in his later years, seem to have been within his family and with the businessmen and women who hunted and fished with him in the Adirondacks or who summered at Prout's Neck—not with William Dean Howells or Sarah Orne Jewett and her friends in nearby Kittery and South Berwick, Maine, and certainly not with Mark Twain, Henry James, William James, or other leading literary and intellectual figures of the period.[1]

Given this situation, the tendency in Homer criticism for years has been to examine his art in isolation from its literary context, to focus on his stylistic development or his realism as a general "reflec-tion" of American culture, only occasionally pointing out affinities between his artistic achievement and that of American literary figures. But recent criticism has begun to examine individual works in closer detail, locating them more specifically in their cultural contexts and linking their visual language to the ideas and iconography of Homer's time and place.[2]

It is thus time to reopen the question of Winslow Homer's relation to his literary contemporaries. In doing so, we must construe "literary" in the broadest sense: not just belles lettres—novels, stories, and poems—but also the work of critics, journalists, and social commentators who gave verbal form to thoughts and feelings, to metaphysical ideals and personal predilections, and to the ideology of their time. Formalist analyses have taught us much about Homer's achievement, but by mapping the literary territory within which his art functioned, we can see his works from new perspectives, not simply as isolated images within a stylistic sequence.

It is in Homer's early graphic work that we see most vividly the interplay between visual and verbal. It is also here that the separation of Homer's art from its literary context is most distorting and deprives us of useful insights into this elusive, laconic man and artist. Given his reticence, Homer's intentions and attitudes can only be inferred. We must study the points at

which his work intersects its verbal counterparts and focus on the interaction between the two. Our assumption is that culture is a social process, not a reified abstraction or a "background" that art illustrates or reflects, passively; the work of visual art is a historical act within that process, part of a complex game of social signification and cultural self-definition.

Homer's entry into the world of visual art was through the predominantly verbal medium of illustrated magazines, and he became and remained successful as a graphic artist because he learned to relate his work effectively to the written word. His skills as a pictorial designer matured over time, and his art developed more complex relationships to the texts with which it was connected. His early visual narratives were often anecdotal and simply supported the dominant ideology of his culture as articulated in the texts he illustrated. Magazine editors frequently said that Homer's pictures needed no text, "They tell their own story."[3] Yet words often intervened to interpret, define a moral, or associate an image with a situation or incident that expressed contemporary values. Homer's works became increasingly complex and sometimes enigmatic in their point of view, and ultimately, in some of the late oils and watercolors, they stood in ironic relation to the central values of his culture. This shift paralleled a change in the cultural definition and expectations of what constitutes a work of art, as recorded in the criticism of Homer's work. The later criticism, especially from about 1881 on, increasingly sought to judge his art in terms of "purely pictorial values," to dissociate meaning from its cultural contexts—to become, in a sense, "modern." The significance of Homer's "isolation" and the ruptures effected by his works from the central values of his culture can be more fully appreciated once Homer's early participation in the literary world has been established.

First Efforts: Rural Scenes And Holiday Rituals

The culture of Boston and Cambridge, where Homer grew up, was an eminently literary culture. Of course, New England was also home to visual artists, such as Washington Allston, Chester Harding, and Henrietta Benson Homer. Art patronage and exhibition possibilities existed, especially at the Boston Athenaeum (a conspicuously literary place).[4] But Winslow Homer (and his father) chose a path followed by many talented New England artists, becoming an apprentice at the lithographic firm of J. H. Bufford.[5] Here he not only learned about graphic processes, which facilitated his entry into the world of visual art, but he was introduced to the relationship between word and image. The lithographer's picture was usually linked to and frequently dependent on a text of some kind. In his first lithographs Homer designed covers to sell music and texts, adapting existing images to the sentimental needs of this popular art form.

The extent of Homer's freedom in choosing the images he submitted to *Ballou's Pictorial Drawing Room Companion* or *Harper's Weekly* in the late 1850s, after he had completed his apprenticeship, is an open question, but the magazines offer occasional clues. In 1857 the commentary on *The Corner of Winter, Washington and Summer Streets*, explained that "the local view upon this page, drawn expressly for us by Mr. Winslow Homer, a promising young artist of this city, is exceedingly faithful in architectural detail and spirited in character." It then went on to tout the various businesses depicted by Homer and, more generally, the values of Boston urban life.[6]

Homer was often engaged to illustrate local subjects such as *Class Day, at Harvard University* or the *Emigrant Arrival at Constitution Wharf, Boston*. In 1859 *Ballou's Pictorial* commented, "Our artist, Mr. Homer, has faithfully executed the commission we gave him to furnish us with two original pictures representing scenes in sleighing time, and the result is before us."[7] This suggests greater independence on Homer's part. But whether he was transferring individual photographic portraits to a block for engraving, or combining Brady photographs into a composite image of *The Seceding South Carolina Delegation* (1860), or offering *The Bathe at Newport* as one of his earliest images of *Our Watering Places*, Homer's illustra-

1. Winslow Homer, *Husking the Corn in New England*, wood engraving *Harper's Weekly*, 13 November 1858

tions were shaped at least in part by the magazines. Despite his often-quoted *later* statement about such "slavery" and his desire to have no "master,"[8] his freedom as a graphic artist was always a relative matter. To be acceptable, his images had to meet the needs of his editors and their audiences. The Homer who in 1890 could sarcastically refuse the requests by the purchaser of his oil painting *Promenade on the Beach* for a narrative explanation, or in 1902 could write to his dealer, Knoedler, "You ask me for a full description of my Picture of the 'Gulf Stream'—I regret very much that I have painted a picture that requires any description," should not be read back into the Homer of the early years.[9]

Pictures had to be narratively readable to magazine audiences of the 1850s and 1860s, and Homer packed them full of incidents, which in turn set off—if they were not generated by—editorial commentaries. *Husking the Corn in New England* (fig. 1), one of his more raucous genre scenes in *Harper's Weekly* of 1858, had appeared in a

simpler version the previous year in *Ballou's Pictorial* as *Husking Party, Finding the Red Ears*. The text accompanying the first version explained to readers the "right" of the young man who finds the red ear to "a kiss from the nearest damsel." While reassuring the audience of the legitimacy of this rural sexual ritual by labeling it a "merry struggle," the commentary expressed a fear that "the new-fangled husking-machines . . . would banish one important resource from our calendar of winter sports." The text thus at once attempted to control and legitimize the implications of the visual narrative within acceptable social and moral standards and nostalgically framed the rural scene for an increasingly urban, machine-oriented audience.[10]

The revised version of the engraving in *Harper's Weekly* (fig. 1) is structurally stronger but more complex in its anecdotal organization. The viewer's eye moves from group to group without finding a single clear focus, which allows us to take in sequentially the varied activity like bystand-

ers—along with the genteel couple at the lower right—but without arriving at a single judgment. The rounded corners at the top of the pictorial frame declare the artifice.

The accompanying text briefly explains the rituals of a cornhusking, then quotes the third canto of "The Hasty Pudding," a mock-epic poem by the "Connecticut Wit," Joel Barlow (1754–1812), extolling New England country values and the simple life.[11] A counterpoint is thus established between Barlow's consciously inflated neo-classical rhetoric and Homer's swirling, melodramatic composition. Both verbal and visual languages are used to define a gender drama of varying intensity, from the decorous to the frankly assaultive. The juxtaposition of the two languages illuminates the uses of the comic to assert, however nostalgically, the value of rural fecundity and male dominance. Ironically, neither artist's attempt to recapture the past could ultimately be sustained: in 1793 Barlow returned to Paris, where he was campaigning for a seat in the French National Assembly, only to see the new French Republic plunge into a Reign of Terror; Homer's rural America was on the brink of Civil War. But in 1858 the dynamic structural interplay between image and text adumbrates a collusion between artist and writer, as they argue out the values of their culture.

The rituals of rural life were a primary subject for Homer in the late 1850s, with his holiday pictures forming a special group. Those published in *Harper's Weekly* to celebrate Thanksgiving in 1858 (fig. 2, for example) emphasize the centrality of family, prosperity, and harmony across the generations. The anonymous poem accompanying these scenes makes explicit a national point—"We pitied those poor countries where/There's no 'Thanksgiving Day'"—and extends that to a social responsibility that devolves on women, which does not form a part of Homer's pictorial sequence:

But Mother, in her kindly heart,
Never forgets the poor;
And many an humbler board was spread
From her abundant store.

The Homer sequence ends in a dancing scene that involves several generations, while the poetic text offers a spiritual closing:

I'll wind up with the very words
I've often heard them say:
"Thank God for all his annual gifts,
And this—Thanksgiving Day!"

Picture and text complement one another, explicating the vision of the celebrations and the social and spiritual values they support. Where the poet balks—

The dinner came, but here, alas!
I find description weak
For words to suit those pumpkin-pies
'Twere vain indeed to seek;—

Homer comes to the rescue. In his dinner scene (fig. 2) he shows chubby-faced children eating greedily in the foreground, an elegant couple toasting each other at the near end of the table, and beyond, the old host carving a turkey while a liveried servant pours. The details of the scene describe the event; but Homer is also learning here to map social space pictorially, as we move from youth to age, from self-indulgence through the various ritual acts of the feast to their culmination in the master and his black servant—in 1858 surely a loaded image that substitutes for the national conflict over slavery an image of family harmony that keeps the black in his "proper" role of subordination. And the diagonal, planar organization that shapes this hierarchy is completed in the wall behind: a still life of dead game; a central tondo of an embracing couple, imaging the loving relations this family scene embodies; and an antlered creature in a mountain setting (like a Landseer) presiding over the fireplace. If there is a weakness in the work, it is the tendency toward the stereotypical in both word and image (Homer often generalized facial features—almost caricatures here) and the superabundance of detail.[12]

Toward Emblem

In *Thanksgiving Day, 1860—The Two Great Classes of Society* (fig. 3), Homer clarifies and transforms the visual strategies for

2. Winslow Homer, *Thanksgiving Day—The Dinner; Thanksgiving Day—The Dance*, wood engraving
Harper's Weekly, 27 November 1858

shaping the social significance of his images. The engraving had no direct verbal commentary when published in *Harper's Weekly*, but the leading editorial gave the image a political context by discussing the current economic crisis and contrasting what *Harper's* hoped would be a healthier financial situation in 1860 with the "extravagance in living" that had preceded the crisis of 1857.[13] Homer's engraving echoed this warning. Its emblematic organization used the verbal to shape the visual message: "Those who have more Dinners than appetite/Those who have more appetite than Dinners." The vague poetic appeal to genteel philanthropy in the engraving of 1858 has become a tightly organized drama of contrasts.

In *Thanksgiving Day, 1860,* Homer translates social values into pictorial language. In the corners of the upper tier, a stylish self-indulgent woman being carried by another in a well-lit interior is set against a poor lone woman working in a dark garret by candlelight. The rounded corner on the left is repeated by the oval mirror with its reflection of the young socialite pair. In the opposite corner a harsh diagonal frames the haloed figure, suggesting saintly female self-sacrifice. Between these scenes a gentleman lounges before a fire, while a poor man steals chickens for supper. The rich man's leg seems to stretch the frame that contains him, compressing the space of the poor man. He is, ironically, reading a *Harper's Weekly*, and over his mantel is an

3. Winslow Homer, *Thanksgiving Day, 1860—The Two Great Classes of Society,* wood engraving
Harper's Weekly, 1 December 1860

image (cued by the inscription "HRH") of the young Prince of Wales, who had been lavishly entertained by New York high society during an eight-day visit in October 1860.[14]

In the lower range of the engraving ladies and gentlemen attend the opera (and observe one another) on the left under the mask of comedy. In the center a miserly Scrooge-like figure turns from counting his money to see the huddled poor out the window, and beneath him and a Christmas wreath hangs a profusion of game for a feast. On the lower right, under the mask of tragedy, Homer effects an important change in point of view. The viewer becomes audience as a drama of poverty is enacted on a stage: a young bootblack enters with bread for two poor women, the younger one in bed, the older distraught with head in hand, and a cradle at the foot of the bed. Behind them through two windows two men can be seen with a bottle in hand, standing in the street before a tavern sign. Parallel to this scene, a picture on the wall to the left depicts a donkey with a turbaned man kneeling next to a naked figure seated against a rock: clearly a print of "The Good Samaritan." As with the 1858 dinner scene, Homer wittily frames and plays off art within art, but this time in a specifically emblematic way. The tight organization of pairings—of the two women, the boy and unseen baby, the street world outside revealing secular self-indulgence and the biblical parable on the wall within (even a pair of irons on the shelf)—asks the viewer to reconstruct the presumptive narrative: a new mother abandoned by men, dependent on the efforts of a young bootblack, a son or brother, for sustenance; and this story of contemporary social and moral failure illuminated by the secondary *fatto* of the Good Samaritan on the wall, by which we can measure our spiritual duty: "Go, and do likewise" (Luke 10:37).

The occasion of Thanksgiving had given Homer the initial idea for a kind of Dickensian drama, based on the verbal text of "the two great classes." This in turn led him to organize an elaborate sign system, a formal pattern of visual images—narrative, biblical, and symbolic—that thematically and structurally undercut the com-

placency of the middle-class audience in order to provoke a moral response.[15] The explicitly emblematic organization of picture and text links Homer's work with older traditions. Just as the elegant, aristocratic emblematic mode in seventeenth- and eighteenth-century England passed from the metaphysical wit of Francis Quarles and his visual contemporaries to John Bunyan and the popular tradition, so in eighteenth- and nineteenth-century America, Thomas Smith gave way to Charles Willson Peale, and thence to Thomas Cole. These are high art examples of a popular graphic tradition that included hieroglyphic Bibles for children and books like *Emblems and Allegories* (1851) by William Holmes and John W. Barber. In its composite images *Harper's Weekly* extended and renewed the emblematic mode of conception and representation for a broad middle-class magazine audience.[16]

In *Thanksgiving Day, 1860,* and other such images produced by Homer during the Civil War, like *News from the War* or *Our Women and the War* (both of 1862), the emblematic organization articulated a dominant social ideology that contained and controlled the conflict. Some of Homer's early Civil War wood engravings were reportorial accounts of the Peninsular campaign based on his visits to the front; others were scenes of life in camp; and a few, such as the melodramatic *Bayonet Charge* and *Cavalry Charge* or the stunningly simple *Sharpshooter on Picket Duty,* focused on combat. By contrast, the emblematic images, which have been generally undervalued by scholars, involve a complex linking of picture and text. *News from the War* of 14 July 1862 is *about* verbal communication, and it instructs its audience in how to respond to the great conflict: two figures—a heroic trumpeting man amid a halo of stars and stripes, and a sorrowing woman at home, expressing "tender feelings" at the news of the "Wounded"—articulate appropriate gender roles with a range of other responses organized around them.[17]

What *Harper's Weekly* of 6 September 1862 called *Our Women and the War* (fig. 4) Homer entitled "The Influence of Women." Scenes in the engraving are ar-

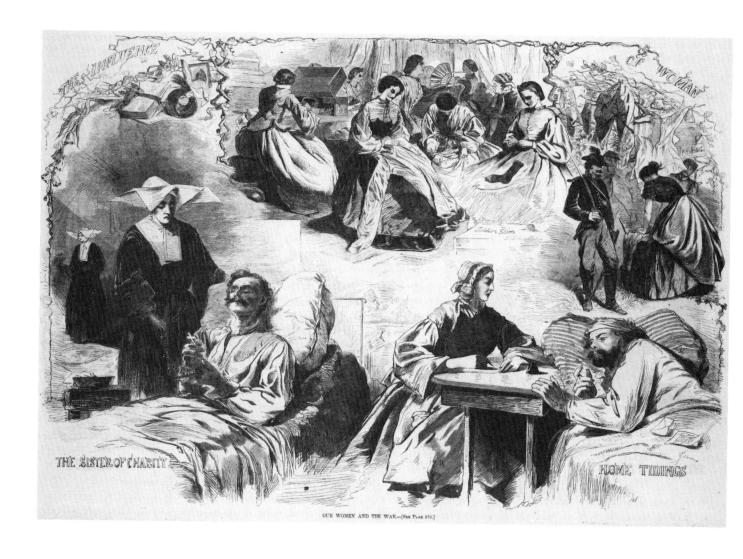

OUR WOMEN AND THE WAR.—[See Page 570.]

ranged in a spiral progression, beginning in the upper left corner where Homer gathered a bundle of letters, a fashionable hat, and a man's framed picture (with a bee seeking a flower). In the upper center fashionable young women sew clothing for the absent soldiers, both by hand and by machine. In the upper right a woman bends over her washing in camp, with a uniformed cavalryman beside her. And in two hospital scenes at the bottom an older nurse writes a letter dictated by one of the wounded ("Home Tidings"), while a dying soldier is attended by a Catholic Sister of Charity—"that exquisite type of angelic womanhood," according to the editorial commentary.

The value of these images lay not merely in their visual information but in the ways in which they eased the social tension and conflict over women's role in the war. Proper middle-class youth at home was contrasted to the working-class washerwoman—"honest Biddy, who has probably got a lover or husband or brother at the war," as the commentary put it, in an attempt to relieve the sexual fears of wartime audiences about the presence of women in the camps. The nurse taking dictation was clearly Homer's visual response to the wartime call for older, married, or homely women to serve as nurses. And the nun in the starched cornette of Normandy became, in the commentary, a

4. Winslow Homer, *Our Women and the War*, wood engraving
Harper's Weekly, 6 September 1862

spiritual "type," which at once desexualized her and relieved Protestant anxiety by thus generalizing her Christian role rather than focusing, as Homer had, on her specifically Catholic action of administering last rites. The text concluded flatly:

The moral of the picture is sufficiently obvious; there is no woman who can not in some way do something to help the army.

In the Crimean War glory and fame awaited the charitable efforts of Florence Nightingale and her noble band of lady nurses. This war of ours has developed scores of Florence Nightingales, whose name no one knows, but whose reward, in the soldier's gratitude and Heaven's approval, is the highest guerdon women can ever win.[18]

Issues of class and gender, of religious anxiety and sectarian conflict, were pictorially organized into a coherent pattern and verbally locked into place. We may wince at the reduction of Homer's complex pictorial contribution to a flat moral statement; but the function of ideology, and of the popular emblem that gave it aesthetic form, lay precisely in its capacity to suppress class and gender conflict, to make people experience it as "natural," shared by all, and to make picture and text an easily readable language that would elicit support for national ideological goals without threatening traditional gender roles. The American Florence Nightingale was not to be a radical feminist if *Harper's* had anything to say about it. Like her English source, she was socially reconstructed to accord with the housewifely and maternal image.[19]

The Urban Vision

If Homer's emblematic engravings reveal the interplay between verbal idea and visual image—and the artist's complicity in marketing the dominant ideology of his society—his work as a magazine illustrator during the years he lived in Boston and New York also makes clear his participation in urban culture. As a painter, he was attracted almost exclusively to rural scenes and seascapes, and this is the work that has drawn the attention of scholars and critics over the years. Our understanding of Homer as devoted to rural life, the sea, and "Nature" is based on our privileging of his "high art" production, but his graphic images are complex combinations and reorganizations of his drawings, watercolors, and oils. By viewing Homer's work primarily in formalist terms and accepting his own evaluation of his graphic endeavors as hackwork, we may also miss the ways in which he responded to the urban environment.

Urban scenes formed an important part of life for *Harper's Weekly* readers, and Homer explored "the two great classes" under the eye of the magazine staff. In Boston during the 1850s the elegant couples promenade on the Common, and the poor scavenge on the new Back Bay landfill. In New York during the war years elegant couples swirl at the famous Russian Ball or attend various fairs, and after the war women shop on *Opening Day* or spend time *Waiting for Calls on New Year's Day* while men gather at jury trials. These scenes differ markedly from a pair of gender-differentiated images of the poor from 1874: destitute men sprawled in a room of the police station-house for a free night's lodgings, and women and children as objects of charity at St. Barnabas House (figs. 5 and 6). In these latter images murky disorder is pitted against a clarified pattern of organized benevolence through Homer's translation of cultural values into pictorial ones.

The written commentaries in *Harper's Weekly* reinforce this. *Station-House Lodgers* gives a grim account of a midnight visit to the Seventeenth Precinct Station-House:

Around us, as shown in the sketch on page 132, in almost inextricable confusion, are stretched the sleepers, and here and there a wakeful or restless one turns and looks toward us for a moment. . . . There is a Babel-like confusion of snoring, and now and then a young man at the edge of the throng starts nervously and sighs, and an old man near the centre moves his hands tremulously about his face and groans in his sleep. Between this man so near us, and, as it were, just entering upon a career with which prison life and prison scenes will have more and more to do as he advances, and the poor wreck going to pieces over there, we

5. Winslow Homer, *Station-House Lodgers*, wood engraving
Harper's Weekly, 7 February 1874

6. Winslow Homer, *New York Charities—St. Barnabas House, 304 Mulberry Street*, wood engraving
Harper's Weekly, 18 April 1874

see the shadow of New York—the shadow of a city where misrule and riotous influences have done their work; where one hundred thousand human beings, men, women, and children, are sent to the penitentiary, the asylums, the almshouse, the hospitals, and the prisons in a single year! One hundred and thirty thousand persons who have been convicted criminals living at large in our midst![20]

The account moves back and forth between vivid renderings of the experience and a heaping up of urban statistics, between a stark depiction of the life of "what we are pleased to call 'the lower strata of the city' " and pungent attacks on the complacency of its readership. Given the statistics on deaths from disease, "3000 infants . . . annually abandoned, sent to the public hospitals, left in the public streets, or placed in the hands of those who 'keep them til *death*' for a small sum, while 113 more were found during the past year dead and lying in ashbarrels," the essay goes on,

we may get some idea of the terrors of life among the very poor in New York city. We may understand better why, when bright eyes are glancing merrily at the falling snow, and bright little feet are gliding over the ice in the Park, muttered prayers and bitter curses go up from cellars and garrets, while wan hands, bony hands, and little hands quiver about the embers of a dying fire.[21]

I quote the article at such length both to put Winslow Homer's New York City in a broader social context (in which his well-known skating scenes[22] become images not of "American" life but of one of "the two great classes") and also to indicate the power of the prose to render this *tranche de vie* and to juxtapose a relentless factuality and the optimistic and sentimental clichés of the middle class. When the writer of the article begins to sentimentalize the poor, by generalizing their situation and offering vague utopian reflections on "an opening spring-time for these poor souls in some far-off land where poverty would lose its sting," the doorman at the station-house interrupts abruptly with a "Get out of this" to rouse the weary men at 5:30 A.M. so that the place can be scrubbed clean.[23]

It is likely that Homer accompanied the writer to the station-house to sketch what the article was describing. Whether willingly or not, Homer participated in this exposé of "how the other half lives." Jacob Riis' famous book of that title was not published until 1890, though Riis later claimed to have experienced personally the brutalizing effect of the police station-house lodgings as a new immigrant in 1870. Riis' own campaign as a police reporter to close down these breeding places of crime and disease led him to create a series of stunning flash camera images, which were then turned into lantern slides for lectures and either converted into line drawings by engravers like Kenyon Cox or printed in the new half-tone process in magazine articles and books in the late 1880s. The reform agitation culminated in the closing of the police station-house lodgings on 15 February 1896 by order of Riis' friend and fellow campaigner, Police Commissioner Theodore Roosevelt.[24]

Homer's illustration of 7 February 1874 is thus an early stage in the public documentary campaign against the condition of the poor, before photo-engraving made available the work of Riis and others. It was the male counterpart of an image by A. Gaale of women entitled *Shelter for the Homeless—Night Scene in a New York Station-House* (fig. 7), which had appeared in the 13 December 1873 issue of *Harper's Weekly*. The text, as the title suggests, emphasized the lodging house as a refuge wherein the "most pathetic scenes may often be witnessed around the friendly stove, where the poor wretched creatures crowd to warm and dry themselves."[25] Homer's version of the subject two months later was equally tied to the prose description, which seems to have controlled his pictorial point of view as well as his subject matter.

Protest had its limits, however. The exposé of the station-house lodgings must also be seen in the context of the cover image Thomas Nast drew for the 7 February 1874 issue of the magazine (fig. 8), contrasting "honest working-people" (a working-class family) with the "emancipator of labor," depicted as the deathly enticement of "communists." The Seventeenth Precinct Station-House was the place to which labor demonstrators had been brought after the police suppressed a major labor pro-

7. A. Gaale, *Shelter for the Homeless—Night Scene in a New York Station-House*, wood engraving
Harper's Weekly, 13 December 1873

test rally on 13 January 1874. The *Harper's Weekly* editorial for 7 February praised the unions that had declared "the identity of interests between the employers and employed" and preached "Communism is a foreign product, which can hardly be made to flourish on American soil."[26] To lament the passive and sleeping poor was one thing; to organize in protest of poverty and to seek redress was quite another. An implicit dialogue is established between the Homer and Nast images and their related texts.[27]

The *New York Charities—St. Barnabas House, 304 Mulberry Street* (fig. 6), offers a striking contrast, in its responses both to poverty and to gender, to the *Station-House Lodgers* images of both Homer and Gaale

that had run in the preceding months. The commentary to which it was related had its share of statistics: about the number of the working poor ("In this city of one million inhabitants there are sixty thousand girls and forty thousand married women who earn their own bread"); their low wages ($3.44 per week in prosperous times); and the functioning of those charitable institutions that were trying to meet the needs of the unemployed, the dislocated, and the orphaned children. The narrative description of the situation of these women is more sentimental in language and less actively charged in cadence and intellectual content than the description of the men, and it mutes the feeling of class conflict, of an industrial and com-

HARPER'S WEEKLY.
A
JOURNAL OF CIVILIZATION

VOL. XVIII—No. 893.] NEW YORK, SATURDAY, FEBRUARY 7, 1874. [WITH A SUPPLEMENT. PRICE TEN CENTS.

Entered according to Act of Congress, in the Year 1874, by Harper & Brothers, in the Office of the Librarian of Congress, at Washington.

8. Thomas Nast, *The Emancipator of Labor and the Honest Working-people*, wood engraving *Harper's Weekly*, 7 February 1874

young girls, who had been to Fall River to work in the factories there, but on account of the cessation of work were forced back to the city, enter and engage the matron in conversation." There is a somberness of expression and gesture in many of the women in both the upper and the lower range, which depicts the various activities of the house. The hopeful pair of children in white in the lower right corner contrast strongly to the two women to the far right, one turned in quiet despair against the wall. The commentary tells us that "inebriety is the only thing that has power to drive one away from that door," and as if to prove this, *Harper's* placed immediately after the Homer image another full-page spread, engraved in dark tones and thick lines from a drawing by C. S. Reinhart, entitled *The Poor Drunkard—More Helpless Than a Child* (fig. 9).

However, by contrast to the sprawling man in the Reinhart or the *Station-House Lodgers* images, Homer here lets the figures and groupings float in white space in a subtly toned pattern of female benevolence. His pictorial choices here are as sensitive to the poignant commentary of the text, which ends when the two women at the upper right "tell their simple story, and straightway they are taken into the bosom of this household of waifs," as was his harsh depiction of the tangle of men to the driving prose of the station-house exposé. In both cases, Homer's images served the needs of his employers, and his visual language shared their ideological perspectives.

Women and the Sea

In the light of these and similar works for the magazines, Homer's better-known and frequently discussed rural and seaside scenes come into focus somewhat differently, as choices. They represented a more or less conscious turning away from the New York urban world in which Homer lived and worked and marketed his art from 1859 to 1881, to seek "subjects" in the rural world.[29] On the whole, both the watercolors Homer created and marketed successfully from 1873 on and the oil paintings he created from the 1860s to the end of his

mercial economy that was not operating effectively for all Americans.[28]

The organization of Homer's engraving expresses this difference. He exercised more pictorial control, fashioning the images and ideas of the accompanying text into a stable vision of the good works of the Episcopal Sisters of Mercy, emblematized in the hieratic serving figure at the top center beneath the motto (mentioned in the text) "Peace be to this House." She is framed to the left by two discouraged young women seeking entry, and to the right by a group described in the text: "two

career are stark and simple in their settings. In contrast to the bustling and crowded urban scenes of the early magazine engravings, with their complex depictions of the social life of Americans at work and at leisure, the oils and watercolors seem like visual acts of depopulation, of seeking a place apart, a retreat to the lone—if not lonely—countryside and coast. Structurally, the paintings are generally acts of simplification. Clearly, in part, this had to do with differences between the line and tone of engraving and the color possible in oils and watercolors. Also, as a designer of pictorial space, Homer was learning to say more with less, which is surely one of his great strengths as an artist.

The issue must not, however, be defined solely in formal terms. The transformation also occurred, in part, because Homer no longer needed to respond to the demands of a narrative or verbal construction of "reality" he had shared—more or less—with his editors. His paintings and watercolors did not depend on commissions he received or texts he was illustrating. It is not that Homer was now "free" to be an artist. He was always an artist. It is rather that the nature of the artistic task changed.

As Homer was released from what he felt to be the burden of making his living through magazine work and was freer to define his own subjects, his responsiveness to his culture also changed. While working for the magazines, his visual statements seemed to reinforce society's dominant ideology: that rural values be preserved and urban life purged of corruption; that the power of white Anglo-Saxon Protestants be maintained over other racial stock (one thinks of the early caricatures of blacks and the stereotyping of the Irish and other non-WASP ethnic groups); that the conflict existing between social classes be controlled; and that women not be allowed to threaten the hegemony of men, even though they had more freedom to engage in leisure activities like croquet and skating and to work in mills and factories or as teachers, nurses, and Sisters of Mercy. As Homer gained increasing financial success as an artist in oils and watercolors in the 1860s, 1870s, and 1880s, he distanced himself from his audience and from the verbal

9. C. S. Reinhart, *The Poor Drunkard—More Helpless Than a Child*, wood engraving
Harper's Weekly, 18 April 1874

context in which he had worked for the magazines, and his art seems at once to withdraw from and to reconsider these ideological stances.

The process involved shifts in American cultural attitudes, Homer's chosen media, how and for whom his work was marketed, and the critical reaction to his achievement. These shifts are illuminated by the changing relation of visual to verbal in his work. That Homer was specifically the illustrator of texts in his early years is well known. Ella Rodman's "The Mistress of the Parsonage" appeared serially in *Harper's Weekly* in 1860 in five parts with eight small illustrations. In this group one can see Homer beginning to find the graphic means to define some of the key dramatic moments in this sentimental tale. The climax of the story comes in an emotional confrontation scene entitled, like so many later Homer engravings and paintings, *On the Beach* (fig. 10). In the illustration the light and dark values of sea and moonlight and the arrangement of the forms of the lover, the pleading young woman, and the rejecting ministerial spouse become the visual means for dramatizing conflicting values.

10. Winslow Homer, *On the Beach*, wood engraving
Harper's Weekly, 10 March 1860

A later engraving, from a pair entitled *Our Watering Places* in *Harper's Weekly* of 26 August 1865,[30] is more complex. *The Empty Sleeve at Newport* (fig. 11) was linked with an anonymous story of the same name, subtitled "Why Edna Ackland Learned to Drive." It is not clear whether the story was written in response to Homer's image, or whether Homer illustrated a preexisting text. The image boldly measures the costs of war. The dark values of the man's coat, folded sleeve, shadowed head, and kepi become a vertical accent against the extended horizontal lines of the woman's arms, reins, whip, and the beach and horizon beyond. The curvilinear shape of the coach echoes and thus calls attention to the man's mutilated form.

The story pushes this visual organization further, stressing Captain Harry Ash's dark brooding over his war injury, his jealousy of his former love, who dances and rows boats at the seaside resort. In a nocturnal confrontation scene she confesses that she has learned to be thus skilled in order to help him in his present condition. They are reconciled "in a soft shower of

11. Winslow Homer, *Our Watering Places—The Empty Sleeve at Newport*, wood engraving
Harper's Weekly, 26 August 1865

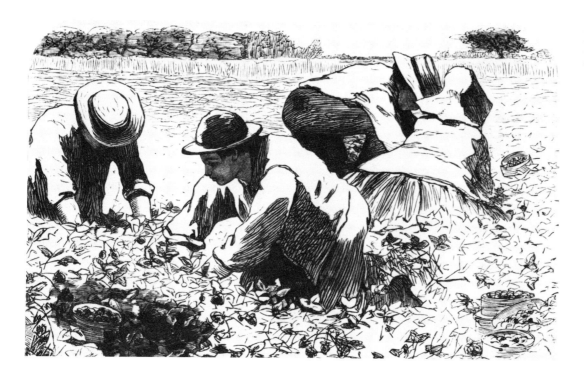

12. Winslow Homer, *The Strawberry Bed*, wood engraving
Our Young Folks, July 1868

kisses," but the last lines drive home the ideological message: "They are married now, and you may see them any day driving upon the Newport beach in the pleasant August afternoons. Her hands guide the reins, and he sits with his empty sleeve beside her. Yet, for all that, his eye is on the road and his voice guides her; so that, in reality, she is only his left hand, and he, the husband, drives."[31] Clearly the Homer engraving does not say this. It is balanced and ordered, male and female. But the word will not tolerate any ambiguity about gender roles, and, insisting upon a "reality" beyond what Homer makes us see, the story resolves the tension that Homer holds in balance.

The gap between visual and verbal widened in the succeeding years, as Homer's images of American life at times refused the ideological closures that his texts demanded. His bold pictorialism was occasionally at odds with the sometimes cloying didacticism of *Our Young Folks: An Illustrated Magazine for Boys and Girls.* Homer's *The Strawberry Bed* frontispiece (fig. 12) for the July 1868 issue is a simple but vivid scenic rendering, while J. T.

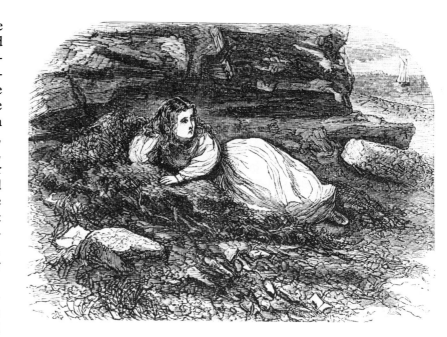

Trowbridge's accompanying poem personifies the "poor little berries" who speak to "little Pearl Honeydew, six years old." Between Homer's picture and its poetic text appeared "A Story of the Sea" by May Mather, illustrated by Homer's fellow resident in the University Studio Building,

13. William J. Hennessy, *Her Nest under the Shadow of the Boulder*, wood engraving
Our Young Folks, July 1868

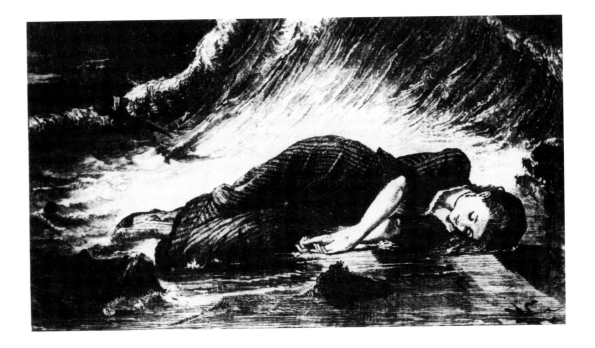

14. Jacques Bertrand,
Virginia Drowned, wood
engraving
Every Saturday, 30 July 1870

W. J. Hennessy.[32] In this story a young girl
who loves the sea disappears from her nest
in the cliff (fig. 13) during a storm: "A few
months after the broken-hearted grand-
parents were gathered into God's Acre, a
tortoise-shell comb was found in a crevice
of the rock under the boulder; and, to this
day, yarn-loving old fishermen protest they
hear at times the strangest kind of music
around the red-house cliffs."[33]

The motif of the young woman and the
turbulent sea was shortly to be Homer's
own, most notably during and after his trip
to Cullercoats on the British North Sea
coast in 1881. Pointing in that direction was
an engraving after *The Fisherman's Dar-
ling* by the British artist John D. Watson,
which appeared in the 4 March 1871 issue
of the Boston periodical *Every Saturday*, at
a time when Homer was contributing to
this journal. The accompanying text sin-
gled out for praise such British north coast
sketches of fisherfolk as a challenge to the
artist to deal with the contemporary, to
work with "what he sees and knows," a
great improvement over medieval costume
dramas (the writer undoubtedly had the
Pre-Raphaelites in mind).[34] More immedi-
ately relevant to Homer's own work, four
months earlier and the week before Hom-
er's important *High Tide* and *Low Tide*

engravings appeared, the magazine pub-
lished an engraving after Jacques Ber-
trand's *Virginia Drowned* (1869) (fig. 14),
based on Bernardin de St. Pierre's contin-
uously popular romantic tale of *Paul et
Virginie*. The painting was "now attract-
ing a great deal of attention in London,"
said *Every Saturday*. In both theme and
form, this work looked forward to Homer's
own use of shipwreck material.[35]

The first occasion came in April 1873,
after the famous wreck of the ship *Atlantic*
off the coast of Newfoundland. The *Har-
per's Weekly* coverage of this disaster (pos-
sibly a scandal in maritime terms) was il-
lustrated with numerous engravings, and
Homer contributed one entitled *Cast Up
by the Sea* (fig. 15). It is a stark representa-
tion of the power of the sea and its sensu-
ous link to the woman under the prurient
gaze of the viewer and the fisherman, who
holds in his hand not a benign shepherd's
crook but a sharply pointed gaff hook. A
deeply troubling image, in which the
wreck itself is relegated to the distant ho-
rizon, Homer adapted it from Daniel Hun-
tington's 1845 engraving for *The Wreck of
the Hesperus* (fig. 16) in one of many illus-
trated editions of Longfellow's poetry.[36]
Given the multiple contexts of Homer's
engraving, its significance was multiva-

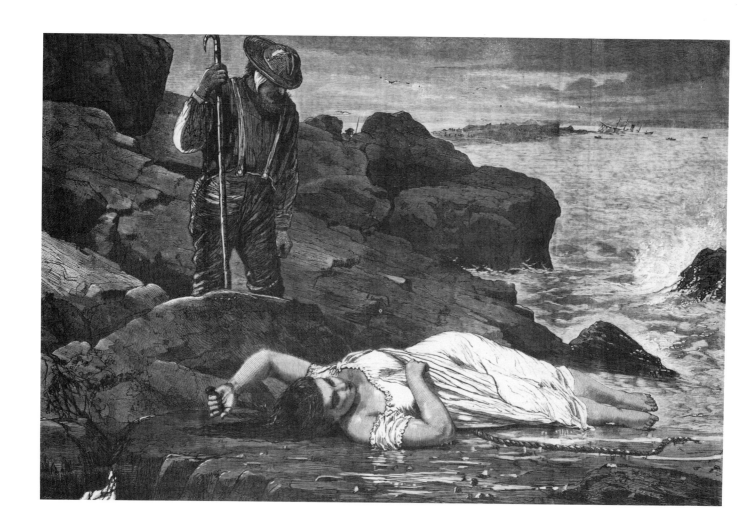

lent. In part it was an interpretation of a grim detail in the *Atlantic* narrative, noted in many newspaper accounts.[37] In part it was a rethinking of Longfellow's 1839 ballad about the wreck off Norman's Woe (Gloucester, Massachusetts) in the months before Homer himself went to Gloucester for the summer to paint sun-filled watercolors of children picking berries and playing by the sea. *Cast Up by the Sea* is a paradoxical and ironic image of beauty and death, sexually alluring and exploitative, and at the same time harsh and forbidding. It is not quite the cry of metaphysical anguish at the end of Longfellow's ballad: "Christ, save us all from a death like this / On the reef of Norman's Woe." It holds out against spiritual closure, as does Homer's haunting *Dad's Coming!* of 1872 (fig. 17) when compared with the text in *Harper's Weekly* and its dreadful:

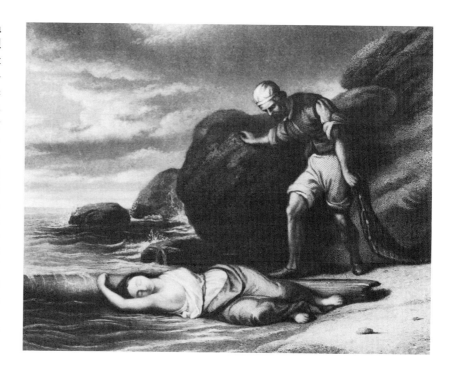

15. Winslow Homer, *The Wreck of the "Atlantic"— Cast Up by the Sea*, wood engraving
Harper's Weekly, 26 April 1873

16. Daniel Huntington, *The Wreck of the Hesperus*, wood engraving
In *Poems by Henry Wadsworth Longfellow* (Philadelphia, 1845), courtesy Clifton Waller Barrett Collection, Alderman Library, University of Virginia

17. Winslow Homer, *"Dad's Coming!"* wood engraving
Harper's Weekly, 1 November 1873

*See he is coming! Dad's coming! I see him!
Shout, little Johnny, shout loud in your glee!
Only God heareth the prayer that is whispered
For thanks that the sailor comes safely from sea.*

This image also belies the text's "Ah, happy mother." The mother in Homer's engraving is not to be construed as "happy":

*while clasping your treasures,
How little you think of Eternity's shores,
Where hearts true and loyal have parted in anguish. . . .*[38]

Homer in these graphic works eschews the stereotypes of sentimental religion and family values to which the poetic texts often cling. *Cast Up by the Sea* equally denies the fairytale ending of the May Mather/Hennessy collaboration in "A Story of the Sea," or the romantically decorous Bertrand version in *Virginia Drowned*, or the distancing exoticism (of the turbaned figure) in Huntington's *Wreck of the Hesperus*. Out of a web of conflict-

ing texts Homer fashions an image of compelling power and ambiguity in which the woman is the alluring victim of the sea and of man. Homer would re-enact this drama with even greater force in his great oils of the 1880s, *Undertow* and *The Life Line* (see Cikovsky, fig. 13). These works forbid any linear interpretation, creating, as Homer does in his use of sources in *Cast Up by the Sea*, ironic ruptures with their own narratives.

Toward Textual Freedom

Homer's images thus became implicit critical commentaries on social and religious ideals and on the middle-class values articulated by the magazine writers with whom he had worked. The disjunction between picture and text opened up new possibilities in the construction of visual meaning that Homer explored most fully after he had virtually abandoned the magazines in

1875. His finest works thereafter, in oil and watercolor, often internalized this ironic disjunction between the obvious surface narrative and some latent undercurrent or countercurrent of meaning that was, in one way or another, troubled and troubling. This development in Homer from the narrative and the anecdotal to the structurally simple but ironically charged images of the later years was in large measure a function of the deepening and darkening of his vision and the shift in media; but it was also a response to the verbal culture within which he functioned, and it corresponded to shifts in the aesthetic and critical premises of his audience.

We have emphasized the interaction through which Homer's magazine employers and writers shaped, or reshaped, his visual presentations to reconcile them with the ideological demands of their audiences. Another recurrent refrain in the magazines, however, from the late 1850s on, attempted to differentiate the role of the visual from the verbal. Sometimes the magazines stressed the narrative content of images, which "need no text. They tell their own story." At other times they said that the readers' associations, sometimes with some prodding from the editors, could provide an imaginative context: "The accompanying engravings need no letterpress. They will be recognized and admired by all who have spent a spring in the temperate zone;" or more simply, "The pictures on the preceding page need no description." In the pages of *Every Saturday* in 1870 they said of *The Robin's Note* that Homer had "composed a charming summer picture, half picture and half poem." In October of the same year they asserted that his *Chestnutting* needed "no explanation," and in December, that one of his trapping scenes would be recognized by all visitors to the Adirondacks as a faithful representation: "The illustration needs no key."[39]

At times the distinction between visual and verbal was denied. Of *Making Hay* in 1872 (fig. 18) the commentary said, "Mr. Winslow Homer's beautiful picture on p. 529 is a poem in itself, a summer idyll, suggestive of all that is most pleasant and attractive in rural life." The editors claimed that they could amass a veritable anthology of English literature from Chaucer to the present that was related to new-mown hay. But they settled for one new four-stanza "companion piece" (presumably written for the occasion) by Mary D. Brine, a rural romance that made clear that the mowing of hay was a metaphor for sexual encounter, that "making hay while the sun shines" in 1872 was *not* just about seasonal labor in the fields.[40] The poem thus extended the meaning of the Homer image, turned the innocent young boy and girl in the lower right into "Roger" the mower and "Maggie, the farmer's lass," and offered the viewer—then and now—the richer iconographic possibilities.

The importance of this becomes apparent in Homer's problematic 1876 oil, *Answering the Horn* (fig. 19). The title may seem to explain the young mower's gesture, but it does not account for the young woman who holds his hat and a jug with one hand and covers her mouth with the other, while the scythe handle points toward her in a remarkably phallic manner. This structurally simple and suggestively powerful visual image remains narratively incomplete, ambiguous, and without the closure that Homer's graphics of the preceding twenty years had offered through their verbal context. Here, as in so many of Homer's later works in oil or watercolor, the structural simplicity and the narrative surface of the image are belied by its ironic subtext, with a subversive undercurrent of richer and more troubling implications.[41]

There is, finally, another note that emerged more clearly in the commentaries on Homer's final engravings of the 1870s. Of *Ship Building, Gloucester Harbor*, in 1873, the editors asserted, "The picture speaks for itself." But they went on to say that it "is interesting not only as a work of art but also as suggestive of the renewed enterprise and activity which are beginning to manifest themselves in American shipyards."[42] To this writer a "work of art" had its own value. Its informational or economic message seemed to be a separate matter.

This isolation of the work of art from its narrative, from its associative and verbal

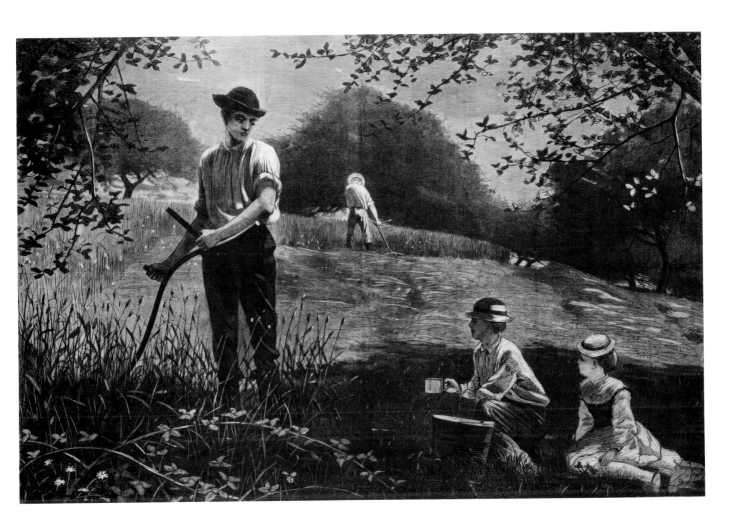

18. Winslow Homer, *Making Hay*, wood engraving
Harper's Weekly, 6 July 1872

context, and from its social function as the embodiment of contemporary ideology must be recognized as a distinctly different approach to the critical understanding of Homer and the nature of visual art in the 1870s. It occurred just as the Aesthetic Movement was reaching American shores,[43] and it was the central issue in Henry James' famous *Galaxy* review of "Some Pictures Lately Exhibited" (1875). Thirty-three year-old James was himself in the process of forging an aesthetic theory as a critic and writer of fiction.

James' ambivalence toward Homer, his rather snobbish cosmopolitan distaste for Homer's rural subject matter, and his equal recognition of Homer's strength are well known. In context, the Homer passages in the James review indicate that the issue

that concerned James, articulated in the opening lines, was "the standing quarrel between the painters and the litterateurs," between an art that is dependent upon its "literary" merit, its narrative or associative content, and that which is dependent upon "purely pictorial values." "Mr. Homer's pictures . . . imply no explanatory sonnets; the artist turns his back squarely and frankly upon literature."[44] What James recognized in Homer's work in its transitional stage of 1875, one year before *Answering the Horn*, was its newfound freedom from subservience to a text.

It was James himself, in his own fictional art as well as in his critical theory, who would become the great spokesperson for the central importance of point of view: that what is known is what is seen or

19. Winslow Homer, *Answering the Horn*, 1876, oil on canvas
Courtesy of the Muskegon Museum of Art, Michigan

shaped (often, in James as in Homer, iron-ically) by a constructed angle of vision; that the drama of a story or a narrative and its way of embodying values lies in the particular aesthetic order through which it contains and controls its vision. The great masterpieces of Homer's maturity—not only *Life Line* and *Undertow* but also *Fog Warning, Huntsman and Dogs, The Fox Hunt, The Gulf Stream, Right and Left,* and a number of his watercolors as well—achieve their strength through a pictorial structure that holds in ironic balance an implicit rather than an explicit narrative or symbolic content. The contemporary criticism of Homer's late work stressed its

formal values, his "constructive imagina-tion," his freedom from the anecdotal. This reinforced and facilitated the new direc-tion of his work in a dialogue between pic-ture and text that was radically different from the one in which Homer had been engaged during his earlier years.[45] Homer of the 1880s and beyond was no longer spokesperson for the dominant ideology of American culture. He shaped a vantage point as the outsider, the observer. Looking at Western culture and its values at the end of his career, Henry James said, "I have the imagination of disaster." In that re-spect, too, he and the late Winslow Homer were perhaps "kindred spirits."

NOTES

1. For Homer's library, see David Tatham, "Winslow Homer's Library," *American Art Journal* 9 (May 1977), 92–98; for his friendships, see Lloyd Goodrich, *Winslow Homer* (New York, 1944); Gordon Hen-dricks, *The Life and Work of Winslow Homer* (New York, 1979); for his relation to de Kay, Gilder, and the Tile Club, see the biographical and index entries on these topics in Doreen Bolger Burke et al., *In Pursuit of Beauty: Americans and the Aesthetic Movement* [exh. cat., The Metropolitan Museum of Art] (New York, 1986).

2. John Wilmerding pointed to Homer's affinities with American writers in *Winslow Homer* (New York, 1972). Among the most important of recent contextual studies are Christopher Kent Wilson, "Winslow Homer's *The Veteran in a New Field*: A Study of the Harvest Metaphor and Popular Cul-ture," *American Art Journal* 17 (autumn 1985), 2–27; Christopher Kent Wilson, "Winslow Homer's *Thanksgiving Day—Hanging Up the Musket*," *Amer-ican Art Journal* 18, no. 4 (1986), 76–83; Nicolai Ci-kovsky, Jr., "Winslow Homer's *School Time*: 'A Pic-ture Thoroughly National,' " *Essays in Honor of Paul Mellon, Collector and Benefactor*, edited by John Wilmerding (Washington, 1986), 47–69; and most no-tably, Peter H. Wood and Karen C. C. Dalton, *Wins-low Homer's Images of Blacks: The Civil War and Reconstruction Years*, introduction by Richard J. Powell [exh. cat., The Menil Collection] (Austin, 1988), and Marc Simpson et al., *Winslow Homer: Paintings of the Civil War* [exh. cat., The Fine Arts

Museums of San Francisco] (San Francisco, 1988).

3. *Harper's Weekly*, 4 September 1858, 570; compare 2 April 1859, 216; 30 April 1859, 282.

4. See *The Boston Athenaeum Art Exhibition Index, 1827–1874*, compiled and edited by Robert F. Perkins, Jr., and William J. Gavin III (Boston, 1980); Lillian B. Miller, *Patrons and Patriotism: The Encouragement of the Fine Arts in the United States, 1790–1860* (Chi-cago, 1966), 111–120. For an important exhibition dur-ing Homer's years there, see Susan P. Casteras, "The 1857–58 Exhibition of English Art in America: Criti-cal Responses to Pre-Raphaelitism," in Linda S. Fer-ber and William H. Gerdts, *The New Path: Ruskin and the American Pre-Raphaelites* [exh. cat., Brook-lyn Museum] (Brooklyn, 1985), 115–133. As Casteras points out, Boston critics were largely hostile to pre-Raphaelite principles; like many others, they re-sponded to the literary content of the paintings and were skeptical of the literalism of detail among the pre-Raphaelites.

5. The best account of Homer's graphic training is David Tatham, "Winslow Homer in Boston, 1854–1859" (Ph.D. diss., Syracuse University, 1970).

6. *Ballou's Pictorial*, 13 June 1857, 369. For a full dis-cussion of this particular work, see David Tatham, "A Drawing by Winslow Homer: *Corner of Winter, Washington and Summer Streets*," *American Art Journal* 18, no. 3 (1986), 40–50. The most complete and helpful listing of all Homer's graphic work is

Mavis Parrot Kelsey, *Winslow Homer Graphics*, edited by Katherine S. Howe, introduction by David F. Tatham [exh. cat., Museum of Fine Arts, Houston] (Houston, 1977).

7. 29 January 1859, 72; Tatham 1970, 164 notes that the text accompanying Homer's *Scene on the Back Bay Lands, Boston* ("Mr. Homer has selected for illustration. . . .") indicates the wide latitude given Homer in selecting his own subjects. *Ballou's Pictorial*, 21 May 1859, 328.

8. G. W. Sheldon, *American Painters*, enlarged ed. (New York, 1881), 27.

9. The letters are quoted in Hendricks 1979, 139, 141, 250. The sarcastic tone in these letters, unusual for this formally polite man, seems to be one that Homer adopted as a defensive verbal strategy. Both works seem to call for some narrative closure. The viewer's demand was a legitimate one, which Homer buffered with sarcasm.

10. "Thanksgiving in New England," *Ballou's Pictorial*, 28 November 1857, 344. The image is reproduced in Kelsey 1977, 60.

11. The poem was written in 1793 when Barlow was in France. For Barlow, see James Woodress, *A Yankee's Odyssey: The Life of Joel Barlow* (Philadelphia, 1958); Emory Elliott, *Revolutionary Writers: Literature and Authority in the New Republic, 1725–1810* (New York, 1982), 92–127; Robert D. Arner, "The Smooth and Emblematic Song: Joel Barlow's *The Hasty Pudding*," *Early American Literature* 7 (spring 1972), 76–91. The poem was well known and frequently reprinted. See, for example, William E. Burton, ed., *The Cyclopaedia of Wit and Humor* (New York, 1858), 19–22.

12. *Harper's Weekly*, 27 November 1859, engravings on pp. 760–761; the poem, "Our Thanksgiving," on p. 762. The first of the four engravings indicates that the location is "Belmont" (Massachusetts), the Homer family home. For the role of blacks in Homer's art, see Wood and Dalton 1988.

13. *Harper's Weekly*, 1 December 1860, 754; the double-page engraving is on pp. 760–761.

14. Homer's comic response in *Harper's Weekly* to Edward's visit, *Welcome to the Prince of Wales*, was published on 20 October 1860 (p. 657), the day of Prince Edward's departure. For a good account of the proceedings by one involved in planning them, see Allan Nevins and Milton Halsey Thomas, eds., *The Diary of George Templeton Strong*, 4 vols. (New York, 1952), 3: 45–52.

15. A related earlier composite image appeared in his 3 December 1859 *Harper's Weekly* offering, *A Merry Christmas and a Happy New Year*, with its Fifth Avenue rich vs. 59th Street poor, between which a stock New Testament scene of "The Origins of Christmas" and a lower range of children, from a woman instructing them in dancing to a black servant holding up a white baby to the admiration of a white young woman. The landscape background of the 59th Street vignette is of the area that was just becoming Central Park. Homer had arrived in New York in the months after the Olmsted plan had been accepted and was a lively topic of discussion. For the Central Park context and related images, see Elizabeth Barlow, *Frederick Law Olmsted's New York*, ill. William Alex [exh. cat., Whitney Museum of American Art] (New York, 1972), 12–25, 58–59.

16. For the English background, see Rosemary Freeman, *English Emblem Books* (London, 1948); for the continuities of the American tradition, see Roger B. Stein, "Thomas Smith's Self-Portrait: Image/Text as Artifact," *Art Journal* 44 (winter 1984), 316–327; Roger B. Stein, "Charles Willson Peale's Expressive Design: The Artist in His Museum," *Prospects* 6 (1981), 139–153; Alan Wallach, "The *Voyage of Life* as Popular Art," *Art Bulletin* 59 (June 1977), 234–241; and George Monteiro and Barton Levi St. Armand, "The Experienced Emblem: A Study of the Poetry of Emily Dickinson," *Prospects* 6 (1981), 186–280. David Tatham estimates that by the early 1860s *Harper's Weekly* subscriber list was over 100,000 and that "these subscribers could expect in a single year to see over 700 black-and-white wood engravings, a quantity unimaginable in any magazine prior to the 1840s." David Tatham, *Winslow Homer: Prints from Harper's Weekly* [exh. cat., Gallery Association of New York State] (Hamilton, N.Y., 1979), 1.

17. For a listing of these Civil War images, see Kelsey 1977, 27–30; many are reproduced in Julian Grossman, *Echo of a Distant Drum: Winslow Homer and the Civil War* (New York, 1974), in Simpson 1988, and in Wood and Dalton 1988.

18. *Harper's Weekly*, 6 September 1862, 570; the engraving is on pp. 568–569. For a good summary of the role of women and the anxieties about gender, see Mary Elizabeth Massey, *Bonnet Brigades* (New York, 1966), esp. 43–64, who points out that the Sisters of Charity were solicited by the doctors and the federal government to serve in the hospitals because of their skill, efficiency, and probably also their obedience to authority (47). The "Cornette Sisters" were an order based in Emmitsburg, Maryland, and were already active in the hospitals of Washington by early 1862, when Homer would have seen them there after the heavy casualties of the first year of the war. They were frequently called "Angels of the Battlefield," as letters of the time testify, and had historically been involved in hospital work. See George Barton, *Angels of the Battlefield: A History of the Labors of the Catholic Sisterhoods in the Late Civil War* (Philadelphia, 1897), 1–5, 35–40; James J. Walsh, compiler, *These Splendid Sisters* (New York, 1927), 164–223. For a vivid contemporary account of a brief experience as a nurse, see Louisa May Alcott, *Hospital Sketches*, edited by Bessie Z. Jones (Cambridge, Mass., 1960). Most of the material in the book appeared in the May and June 1863 issues of the magazine *Commonwealth*, and in book form in August 1863. Alcott includes her own scene of letter-writing for a dying man (49–58) and caustic remarks about the failure of Protestant chaplains to respond adequately to the needs of the sick and dying (77–80). For an important discussion that puts Homer's engraving in the social and pictorial context of Eastman Johnson, see Patricia Hills, "Eastman Johnson's *The Field Hospital,*

The U.S. Sanitary Commission, and Women in the Civil War," *Minneapolis Institute of Arts Bulletin* 65 (1981–1982 [1986]), 66–81.

The importance of *Harper's* defining the Catholic sisters in 1862 as "that exquisite type of angelic womanhood," as a shared gender ideal to its largely Protestant readership, is notable, for the 1840–1850s had been decades of rabid anti-Catholicism. Nathaniel Hawthorne in 1850 had used similar language to define the multivalence of the "A" and of the changed attitude toward Hester Prynne in *The Scarlet Letter*, as a "self-ordained sister of mercy" (chap. 13) and a "type of something to be sorrowed over. . . . The angel and apostle of the coming revelation must be a woman indeed, but lofty, pure, and beautiful" (chap. 24). The multivalence of the "A" includes its meaning as angel. What is shared with the 1862 *Harper's Weekly* commentary is the continuity of the biblical "type" as a figural mode of interpreting present events in terms that ultimately refer to the New Testament. For the significance of the tradition, see Stein 1984, esp. 323–325 and notes; Ursula Brumm, *American Thought and Religious Typology* (New Brunswick, N.J., 1970); and Monteiro and St. Armand 1981.

One final note: among the scribbles on the wall to the right of the dying officer's bed one can discern the word "Jeff" and a profile caricature of a bearded and mustached head, both possibly allusions to Jefferson Davis, and the notation "61 Regt."—a clear allusion to the Sixty-First New York Infantry Regiment of the Union Army's Second Corps, which was under the command of Homer's friend and host during the spring 1862 Peninsular Campaign, Lieutenant Colonel (later General) Francis Channing Barlow. Simpson 1988, 16, 19, 249.

19. See Griselda Pollock, "Women, Art, and Ideology: Questions for Feminist Art Historians," *Woman's Art Journal* 4 (spring/summer 1983), 39–44.

20. "Station-House Lodgers," *Harper's Weekly*, 7 February 1874, 133; the engraving is on p. 132. The Seventeenth Precinct Station-House was located at the corner of First Avenue and Fifth Street, according to Trow's *New York City Directory* (New York, 1873), 6, 17, 610, which also lists "Homer, W., artist" as a resident of Studio Building at 51 West 10th Street. The last published New York City Common Council, *Manual of the Corporation of the City of New York* (New York, 1871), 92, lists seventy-one men as the complement of this precinct, including two "doormen," who managed the lodging rooms.

21. "Station-House Lodgers," 1874, 134.

22. See, for example, Kelsey 1977, engraving nos. 74 (1860), 108 (1862), 141 (1866), 152 (1868), and 213 (1871).

23. "Station-House Lodgers," 1874, 134. This work was traditionally done by some of the women lodgers. The Homer engraving is of the room for men; the women were lodged separately, in a corridor around a stove. For an image of a related women's room, see fig. 7.

24. Jacob Riis' account of the campaign occurs in his autobiographical *The Making of an American* (New York, 1901), 250–262. For his early experience, with its probably fictionalized tale of the homeless dog whom the police bludgeon to death at the station-house door, leading Riis later to take "revenge," see pp. 70–74. For finely executed modern prints of the Riis station-house photos, see Alexander Alland, *Jacob A. Riis: Photographer and Citizen* (Millerton, N.Y., 1974), 60–76. Alland points out that flash photography was first used in Germany in 1887 and adopted by Riis in 1888, which also saw the first large-scale use of the new process of half-tone printing of photographs (pp. 26–30). For a brief treatment of the station-house, see Jacob Riis, *How the Other Half Lives* (New York, 1890), 82–91; for comparable material, incorporating some of Riis' images, see the famous exposé by Mrs. Helen Campbell et al., *Darkness and Daylight, or Lights and Shadows of New York Life: A Woman's Story of Gospel, Temperance, Mission and Rescue Work* (Hartford, Conn., 1891), 420–424, 646–656.

25. *Harper's Weekly*, 13 December 1873, 1110; the illustration is on p. 1109.

26. "The Emancipator of Labor," *Harper's Weekly*, 7 February 1874, 122. At a mass labor rally held at the Cooper Institute on 12 December 1873, a "Committee of Safety" (labeled in the Nast cartoon under the skeleton's outstretched right arm) led by socialists had urged that the unemployed demand from the city government both food and employment. The Ironworker's Union Local 25 and the Workingmen's Council of the city passed resolutions disassociating themselves from the socialists, in part because many of them were foreigners. The next major rally, organized by the Committee of Safety for 13 January 1873, was the one suppressed by the police. For newspaper accounts of these events, see *The New York Times*: 5 December 1873, 8, col. 4; "Communism in New York," 12 December 1873, 4, col. 3; and 5, cols. 1–2 (for a description of the meeting); "Labor Demagogues," 13 January 1874, 4, col. 5; "Defeat of the Communists," 14 January 1874, 2, col. 3, and 4, col. 2 (the editorial: "Persons arrested yesterday seem all to have been foreigners—chiefly German or Irishmen. Communist is not a weed of native growth").

27. One month later Homer contributed another troubling image of New York City life to *Harper's Weekly*, pointing the finger—in a stereotypically racist manner—at another "foreign" group. *The Chinese in New York—Scene in a Baxter Street Club House* gave central prominence to men smoking in an opium den. *Harper's Weekly*, 7 March 1874, 212; compare Riis 1890, 92–103; Campbell 1891, 549–573. Homer's engraving looks like a composite of images taken from photographs by Riis and others in *Darkness and Daylight*, though obviously the chronology is the reverse; Riis was working photographically within an existing graphic convention.

28. *Harper's Weekly*, 18 April 1874, 342; the image is on 336, and that by C. S. Reinhart, discussed below, is on 337. According to a four-page brochure, an appeal for funds from the Committee on St. Barnabas House dated 1 March 1870 (in the collection of the New York Public Library), the house "was originally

opened by Mrs. William Richmond, under the name of the 'Home for Homeless Women and Children.' It was before her death purchased by the N.Y.P[rotestant].E[piscopal]. City Mission Society, and opened in June, 1865, under the name of St. Barnabas' House. . . . [It] was intended for a temporary resting place," and most who came were assisted in finding jobs or sent to institutions or friends. It served as a half-way house for women recently hospitalized who still needed rest, and it regularly took in children who were homeless or needed day care so that parents might work.

29. The alternatives, of course, were not absolute. The rural *Morning Bell*, a graphic reworking of a painting that Gordon Hendricks has re-identified as *The Mill* (exhibited in 1872) (Hendricks 1979, 90), appeared as an engraving in *Harper's Weekly* on 13 December 1873, only two months before the *Station-House Lodgers* and four months before *New York Charities*, with its allusion to the two mill girls from the Fall River factories. It is related to Homer's earlier mill image of *New England Factory Life—"Bell Time"* in *Harper's Weekly*, 25 July 1868, 472, and to the illustration of the female mill operative in William Cullen Bryant's *The Song of the Sower* (New York, 1871), 29.

30. The *Horse Racing at Saratoga* scene is captioned "Drawn by Winslow Homer." *The Empty Sleeve at Newport* is not, though it is generally accepted as his by Homer scholars on the basis of style: Kelsey 1977, 30 [#136]; Hendricks 1979, 326; and Wilson 1985, 2–27, fig. 5.

31. *Harper's Weekly*, 25 August 1865, 534; the engraving is on p. 532.

32. See Thomas Bailey Aldrich's series, "Among the Studios," which appeared in the same *Our Young Folks*. The article on Homer is from vol. 2, July 1866, 393–398; that on Hennessy is from vol. 2, September 1866, 573–576. For further information on Hennessy, see Tatham 1970, 200–201, and Lucretia H. Giese, "Winslow Homer's Civil War Painting *The Initials*: A Little-Known Drawing and Related Works," *American Art Journal* 18, no. 3 (1986), 12 and notes 29 and 30.

33. May Mather, "A Story of the Sea," *Our Young Folks* 4 (July 1868), 389, is a brief children's version of a popular genre, the best-known example of which is Harriet Beecher Stowe's *The Pearl of Orr's Island* (Boston, 1862; facsimile reprint, Hartford, Conn., 1979). In its plot—turning upon shipwrecks, bodies washed ashore, and identifying jewelry—its echoes of Shakespeare's *Tempest*, and specific motifs like the grotto in the rocks, the grandparents, the Maine coast setting, and the fairy-like heroine, Stowe's tale may well have been a source for the Mather story (see Stowe 1979, 57–58, 101–103, 150–152, 277, 337, 415, 435). In its powerful rendering of the Maine coast, *Pearl of Orr's Island* was also the inspiration for the more realistic stories of the 1870s–1890s by Sarah Orne Jewett (1849–1909), including *The Country of the Pointed Firs* (Boston, 1896), the comparison of which to Homer's Maine coast painting of the same years is beyond the scope of the present essay. For

Jewett's sense of the importance of Stowe's *Pearl* to her generation, see *Letters of Sarah Orne Jewett*, edited by Annie Fields (Boston, 1911), 8, 46–47.

Our Young Folks may have stimulated Homer's imagination in other ways as well. There is a remarkable similarity, pointed out to me by my former student Stanley Kauffman, between the engraving of children in a catboat, which Homer's colleague Harry Fenn did six months earlier for the January 1868 issue as an illustration for Helen C. Weeks' "Inland and Shoreland" (p. 57), and Homer's famous *A Fair Wind (Breezing Up)*, 1876 (National Gallery of Art, Washington). Homer and Fenn shared in illustrating a number of works, including John Greenleaf Whittier, *Ballads of New England* (Boston, 1870), and William Cullen Bryant, *The Song of the Sower* (New York 1871), gift editions probably done for the Christmas trade and copyrighted 1869 and 1870.

34. *Every Saturday*, 4 March 1871, 199; the engraving is on p. 205. For the significance of Watson, see Helen Cooper, *Winslow Homer Watercolors* [exh. cat., National Gallery of Art] (Washington, 1986), 105 and n. 26.

35. *Every Saturday*, 30 July 1870, engraving on p. 493, text on p. 483. For the popularity of the book, visually as well as verbally, in America and Europe, see Paul Toinet, *Paul et Virginie: Répertoire bibliographique et iconographique* (Paris, 1963).

36. The source was first identified in Philip C. Beam, *Winslow Homer at Prout's Neck* (Boston, 1966), 12. *Poems by Henry Wadsworth Longfellow, with Illustrations by D. Huntington* was first issued in Philadelphia (Carey & Hart, 1845). It had reached a 5th edition by 1847. I discussed the implications of this borrowing in a paper on Homer to the College Art Association in 1974. The scene was illustrated by other leading graphic artists, including Birket Foster, A. Buhler, and John Gilbert. I am indebted to the John Carter Brown Library, Providence, Rhode Island, for the opportunity to examine the various editions of the poem.

For Homer's illustrations for editions of poems by Longfellow, Whittier, Bryant, and others during these years, see Kelsey 1977, 41–44; David Tatham, "Winslow Homer and the New England Poets," *Proceedings of the American Antiquarian Society* 89 (October 1979), 241–260.

37. For the analysis of newspaper and magazine accounts of the wreck, I am indebted to the unpublished research of my former student Philip Clay, subsequently delivered as a Frick Symposium talk, 7 April 1984.

38. *Harper's Weekly*, 1 November 1873, 970.

39. *Harper's Weekly*, 4 September 1858, 570; 2 April 1859, 216 (the text to *March Winds* and *April Showers*); 30 April 1859, 280 (the text to *May-Day in the Country*); *Every Saturday*, 20 August 1870, 531, image on p. 529; 29 October 1870, 691, image on p. 700; and 24 December 1870, 838, *Trapping in the Adirondacks* on p. 849.

40. "Making Hay," *Harper's Weekly*, 6 July 1872, 530; image on p. 529.

41. For an alternative analysis of this work, see J. Gray Sweeney, *American Painting* [exh. cat., Muskegon Museum of Art] (Muskegon, Mich., 1980), 70–71, 113. I am indebted to Gray Sweeney for bringing this work to my attention in 1978. For Homer's earlier haying scenes, see John Wilmerding, "Winslow Homer's Creative Process," *The Magazine Antiques* 108 (November 1975), 965–971.

42. *Harper's Weekly*, 11 October 1873, 902; image on p. 900. The engraving is, as Lloyd Goodrich pointed out years ago, a complex composition that drew on two earlier oils and a watercolor. See Lloyd Goodrich, *The Graphic Art of Winslow Homer* [exh. cat., Museum of Graphic Art] (New York, 1968), 12–13, and plates 72–75.

43. See Burke et al. 1986.

44. *The Galaxy* 20 (July 1875), as reprinted in *The Painter's Eye: Notes and Essays on the Pictorial Arts by Henry James*, edited by John L. Sweeney (Cambridge, Mass., 1956), 88, 89, 91.

45. Typical of the finest of the newer Homer criticism of the 1880s is the work of [Marianna Griswold] Mrs. Schuyler Van Rensselaer, revised in her essay on Homer in *Six Portraits* (Boston, 1889), 237–274. The Homer scrapbooks at Bowdoin College include a number of these newer voices. In the 1883 exhibition of Homer's Cullercoats work, *A Voice from the Cliffs* is singled out: "To give a title to such a beautiful work seems unnecessary. This is the very reverse of 'anecdote painting'. We care for the figures themselves, not for what they are supposed to be doing. They existed for the painter's eye, and not for the storyteller's purpose." Examples of this kind could be endlessly multiplied. I am grateful to John Coffey, former curator of the Bowdoin College Museum of Art, for his kindness in facilitating my examination of these materials.

HENRY ADAMS
The Nelson-Atkins Museum of Art

Winslow Homer's "Impressionism" and Its Relation to His Trip to France

For a brief period, from the mid-1860s through the early 1870s, Winslow Homer occasionally made paintings that are remarkably close in appearance to the early work of the French impressionists. *Long Branch, New Jersey*, painted in 1869, exemplifies this trend (fig. 1). As with most French impressionist paintings, the canvas shows outdoor recreation, in this case a day at the beach with ladies in fashionable dresses and parasols. The color glows with the intensity of sunlight, and the handling of the paint is free and sketchy, in keeping with the informal nature of the scene.[1]

Long Branch does not stand alone among Homer's paintings in its resemblance to French impressionist works. A number of paintings that date from this period, for example, *The Bridle Path, White Mountains*, and *Croquet Scene*, display impressionist qualities (figs. 2 and 3). Homer did not consistently produce paintings in the impressionist style, however; he simultaneously executed works in a more conservative style.[2] This period of time, moreover, was relatively brief, and as Homer matured as an artist, his palette grew darker and his subject matter more somber on the whole.

Since the 1940s writers on Winslow Homer have commented on his impressionist qualities of this group of works.[3] They have strongly disagreed, however, on why Homer turned to impressionism and how he could have been exposed to impressionist ideas. The first French impressionist exhibition was held in 1874, but by that time Homer, at least in his oil paintings, had already begun to abandon a bright palette and turn away from impressionist effects. Did Homer know about French impressionism? And if so, how?

Much of the controversy about this issue has centered on Homer's trip to France—and first trip abroad—which corresponds roughly with the time he began to paint impressionist works. Embarking for Paris on 5 December 1866, Homer stayed in Europe almost exactly a year until his money had run out. He returned to New York on 18 December 1867, borrowing money from an American artist friend to pay for his return voyage.[4] Unfortunately, little documentation survives to indicate what Homer did in France, beyond the nineteen small paintings he made there (see appendix) and three illustrations he sent home to *Harper's Magazine*, one depicting art students and copyists in the Louvre, and the other two, couples kicking up their legs in the dance halls of Montmartre.[5]

Few issues in the history of nineteenth-century American art have given rise to such radically different assertions as the effect of this trip on Homer's subsequent work. For more than half a century writers on Homer unanimously agreed that the visit did not have a decisive impact on the

1. Winslow Homer, *Long Branch, New Jersey*, 1869, oil on canvas, 40.6 x 55.3 (16 x 21 3/4)
Museum of Fine Arts, Boston, Charles Henry Hayden Fund

2. Winslow Homer, *The Bridle Path, White Mountains*, 1868, oil on canvas, 61.3 x 96.5 (24 1/8 x 38)
Sterling and Francine Clark Art Institute, Williamstown, Massachusetts

artist's style.[6] Then in 1958 Albert Ten Eyck Gardner vehemently challenged this view. Gardner maintained that Homer discovered both Japanese prints and French impressionism during his sojourn in Paris and that these two influences altered the entire course of his artistic career. Differing sharply from all previous writers, Gardner maintained that "Homer's trip to Paris was the most important event in his entire career as an artist."[7]

"It would seem most improbable," Gardner declared, "that the man who was to become 'the greatest American artist' would be able to spend such a long time in the very center of the art world and yet remain completely blind and completely unaffected by the exciting new artistic currents of the day. . . . Surely no lively, intelligent young man like Homer, with his keen artist's eye and his active Yankee curiosity, could be so dull, so unperceptive, as not to be aware of what was going on around him."[8]

As this quotation suggests, Gardner's thesis consisted largely of innuendo. Rather than locating contemporary evidence that Homer was affected by the French impressionists, Gardner argued that such evidence is lacking because Homer was deliberately secretive about what he learned. This theme of reticence was taken up by other writers, such as Yvon Bizardel, who wrote that "Homer crossed Paris with his finger on his lips. . . . That is why he used his eyes all the better, studied more closely, and felt and understood all the more deeply."[9]

One would love to have a snapshot of Homer crossing Paris with his finger to his lips. This conjectural argument is not very persuasive. It was certainly possible for a young American to visit Paris in the 1860s without discovering French impressionism. Thomas Eakins arrived in Paris about the same time as Homer, staying a full four years, yet never mentioned impressionism in his extensive letters home and seems to have looked only at the work of the old masters and such academic figures as his teacher Jean-Léon Gérôme.[10] In addition, many of the paintings Gardner reproduced to illustrate the impact of Homer's French

trip were actually executed before Homer went to Paris. His *Croquet Scene*, which has often been compared with such early works by Monet as *Women in a Garden*, was painted just before he left for France (figs. 3 and 4).[11] If these works do reveal French influence, Homer must have learned about impressionism before his trip. In fact, the paintings Homer executed in France are duller in color and generally less impressionistic than those he made in the United States both before and after that journey.[12]

It is apparent even from cursory study, therefore, that Gardner's assertions often rested on shaky foundations. But despite his failure to present solid evidence for his claims, his ideas have been widely repeated, no doubt because they touched on a deeply emotional issue—the significance of nineteenth-century American painting. When Gardner was writing (and indeed, these viewpoints are to some extent still held today), American painting was judged to be dry, conservative, provincial, and aesthetically inferior to French painting, particularly French impressionism. In associating Homer with Japanese prints and French impressionist ideas, Gardner was arguing that Homer was a progressive, forward-looking, and significant artist, worthy to be considered on the same level as the leading French masters rather than pigeon-holed as a provincial American genre painter.[13]

Gardner's thesis raises a series of issues I would like to explore. What trends in modern French painting was Homer aware of, and how did he know of them? What was the influence of his trip to France? Where did he discover Japanese prints, and how did they affect him? Why did he adopt an impressionist manner for a brief period and then abandon it? Did French painting have a lasting significance on his achievement? I do not pretend to be able to answer completely any of these questions, but I do hope to demonstrate that Homer was affected by French modernist ideas, although in ways that are rather more complex than has been supposed. Homer's impressionism, I believe, reflected a mix of French and American influences.

American Attitudes Toward French Painting in the 1860s

To understand Homer's relationship to French art it is helpful to know something of the major aesthetic controversy that dominated art criticism in the 1860s. This was the battle between the so-called American Pre-Raphaelites and the followers of the Barbizon masters, who epitomized progressive French painting in the opinion of Americans of this period.

Despite their name, the American Pre-Raphaelites produced work that had little relation to that of their better known Pre-Raphaelite brethren in England (figs. 5 and 6). The English Pre-Raphaelites loved to depict dreamy women in medieval dress, whereas the American Pre-Raphaelites were almost exclusively landscape and still-life painters and derived their tenets not so much from knowledge of English painting as from a faithful reading of the criticism of John Ruskin. Their watchword was truth, which in their minds meant a photographic literalness of description, and they banded together in a little club with the odd name of "The Society for the Preservation of Truth in Art."[14] In their manifesto they declared that the artist's task was to go out and study the smallest elements of nature—if need be, a single blade of grass—and transcribe it as accurately as possible, "rejecting nothing."[15] This procedure did not usually lead to very memorable results, unfortunately, and most American Pre-Raphaelite work was distinctly modest. The group produced charming trifles, most often drawings or watercolors rather than oils, which depict such subjects as a weed, a twig, a bird's nest, or a few pieces of fruit.

3. Winslow Homer, *Croquet Scene*, 1866, oil on canvas, 40.6 x 66.0 (16 x 26)
The Art Institute of Chicago, Friends of American Art Collection

4. Claude Monet, *Women in a Garden*, 1866–1867, oil on canvas, 254.6 x 207.7 (100 1/4 x 81 3/4) Musée d'Orsay, Paris

5. Dante Gabriel Rossetti, *My Lady Greensleeves*, 1863, oil on panel, 33.0 x 27.3 (13 x 10 3/4) The Harvard University Museums, Fogg Art Museum, Cambridge, Massachusetts

Although the American Pre-Raphaelites never produced even one painter of the first rank, they dominated artistic debate during the 1860s. Their views gained the support of the single most powerful American critic of the period, Clarence Cook, who with a pen seemingly dipped in acid wrote devastating reviews in the *New York Tribune* of those painters whose work rejected the Pre-Raphaelite creed and followed the new French trends.[16]

Devotees of progressive French painting formed an opposing camp, maintaining that art should consist not of an accumulation of meticulously rendered details, but of powerful, simplified forms and patterns that convey a spiritual and emotional message. They championed the work of such painters as Corot, Delacroix, Courbet, and Millet, whose work inspired the French impressionists, though it was generally darker in color and more romantic in mood. They found their most energetic spokesman, a figure as intense and outspoken as Clarence Cook, in the painter William Morris Hunt, brother of the architect Richard Morris Hunt.

William Morris Hunt dominated the art world of Boston from the time he returned to the United States from France in the middle 1850s until his tragic suicide in 1879. His artistic performance was flawed and uneven, and today he is mentioned only in passing in surveys of American art. In the 1860s, however, he was at the center of artistic controversy, because he represented an approach and viewpoint that was new to American artists.[17]

Hunt had studied painting in France, working first under Thomas Couture, who taught Edouard Manet and led the most progressive atelier of the period. In the early 1850s he fell under the spell of Jean-François Millet, donned French peasant costume, and moved to Barbizon to be-

come Millet's pupil. Indeed, Hunt was one of the first to appreciate Millet, purchasing his famous *Sower* (fig. 7) for a mere sixty dollars and persuading wealthy American friends to acquire the paintings that were rotting on the earthen floor of Millet's studio. Thanks to Hunt's proselytizing, the Museum of Fine Arts in Boston now houses one of the world's largest collections of Millet's art.[18]

Hunt's own work, which combined features of both Couture and Millet, is characterized by great freedom of handling, broad masses of flat color, and a brownish tonality, although in his later years he often painted landscapes outdoors and grew increasingly sensitive to color and the treatment of light. Hunt's work was savaged regularly by Clarence Cook and other like-minded critics for its lack of finish, while Hunt in turn attacked the "niggling" detail that was popular among American painters. Hunt's statements about art proved to be of more lasting interest than his painting, for when his remarks were transcribed by one of his students, the little book that resulted, *Talks on Art*, became an international bestseller.

It is still in print and had a significant influence on later generations of American artists, providing, for example, many of the ideas articulated later by Robert Henri in *The Art Spirit*.[19]

To understand the early reviews of Winslow Homer's work, it is necessary to remember that his paintings were evaluated in the context of the battle between the so-called Pre-Raphaelites and the advocates of French painting. Two comments recur in early writings about Homer—that he was true to nature, and that his work lacked finish. Homer's truth to nature strongly appealed to the art critics, nearly all of whom had a Ruskinian bias, but his "lack of finish" deeply troubled them. Their complaints about this lack of finish were essentially complaints that Homer had allied himself with the new progressive manner of French painting.[20]

Most of Homer's closest artist friends in Boston and New York were committed to the French principles of plein-air painting. J. Foxcroft Cole, whom Homer befriended when he was a young apprentice in Boston, fell under the influence of the Barbizon school and acted as an agent in France

6. John William Hill, *Dead Blue Jay*, c. 1865, watercolor on paper, 14.6 x 30.5 (5 ³/₄ x 12)
The New-York Historical Society

7. Jean-François Millet, *The Sower*, 1850, oil on canvas, 101.0 x 82.6 (39 ³/₄ x 32 ¹/₂)
Museum of Fine Arts, Boston, Gift of Quincy Adams Shaw through Quincy A. Shaw, Jr., and Mrs. Marian Shaw Haughton

8. Winslow Homer, *The Sower*, wood engraving
Scribner's Monthly, August 1878

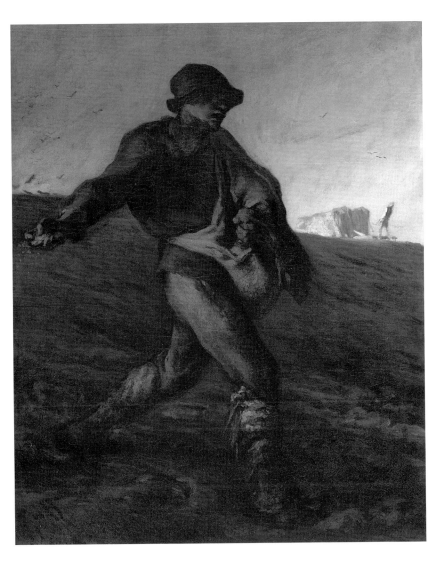

for Seth Vose, the main dealer of the Barbizon painters in the United States. Homer traveled with Cole when he went to France in 1867, visiting some of the favorite haunts of the French painters.[21] In fact, according to John La Farge, Homer had studied and made copies of French lithographs by the Barbizon masters as early as the 1850s.[22] In New York, Homer apparently knew the painter Elihu Vedder, who was closely associated with Hunt; and he was a good friend of Homer Martin, who over the course of his career gradually shifted from the Hudson River school to the Barbizon style of painting.[23] Another of Homer's close friends was John La Farge, among Hunt's first pupils and one of the most sophisticated painters and intellects of his time.[24] Yet Homer had no close friends among the American Pre-Raphaelites or the somewhat older members of the Hudson River school.

Homer had opportunities to see Barbizon paintings in this period, for William Morris Hunt owned at least ten paintings by Millet and had worked assiduously to promote Millet's work—along with that of Corot, Daubigny, Diaz, and Théodore Rousseau—among Bostonian collectors. Homer borrowed heavily from Millet's *Sower* for an illustration of the life of the American farmer in *Scribner's Monthly* magazine (figs. 7 and 8).[25]

Homer could also have derived Barbizon themes through Hunt's own work, as is suggested by a comparison of Homer's *The Veteran in a New Field* and Hunt's *Man in Wheatfield*, both painted in 1865 (figs. 9 and 10). Homer's canvas is less broad and rough in execution than Hunt's, but even its relative lack of finish seemed daring at the time. In fact, a review of the works that Homer put up for sale to finance his trip to France singled out *The Veteran in a New Field* as an "admirable" painting, yet complained nonetheless that its execution was "hasty and slight" and that Homer would be a better artist "if he learns to finish his pictures."[26]

Homer was not simply a follower of Hunt and the new fad of progressive French painting. He was in several respects quite different. Most enthusiasts of the French Barbizon painting in America, such as

Hunt and La Farge, came from upper-class backgrounds, had traveled in Europe, and were college educated—perhaps the first group of American painters to be so. Homer, while his mother had some modest claims to social pretension, came from a poor family, never finished school, and had supported himself for years doing commercial art. He thus came to Barbizon painting from the standpoint of popular illustration. It is apparent in his paintings of the 1860s, however, that Homer had absorbed some of the key elements of Barbizon subject matter, with its emphasis on workers in the fields; and Barbizon paint handling, with its relatively bold brushwork and simplified areas of tone.

Homer's Trip to France

Any doubts about Homer's interest in Barbizon painting can be laid to rest by considering the works he made during his trip to France. He seems to have associated in France chiefly with American artists, such as Alfred Kelsey and J. Foxcroft Cole. The places he painted—Paris and the rural village of Cernay-la-Ville—were favorite American haunts. Paris by the 1860s had replaced Rome and Düsseldorf as the European training ground of choice for American artists, and a restaurant at 6 rue Michodière, "Pumpkin Pie Place," even specialized in a cuisine that supposedly appealed to Americans—baked beans, griddle cakes, and pumpkin pie.[27] Cernay-la-Ville, about forty miles from Paris in Picardy, nearly halfway to Chartres, was a favored location for sketching excursions, largely, it appears, because it had an inexpensive hotel whose proprietor was often willing to accept paintings as payment. Corot and Daubigny both worked there, and the Carnegie Institute in Pittsburgh owns two paintings of the village by the American artist Joseph Woodwell, executed only a year after Homer's visit.[28] Homer was purportedly taken to Cernay by J. Foxcroft Cole; and according to J. Alden Weir, who went to the village to paint some thirty years later, Homer left several paintings of farm workers on the panels of the inn, no doubt as a substitute for paying with cash.[29]

As it happens, Homer probably could not have seen the work of the impressionists in Paris, for in 1867 the jury was unusually conservative and systematically excluded the work of Courbet, Manet, Monet, Renoir, Pissarro, Bazille, Boudin, and Sisley, along with that of other young progressive artists. Manet and Courbet protested this exclusion by erecting pavilions at their own expense in which they staged one-man shows, which were generally ridiculed.[30] Homer may well have seen these displays. But the canvases of these artists, while containing broad brushwork and simplified tonal areas, were much larger in scale than Homer's productions of this period, were not particularly bright in palette, and were not painted outdoors. Paintings such as Manet's *Olympia*, although impressively modern, have little to do with Winslow Homer's impressionist works such as *Long Branch* (fig. 1). Short of going to Le Havre to visit Monet or to Montpellier to visit Bazille, which seems highly improbable, it is hard to see how Homer could have encountered works of plein air impressionism in France.[31] On the other hand, the 1867 Salon contained a virtual retrospective of Millet's work, and the paintings of the Barbizon painters were displayed in great numbers. Not surprisingly, the majority of Homer's French paintings were closely modeled on the achievement of Millet.

The Barbizon subject matter of the majority of Homer's French paintings is apparent even from their titles: *Girl with Pitchfork, Return of the Gleaner, Coming Through the Rye, A French Farm, French Farmyard, The Hayfield, Haymakers, Flowers of the Field, Lady in Field of Flowers, Woman Working in Field, Woman Cutting Hay, Peasants Working in Field,* and *Men Working in Field.* Only six paintings depict nonrural subjects: *Gargoyles of Notre Dame, A Paris Courtyard, The Nurse, Pauline,* and two very similar studies of *Cello Players.*[32]

The influence of William Morris Hunt's teacher Thomas Couture appears in Homer's Parisian paintings and the influence of Millet in his rural ones. Couture's influence is seen in such works as *Pauline,* a sketch Homer made of a vendor of per-

9. Winslow Homer, *The Veteran in a New Field*, 1865, oil on canvas, 61.3 x 96.8 (24 1/8 x 38 1/8)
The Metropolitan Museum of Art, Bequest of Miss Adelaide Milton De Groot

10. William Morris Hunt, *Man in Wheatfield*, 1865, oil on millboard, 15.2 x 21.0 (6 x 8 1/4)
Museum of Fine Arts, Boston, Bequest of Elizabeth S. Gregerson

fumes and soap at the Universal Exposition (fig. 11).[33] Its format, with a vendor set against a flat wall, was explored more than once by Hunt—for example, in his *Violet Girl* (fig. 12) and *Hurdy Gurdy Boy*, executed in the 1850s and widely exhibited in both New York and Boston.[34] The handling of pigment also recalls the work of Hunt, and even more, that of Couture himself, who had devised a shorthand method of quickly building up a figure study over a toned ground with vigorously brushed outlines and broad areas of light and dark (fig. 13).[35] Millet's influence, on the other hand, stands out in Homer's rural studies.[36] *Girl with Pitchfork* (fig. 14), in its subject, coloration, and monumental treatment, brings to mind Millet's *Sower* (fig. 7), which Homer had apparently seen in Boston.[37]

Although Homer's French farm scenes directly imitate a French style of painting, they seem to have been chiefly derived from works that Homer had seen not in France but in the United States. An inter-

11. Winslow Homer, *Pauline*, 1867, oil on canvas, 55.9 x 38.1 (22 x 15) Colby College Museum of Art, Waterville, Maine

12. William Morris Hunt, *The Violet Girl*, 1856, oil on canvas, 100.3 x 81.6 (39 1/2 x 32 1/8) Museum of Art, Rhode Island School of Design, Providence

13. Thomas Couture, *Portrait of a Woman*, c. 1875–1876, 41.0 x 31.8 (16 1/8 x 12 1/2) Musée des Beaux-Arts, Bordeaux

14. Winslow Homer, *Girl with Pitchfork*, 1867, oil on canvas, 61.0 x 26.7 (24 x 10 1/2) The Phillips Collection, Washington, D.C.

a somewhat clumsily conceived pastiche by the Boston artist Albion Bicknell.[38] La Farge's painting is closer to Homer's than is Millet's in many respects, including its size, its predominantly green coloration, and its inclusion of flowers.

In short, the work that Homer did in France does indeed reveal French influence, but that of the Barbizon school, particularly the work of Millet, rather than, that of the impressionists, as Gardner claimed. What should we make, then, of the impressionist paintings Homer made in this period, both before and after his trip to France?

To some extent plein air impressionism was a logical outgrowth of Barbizon painting, and in fact most of the French impressionist painters began their careers making landscapes in the forest of Barbizon. Free brushwork, a direct response to nature, and even an interest in outdoor painting were all significant elements of Barbizon practice. In important respects, however, impressionism was a reaction against Barbizon painting, against its subdued tonalities and its somewhat repetitive subject matter.

Homer's impressionism, in fact, developed in the United States, and the work he did in France represented a brief regression to a more conservative and formulaic imitation of French Barbizon painting. Consequently, it must have been in the United States that Homer encountered the main influences that led him in the direction of impressionism. One influence was probably early French impressionist paintings, for, curiously enough, Homer was able to see French paintings in the United States more advanced than those he encountered in France. Another key influence was probably the artist John La Farge.

Impressionist Influences in the United States

Homer did have an opportunity to see a large group of French impressionist paintings in America the year before he went to France, for the year before Homer's departure the Paris firm of Cadart and Luget staged an exhibition of over a hundred French paintings that traveled to both New

esting case is the little panel *Flowers of the Field*, which shows a little girl against a green hill clutching some flowers (fig. 15). This once again recalls Millet's *The Sower* in its general conception, with a monumental figure before a high horizon. But it more specifically recalls a French-inspired painting by one of Homer's American friends, *Portrait of the Artist* (fig. 16) by John La Farge—a work that had already been imitated at least once by this date, in

York and Boston.[39] The most illustrious painting in this show was Courbet's *La Curée* (fig. 17), purchased with much fanfare by a band of Bostonian collectors and artists known as The Allston Club, which was dominated by William Morris Hunt and by Homer's friends Elihu Vedder and John La Farge. It was apparently the first painting by Courbet to be purchased in America.[40]

In addition, the show included a number of even more daring works of the sort that today are generally described as early examples of French impressionism or proto-impressionism. Along with paintings by Corot, Rousseau, Diaz, and other Barbizon masters, it contained two paintings by Johan Jongkind (a seascape and a scene of Holland), three paintings by Eugène Boudin (all views of Trouville; see fig. 18), and an early work by Claude Monet called in the catalogue *Bord de la Mer* (fig. 19). Throughout its tour the show attracted critical comment and interest, as well as sales, and its French organizers were so encouraged by its success that they quickly assembled another exhibition of 296 French paintings, which toured the United States

18. Eugène Boudin,
Beach at Trouville, c. 1865,
oil on panel, 18.4 x 34.9
(7 1/4 x 13 3/4)
The Phillips Collection,
Washington, D.C.

19. Claude Monet, *View
of the Coast of Le Havre*,
c. 1864, oil on canvas, 40.0 x
73.0 (15 3/4 x 28 3/4)
The Minneapolis Institute of Arts,
Gift of Mr. and Mrs. Theodore Bennett

later the same year. In 1867 the Boston collector Henry C. Angell, a close friend of Hunt, and very likely an acquaintance of Homer as well, purchased a painting by Boudin from Cadart—one of the first Boudins sold at a public sale anywhere.[41]

Until 1866 the paintings by Homer that suggest French influence were related to the Barbizon school, in both color tonality

and subject matter. Shortly after the Cadart show Homer made his first group of paintings that have been likened to French impressionism, the croquet scenes already mentioned, which are said to have been painted on the lawn of his uncle's home in Belmont, Massachusetts.[42] It seems likely that Homer had looked closely at the works by Boudin in the Cadart exhibition, which show a very similar representation of feminine fashions in an outdoor setting and which are quite close in size to Homer's paintings. Indeed, it is the work of Boudin, and not the better known impressionists, that seems to come closest in both subject matter and feeling to Homer's subsequent impressionist works. *Long Branch*, for example, is exactly analogous in subject matter to Boudin's Trouville beach scenes.[43]

Homer's contact with John La Farge may have been as significant to him at this time as his discovery of Boudin. Homer once described La Farge as the only painter with whom he enjoyed discussing art, while La Farge ranked Homer as the greatest American painter of his time and wrote a eulo-

20. Winslow Homer, *Peasants Working in a Field*, 1867, oil on wood, 15.2 x 45.7 (6 x 18)
Courtesy of Peter H. Davidson, Inc., New York

gistic obituary of him while on his own deathbed.[44] The three paintings by Homer that La Farge owned were all small studies painted in France in 1867 (see fig. 20).[45] They may well have been gifts from Homer, and they certainly suggest that the two artists saw much of each other around that date, when they worked in rooms close to each other in the Tenth Street Studio Building. La Farge seems to have introduced Homer to Japanese prints and encouraged him to explore the special challenges of plein air painting.

Homer and Japanese Prints

Many of Homer's paintings have characteristics in common with Japanese art. Writers have compared Homer's *The Morning Bell* with Katsushika Hokusai's *In the Mountains of Totomi Province*; his *Huntsman and Dogs* with Hokusai's *Mount Fuji in Clear Weather*; and his *Kissing the Moon* with Hokusai's *The Great Wave off Kanagawa* (figs. 21–26).[46] The paintings were done at widely spaced intervals in Homer's career, and none of the connections is so close as to establish indubitably Homer's dependence on a Japanese source. But taken as a group, the comparisons are persuasive, particularly as all of the prototypes are taken from Hokusai's *One Hun-*

dred Views of Fuji, suggesting that Homer was familiar with this source specifically.

Homer's contemporaries commented on the affinity between his work and Japanese prints as early as 1868.[47] He undoubtedly was familiar with Japanese art by that time, for in that year he included a vignette borrowed from a Japanese actor print in an engraving for *Harper's Weekly* of "St. Valentine's Day."[48] Stylistic evidence suggests that he became aware of Japanese ideas even earlier.

The issue of Homer's discovery of Japanese art has given rise to many contradictory statements. Gardner maintained that Homer discovered Japanese prints at the Great Exposition in Paris.[49] John Walsh disputed this, maintaining that Japanese prints were not on view at the Exposition.[50] Technically, Walsh was correct, for Japanese prints were not displayed on the Exposition grounds. But an exhibition of Japanese prints sent by the Japanese government was displayed outside the Great Exposition, and by 1867 several stores in Paris were largely devoted to the sale of Japanese bric-a-brac.[51] In fact, 1867 seems to mark the time at which Japanese prints ceased to be an esoteric interest in Paris nurtured by a small group of connoisseurs and instead became *à la mode*. Articles on Japanese art began to appear in greater numbers, notably an important study by Ernest Chesneau; and French painters be-

21. Katsushika Hokusai, *In the Mountains of Totomi Province*, later 1820s, woodblock print
From Hokusai's *Thirty-Six Views of Mount Fuji*

22. Winslow Homer, *The Morning Bell*, 1871–1872, oil on canvas, 61.0 x 97.2 (24 x 38 1/4)
Yale University Art Gallery, New Haven, Connecticut, Bequest of Stephen Carlton Clark

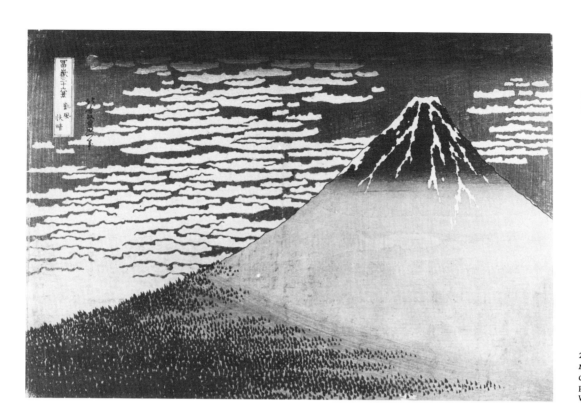

23. Katsushika Hokusai, *Mount Fuji in Clear Weather*, later 1820s, woodblock print
From Hokusai's *Thirty-Six Views of Mount Fuji*, Museum of Art, Carnegie Institute, Collection of Dr. and Mrs. James B. Austin

24. Winslow Homer, *Huntsman and Dogs*, 1891, oil on canvas, 71.1 x 121.9 (28 x 48)
Philadelphia Museum of Art, The Williams L. Elkins Collection

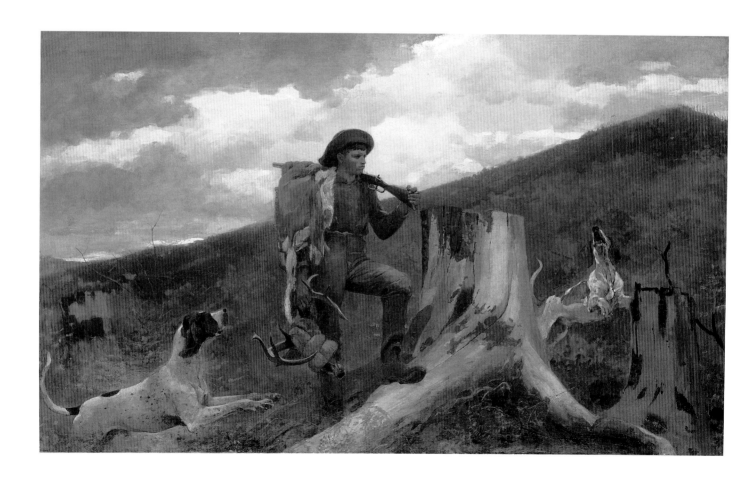

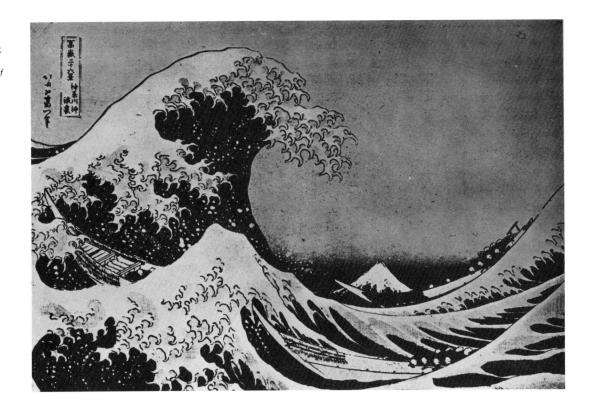

25. Katsushika Hokusai, *The Great Wave off Kanagawa*, later 1820s, woodblock print
From Hokusai's *Thirty-Six Views of Mount Fuji*

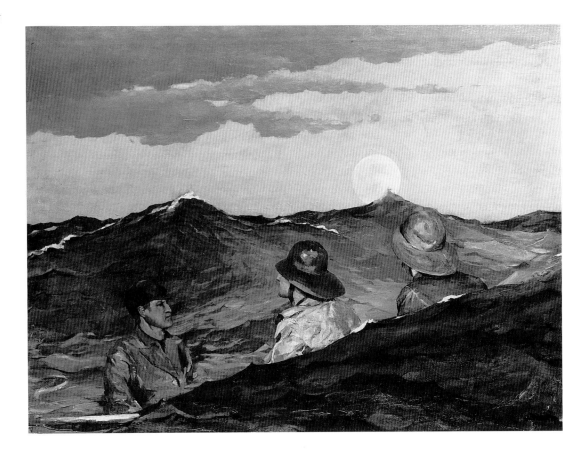

26. Winslow Homer, *Kissing the Moon*, 1904, oil on canvas, 76.2 x 101.6 (30 x 40)
Addison Gallery of American Art, Phillips Academy, Andover, Massachusetts

27. John La Farge, *Ship-wrecked*, wood engraving
Illustration for Alfred, Lord Tennyson's poem *Enoch Arden* (Boston, 1864), facing p. 35

28. John La Farge, *Flowers on a Window Ledge*, c. 1861, oil on canvas, 61.0 x 50.8 (24 x 20)
The Corcoran Gallery of Art, Museum Purchase, Anna E. Clark Fund

gan to use Japanese motifs with greater frequency.[52]

Winslow Homer undoubtedly encountered Japanese prints in Paris. But Gardner was almost certainly wrong in maintaining that he discovered them there. In fact, Homer must have been introduced to Japanese prints before he left for France through his close friend John La Farge.

As has been documented in some detail in a group of recent articles, La Farge began collecting Japanese prints in 1856, as early as any of the French artists, and by the early 1860s owned very large numbers of prints, particularly works by Hokusai and Hiroshige. By 1864 he was making illustrations directly based on Japanese prints, some of which are entirely Japanese in style (fig. 27). La Farge's enthusiasm for Japanese art was not unique but was picked up by other members of Hunt's circle, for example, by Albion Bicknell, Edward Cabot, Elihu Vedder, and, of course, Hunt himself.[53] It seems reasonable to suppose that Homer learned of Japanese prints in America rather than in France, particularly as those qualities of design in his work that Gardner characterized as "Japanese" appear in his work before he visited Paris.[54]

Recent writers have often suggested that Japanese prints affected Homer's sense of design, but they have not considered the change in his sense of color.[55] John La Farge, in an important essay on Japanese art published in 1870, noted that one of the most striking aspects of Japanese prints was their use of clear, brilliant colors:

For the Japanese, no combinations of colors have been improbable. . . . Their colored prints are most charmingly sensitive to the coloring that makes up the appearance of different times of day, to the relations of color which mark the different seasons, so that their landscape efforts give us . . . the illuminated air of the scene of action. They use the local colors to enhance the sensation of the time, and the very colors of the costumes belong to the hour or the season of the landscape.[56]

In 1867 the influential writer Russell Sturgis argued that American artists should turn their backs on the low color harmonies and overcast skies of French Barbizon painting and draw inspiration instead from the brilliant American light and the intense colors of Japanese prints: "Our American sky and sunshine are unmistakeable, and nature surrounds us with lovely colors. If our painters lose sight of these, and think that French pictures are better because soft and gray, or even that they are not much worse for their coldness, they might better have studied of the Japanese than of the French."[57] Sturgis, in essence, was arguing that American artists

should develop a kind of impressionism by disregarding the French and looking at Japanese prints. Homer seems to have followed this suggestion, and on several occasions in the 1870s American critics noted that Homer's use of color had a Japanese effect.

John La Farge and Plein Air Painting

Like Homer's interest in Japanese prints, his "impressionism" must also have been influenced by his contact with John La Farge. At this time La Farge was preoccupied with painting landscapes that often anticipated the work of the French impressionists in their sensitivity to the issues of outdoor color and light. La Farge began this direction as early as 1861, as is apparent from his *Flowers on a Window Ledge* (fig. 28), with its remarkable handling of reflected lights and colored shadow, its subtle differentiation between indoor and outdoor light, and its differing focus between details inside and out. His most ambitious impressionist work was *The Paradise Valley*, on which he worked intermittently from 1866 until 1869, painting outside at a particular time of day and attempting to model almost entirely without shadows but merely through transitions of color.

La Farge was not the only non-French artist at the time to move toward impressionism. Although the style's maturation and flowering have made it seem a uniquely French phenomenon, works similar to those of the early French impressionists had appeared periodically in the mid-nineteenth century in both Europe and the United States. The works of John Constable in England, Giovanni Fattori in Italy, and the young Adolph Menzel in Germany were often impressionist in character. In the mid-1860s several American artists, including not only Homer and La Farge but George Inness, Elihu Vedder, and even Worthington Whittredge, worked outdoors and executed paintings that are relatively bright in key.[58]

Thus, Homer could have picked up impressionist tendencies from many sources. But he was probably most influenced by John La Farge, both because he was closest

to him personally and because La Farge was certainly the most progressive American painter in the impressionist style. Speaking of his brief exposure to the methods of Couture, La Farge recalled:

I noticed how Couture painted his landscapes as a form of curtain behind a study of the model, which in reality belonged to the studio in which it was a part, and, with the uncompromising veracity of youth, I could not understand the necessary compromises with the general truth of nature. Besides that, I was becoming more and more dissatisfied with the systems of painting which assumed some conventional way of modelling in tones that were arbitrary, and of using colour, after all, merely as a manner of decorating these systems of painted drawing. My youthful intolerance required the relations of colour for shadow and for light to be based on some scheme of colour-light that should allow oppositions and gradations representing the different directions and intensities of light in nature, and I already became much interested in the question of the effect of complementary colours.[59]

He later elaborated:

The closed light of the studio is more the same for every one, and for all day, and its problems, however important, are extremely narrow compared with those of out of doors. There I wished to apply principles of light and color of which I had learned a little. I wished by studies from nature to indicate something of this, to be free from recipes as far as possible, and to indicate very carefully, in every part, the exact time of day and circumstances of light.[60]

In one of the very few recorded early interviews with Winslow Homer, published by George Sheldon in 1881, Homer expressed very similar ideas, directly attacking academic studio painting (fig. 29), and arguing that artists should work out-of-doors:

I wouldn't go across the street to see a Bougereau. His pictures look false; he does not get the truth of that which he wishes to represent; his light is not out-door light; his works are waxy and artificial. They are extremely near being frauds. . . . I prefer every time a picture composed and painted outdoors. The thing is done without your knowing it. Very much of the work now done in studios should be done in the open air. This making studies and then taking them home to use them is only half

*right. You get the composition, but you lose
freshness; you miss the subtle, and, to the art-
ist, the finer characteristics of the scene itself.
I tell you it is impossible to paint an out-door
figure in studio-light with any degree of cer-
tainty. Out-doors you have the sky overhead
giving one light; then the reflected light from
whatever reflects; then the direct light of the
sun; so that, in the blending and suffusing of
these different illuminations, there is no such
thing as a line to be seen anywhere. I can tell
in a second if an out-door picture with figures
has been painted in a studio.*[61]

La Farge and Homer sometimes painted
together in the 1860s, and the attribution
of at least one painting—a striking view of
*Newport from Paradise Rocks, Looking
South* (fig. 30)—has been variously assigned
to both Homer and La Farge. The work
bears a close relationship to works of the
late 1860s by La Farge. One of his drawings
(fig. 31) represents an almost identical view,
and his well-known painting of *Bishop
Berkeley's Rock* (fig. 32), made from nearly
the same spot although looking in a differ-
ent direction, is similar in its loose han-
dling of the paint and in its coloration,
with the unusual mix of orange and green-
ish tones. For several reasons, however, it
seems likely that the painting is actually
by Winslow Homer. It shows a mastery of
dramatic design and a vigor of execution
that are more characteristic of Homer than
of La Farge. In addition, the circumstantial
evidence is strong: it was traditionally at-
tributed to Homer; it came from a distin-
guished Boston collection of Homer's
work; and it was shown in a retrospective
of Homer's paintings at the Carnegie Insti-
tute as early as 1911.[62] It once bore Homer's
signature, although unfortunately this was
removed in a recent cleaning. In any case,
whichever of the two artists created the
painting, this confusion between their
work illustrates the close connection that
existed between them in the 1860s.[63]

Conclusion

In summary, Winslow Homer's relation-
ship to French painting, Japanese prints,
and impressionist ideas was more complex

than Albert Ten Eyck Gardner supposed.
First, one must distinguish between two
intertwined currents in Homer's work of
the 1860s, a Barbizon and an impressionist
tendency. Perhaps the major influence on
Homer in this period was the work of the
French Barbizon painters, to whom he was
introduced through William Morris Hunt's
circle in Boston and through his 1867 trip
to France. The paintings Homer made in
France are particularly closely modeled on
those of the Barbizon masters. The influ-

29. William Bouguereau,
Nymphs and Satyr, 1873, oil
on canvas, 260.0 x 180.0
(102 3/8 x 70 7/8)
Sterling and Francine Clark Institute,
Williamstown, Massachusetts

30. Attributed to Winslow Homer, *Newport from Paradise Rocks, Looking South*, c. 1867, oil on canvas, 30.5 x 50.8 (12 x 20)
Private collection, New York

ence of the Barbizon painters was of enduring value, for through their example Homer learned to eschew details and concentrate on fundamentals. Moreover, in their work he first discovered the subject of man against nature that would occupy him for the final half of his career, a theme he eventually transposed from the French farmyard to the open sea and the American wilderness.

Homer's impressionism, by contrast, was chiefly encouraged not by his trip to France but by influences found in the United States, especially Japanese prints and the impressionist work of John La Farge. Homer's impressionist period was brief, but like his Barbizon phase, its significance was lasting, for he continued to hold certain impressionist ideas throughout his career. Although his later work grew more subdued in color, many of his major late paintings were painted out-of-doors and one of their most notable features is their remarkable sensitivity to the most fugitive and fleeting effects of the weather and of the light.[64]

Paintings such as *Long Branch* represent an all too brief episode in Homer's career, when he painted with a colorfulness and freshness that he otherwise achieved only in watercolor. He put behind him the literal-minded accumulation of detail found in the work of academic painters, the American Pre-Raphaelites, and most of his American contemporaries. He reduced each scene to its expressive essentials and presented the figures and activities in their natural envelope of light and air. These paintings show Homer's remarkable synthesis of French ideas and those of his close friend John La Farge, to produce effects that go beyond his immediate models and rival the works of the most advanced European painters.

Albert Ten Eyck Gardner was wrong about how Homer encountered progressive French painting and what he learned from it, but he was correct in recognizing its fundamental importance to Homer's work. As the painter William Glackens perceptively observed in an interview he gave at the time of the Armory Show, Winslow

Homer was "never good, never the power
that he became, until he got under the in-
fluence of France."[65]

CHECKLIST OF THE PAINTINGS HOMER MADE IN FRANCE, 1867

Compiled by Lloyd Goodrich

THE 'CELLO PLAYER'
Canvas, 19 × 13. Signed: "Paris 67/Winslow Homer."
Inscribed on back, not in Homer's hand: "In the Old
University Tower/New York/By Winslow Homer."
Baltimore Museum of Art. Acquired from Homer by
Charles de Kay, friend of Homer, who occupied Hom-
er's room in the tower of the New York University
Building on Washington Square after Homer left for
Paris.

MUSICAL AMATEURS OR AMATEUR MUSICIANS
Canvas, 18 × 15. Signed: "Winslow Homer N.A./67."
The Metropolitan Museum of Art. The cello player is
identical with the one in the preceding. In the Paris
painting the room has a big window with Gothic
frame and a view of another building outside; in *Mu-
sical Amateurs* no window is visible; just a wall, light
from the upper left, some canvases propped up.
 The chronological sequence of these two paintings
is unknown. Also whether *Musical Amateurs* was
painted in Paris or New York.

COMING THROUGH THE RYE
Canvas, 17 × 12. Signed: "Homer/Paris 1867." Private
collection.

A FRENCH FARM
Wood, 11 × 18. Signed: "Homer 18[??]" (last two num-
bers illegible). Krannert Art Museum, University of
Illinois, Champaign. Inscribed on back, probably not
in Homer's hand: "Cernay la Ville. French Farm.
Winslow Homer." Probably National Academy of De-
sign, 43rd Annual Exhibition, 1868, #71, "Picardie,
France."

FRENCH FARMYARD
Wood, 18¹/₈ × 14¹/₄. Not signed or dated. Cooper-
Hewitt Museum, New York.

FLOWERS OF THE FIELD
Canvas, 14¹/₄ × 10¹/₄. Signed: "H." Not dated. David
S. Ramus, Ltd., Atlanta, Ga. (1982).

GARGOYLES OF NOTRE DAME
Canvas, 19 × 13. Signed: "Homer/1867." Private
collection.

GIRL WITH PITCHFORK
Canvas, 24 × 10¹/₂. Signed: "W. H./1867." The Phillips
Collection, Washington.

31. John La Farge, *Paradise Rocks, Newport, Looking South*, 1865, pencil on paper, 14.6 x 20.2 (5 3/4 x 7 15/16) Avery Library, Columbia University

32. John La Farge, *Bishop Berkeley's Rock, Newport*, 1868, oil on canvas, 76.8 x 64.1 (30 1/4 x 25 1/4) The Metropolitan Museum of Art, Gift of Frank Jewett Mather, Jr.

THE GLEANERS OR PEASANTS WORKING IN FIELD
Wood, 6 × 18. Signed: "H 67." American Art Galleries, The John La Farge Collection, 30 March 1911, #657, "Peasants Working in Field." Peter H. Davidson & Co., Inc., New York (1986).

THE HAY FIELD
Canvas, 9 7/8 × 16 3/4. Signed: "Winslow Homer 67." Private collection.

HAYMAKERS
Canvas, 13 × 18 1/4. Signed: "Winslow Homer." Not dated. Mrs. Donald S. Stralem, New York (1978).

LADY IN FIELD OF FLOWERS
Canvas, 18 × 12. Signed: "Homer." Not dated. Davenport Municipal Art Gallery, Iowa.

MEN WORKING IN FIELD
Wood, 4 1/2 × 4 7/8. Signed: "H." Not dated. American Art Galleries, The John La Farge Collection, 30 March 1911, #619. "Men Working in a Field. Study. Painted on wood. Signed lower right corner, 'H.' Height 4 1/2 in.; width 4 7/8 in." Not illustrated. Purchased by Mr. E. B. Child, $30. Present ownership unknown.

THE NURSE
Wood, 19 × 11. Signed: "Homer/1867." Mrs. Norman B. Woolworth, New York (1973).

A PARIS COURTYARD
Canvas, 17 × 11 7/8. Signed: "Homer/Paris 67." Randolph Macon Woman's College, Lynchburg, Va.

PAULINE
Canvas, 21 7/8 × 11 7/8. Not signed or dated. Colby College Museum, Waterville, Me. Inscribed on back, not in Homer's hand: "Unfinished sketch of a woman 'Pauline' done in Paris for AWK[?] in 1867 by Winslow Homer. She sold perfumes and soap at the Exhibition." [The Exposition Universelle, Paris, in which Homer had two paintings. "AWK" was his friend Albert Warren Kelsey, from Belmont, Mass., with whom he shared a studio in Montmartre.]

RETURN OF THE GLEANER
Canvas, 24 × 18 1/4. Signed: "Winslow Homer/1867." The Strong Museum, Rochester, N.Y.

WOMEN WORKING IN FIELD
Wood, 6 3/4 × 12 3/4. Signed: "H 67." American Art Galleries, The John La Farge Collection, 30 March 1911, #623.

WOMAN CUTTING HAY
Canvas mounted on composition board, 9 × 12. Signed: "Homer 1867." Charles and Emma Frye Art Museum, Seattle, Washington.

1. The term "impressionism" has been used to describe progressive French artists of widely differing approaches. To avoid the confusion, I will employ it here in a specific and limited sense, to refer solely to impressionist *plein air* landscape painting, especially as seen in the work of Claude Monet. In fact, Monet's style of the mid-1860s possesses particular analogies with the work of Homer. More specifically, I am thinking of Monet's *Women in a Garden* of 1866-1867 (Louvre, Paris), with its broad, patchy areas of color, as opposed to his shimmering, insubstantial *Boulevard des Capucines* of 1873-1874 (The Nelson-Atkins Museum of Art, Kansas City). Monet's mature impressionist style goes beyond anything ever attempted by Homer. My subject, in short, is the relation of Winslow Homer's work to a specific episode in French landscape art. See *The New Painting: Impressionism 1874-1886* [exh. cat., Fine Arts Museums of San Francisco and National Gallery of Art, Washington] (San Francisco, 1986), for broader treatment of impressionism.

2. Homer painted *Man with a Scythe* (Cooper-Hewitt Museum, Smithsonian Institution) about 1869 as the basis for an illustration in *Appleton's Journal* of 7 August 1869.

3. Lloyd Goodrich, *Winslow Homer* (New York, 1944), 38, noted of Homer that: "His early work showed many curious parallels to the early work of the French impressionists, especially Claude Monet, and to their precursor, Eugène Boudin." Goodrich cited Homer's *The Bridle Path* of 1868 (Sterling and Francine Clark Art Institute, Williamstown), *Long Branch* of 1869 (Museum of Fine Arts, Boston), and *High Tide* of 1870 (The Metropolitan Museum of Art), as impressionistic works. Barbara Novak in *American Painting of the Nineteenth Century* (New York, 1969), 165-174, discussed at length the impressionist qualities of these same three works, as well as of *Croquet Scene*, 1866 (The Art Institute of Chicago), and *Croquet Match*, 1868-1869 (private collection). In the discussion that follows, I use "impressionism" to refer specifically to this small group of Homer's pictures, rather than to the many other works by Homer, distributed throughout his later career, which present occasional analogies with French impressionism but in which the impressionistic qualities are not the most fundamental or striking qualities of the work.

4. The dates of Homer's sailing are provided in Gordon Hendricks, *The Life and Works of Winslow Homer* (New York, 1979), 73, 76.

5. "A Parisian Ball—Dancing at the Mabille, Paris," "A Parisian Ball—Dancing at the Casino," and "Art Students and Copyists in the Louvre Gallery, Paris," in *Harper's Weekly*, 23 November 1867 and 11 January 1868. Homer also drew an illustration of his return voyage, "Homeward Bound," which appeared in *Harper's Weekly*, 21 December 1867. All are reproduced in Philip C. Beam, *Winslow Homer's Magazine Engravings* (New York, 1979), 149, 150, 155. To my knowledge no scholar has noted that Homer in-

cluded a self-portrait in *Dancing at the Casino*. He is the short man with his arm raised in astonishment just to the left of the dancers.

6. Augustus Stonehouse noted that Homer failed to profit from this opportunity to learn about French painting and concluded that, "it is just this slowness to take suggestions that has made Mr. Homer, with all his limitations, the refreshing, the original artist he is." See his "Winslow Homer, "*Art Review* 1, no. 4 (February 1887), 12-13. Similarly, Homer's first biographer, William Howe Downes, wrote that Homer "did no studying and no serious work of any kind worth mentioning while he was in Paris, and it is probable that he devoted most of his time to sightseeing and recreation." See Downes, *The Life and Works of Winslow Homer* (Boston, 1911), 59. Lloyd Goodrich declared that "the influence of this trip on his art was not great." Goodrich 1944, 40.

7. Albert Ten Eyck Gardner, *Winslow Homer: A Retrospective Exhibition* [exh. cat., National Gallery of Art] (Washington, 1958), 28; reprinted in [exh. cat., Museum of Fine Arts] (Boston, 1959), 30; and in an expanded and slightly altered form in *Winslow Homer, American Artist: His World and His Work* (New York, 1961).

8. Gardner 1961, 90.

9. Yvon Bizardel, *American Painters in Paris* (New York, 1960), 168. This is a virtual paraphrase of Gardner in 1958, 43; 1959, 38; 1961, 106: "Perhaps he was at his most Yankee when he chose to keep his mouth shut on the subject of the discoveries he made on his trip to Paris." Goodrich wrote a highly critical review of Gardner's book in *The New York Times Book Review*, 26 November 1961, 7, in which he characterized Gardner's argument as "a highly debatable thesis," and commented that "in this book, a surmise on one page has a way of turning into a certitude on another."

10. Lloyd Goodrich, *Thomas Eakins*, 2 vols. (Cambridge, Mass., 1982), 1:28.

11. David Park Curry, *Winslow Homer, The Croquet Game* [exh. cat., Yale University Art Gallery] (New Haven, Conn., 1984), discusses the dating and sequence of Homer's paintings of croquet. The comparison with Monet's *Women in a Garden*, made by both Novak and Wilmerding, is misleading (Novak 1969, 167-169 and John Wilmerding, *Winslow Homer* (New York, 1972), 48, 64-65). The works look similar in photographs but are vastly different in scale. Homer's is less than a foot high while Monet's is over six feet high—so tall that he had to dig a hole in his garden in which to sink the canvas in order to work on the upper section.

12. As noted by John J. Walsh, Jr., "Winslow Homer, Early Work and the Japanese Print." (Master's thesis, Columbia University, 1965), 17-18.

13. The emotional appeal of Gardner's thesis may also explain why scholars have clung to it despite the lack of solid evidence and may make comprehensible the curious ambivalence with which scholars

have asserted Homer's relationship to the French impressionists while insisting on his uniquely American qualities. A few writers have wholeheartedly endorsed Gardner's ideas. Stuart Feld wrote of Homer's *Croquet Match* (private collection) of c. 1868/1869: "The painting is an effective synthesis of the important lessons Homer had learned from Japanese prints and from the work of the French Impressionists, both of which he had ample opportunity to study during his ten-month visit to France in 1866." *American Genre Painting in the Victorian Era: Winslow Homer, Eastman Johnson and Their Contemporaries* [exh. cat., Hirschl and Adler Galleries] (New York, 1978). Most writers, however, have been less definite. Novak affirmed Goodrich's conclusion that Homer's French trip did not have much influence on his work, and then, a page later, cited several impressionist paintings that "obviously related to the French adventure" (Novak 1969, 173). Wilmerding concluded his discussion of the influence of Homer's trip to France with the somewhat ambiguous statement that "touches of Monet and Boudin continue to surface, whether consciously or unconsciously, throughout Homer's subsequent career" (Wilmerding 1972, 51). Both Novak and Wilmerding, the leading scholars to adopt Gardner's ideas, have significantly altered his thesis. Gardner aggressively maintained that the influence of impressionism and Japanese prints on Homer was fundamental and shaped the entire course of his artistic production. Although he gave few examples to illustrate these influences, those he mentioned were for the most part from the latter half of Homer's career. Novak and Wilmerding, on the other hand, have argued that the influence of impressionism and Japanese prints occurred at a specific moment in Homer's development, shortly after his trip to France, and that this influence was for the most part dissipated fairly soon. They have concentrated on a half dozen paintings dating from the mid-1860s to the early 1870s—those listed in note 3. Gardner alluded in passing to Manet and Courbet, two precursors of mature impressionism, but never specifically referred to the "plein air" impressionism of such figures as Monet, Renoir, Sisley, and Pissarro. Novak and Wilmerding, on the other hand, have likened Homer's work to the early impressionism of Boudin and Monet.

14. A somewhat outdated but still useful account of this group is David Howard Dickason, *The Daring Young Men: The Story of the American Pre-Raphaelites* (Bloomington, Ind., 1953). A more scholarly treatment is provided in Linda S. Ferber and William H. Gerdts, *The New Path* [exh. cat., The Brooklyn Museum] (New York, 1985). The differences between the English Pre-Raphaelites and their American followers have perhaps not been sufficiently stressed. John La Farge maintained friendly contact with several of the English Pre-Raphaelites, such as Dante Gabriel Rossetti, but was opposed to the sort of finicky detail favored by the American Pre-Raphaelites and was regularly attacked by their supporter, Clarence Cook.

15. Thomas Charles Farrer, "A Few Questions Answered," *The New Path* 1 (June 1863), 14.

16. Cook deserves more serious study. For a brief biography, see Dickason, 1953, 87–91. Fuller documentation is provided in John P. Simoni, "Art Critics and Criticism in Nineteenth-Century America" (Ph.D. diss., Ohio State University, 1952).

17. For an introduction to Hunt's work, see Martha J. Hoppin and Henry Adams, *William Morris Hunt: A Memorial Exhibition* [exh. cat., Museum of Fine Arts] (Boston, 1979); and Martha Hoppin, "William Morris Hunt and his Critics," *American Art Review* 2 (September–October 1975), 79–91. Thanks to Hunt, advocacy of the Barbizon school was particularly fervent in Boston, but Barbizon paintings were also widely exhibited and collected in New York. Henry Ward Beecher owned Barbizon paintings in New York in the 1860s; George Ward Nichol sold them at Crayon Gallery; they are frequently mentioned in newspaper reviews.

18. For an excellent account of collecting in Boston, see Alexandra R. Murphy, "French Paintings in Boston: 1800–1900," in Anne L. Poulet and Alexandra R. Murphy, *Corot to Braque* [exh. cat., Museum of Fine Arts] (Boston, 1979).

19. Hoppin and Adams 1979, 22; William Innes Homer, *Robert Henri and His Circle* (Ithaca, New York, 1969), 182.

20. "Fine Arts," *The Nation*, 15 November 1866, 395–396, declared of three oil paintings exhibited by Homer: "They are all three very sketchy, rapidly painted in the 'broadest' manner, and we are sorry to see Mr. Homer's work *always* so slap-dash. . . . These pictures, it should be remembered, are slight and unfinished studies in oil color; it is, as we have hinted, of questionable propriety to exhibit them as for sale." By contrast, George Sheldon, in "American Painters: Winslow Homer and F. A. Bridgman," *Art Journal* (August 1878), 227, maintains: "Many of his [Homer's] finished works have somewhat of the charm of open-air sketches—were, indeed, painted out-doors in the sunlight, in the immediate presence of Nature." Henry James, who had studied painting with Hunt and was a close friend of John La Farge, prefigured a general shift in American taste when he wrote favorably of Homer's generalized execution but criticized the realism of his subject matter. In "On Some Pictures Lately Exhibited," *The Galaxy* 20 (July 1875), 93, James wrote: "Mr. Homer has the great merit, moreover, that he naturally sees everything at one with its envelope of light and air. He sees not in lines, but in masses, in gross, broad masses."

21. Goodrich 1944, 6; Henricks 1979, 27–28, 40, 73, 207, 302; Peter Bermingham, *American Art in the Barbizon Mood* [exh. cat., National Collection of Fine Arts] (Washington, D.C., 1975), 129; David Sellin, *Americans in Brittany and Normandy, 1860–1910* [exh. cat., Phoenix Art Museum] (Phoenix, 1982), 7; Frederick Vinton, *Memorial Exhibition of Joseph Foxcroft Cole (1837–1892)* [exh. cat., Museum of Fine Arts] (Boston, 1893).

22. In *The Higher Life in Art* (New York, 1908), 172–173, La Farge declared that in the 1850s, "not being able to see the originals, he [Homer] drew from the

French lithographs we had here, which were almost entirely devoted to the reproduction of the work of these men. At that time we had but very few examples in the country, exceedingly few, perhaps it might be said none, of Corot, none of Rousseau. By chance there happened to be a few Millets. The foundation then in great part of such an independent talent—I might say more than talent, of such a genius as Mr. Winslow Homer's—refers back then to this school and to the teachings, the inevitable teachings, even from studying them in translations. On that . . . is built a form of painting as absolutely different as it could possibly be; a thoroughly American system of painting, a representation of American light and air, of everything that makes the distinction; even the moral fibre and character of New England being depicted all through the picture, whether it be the rocks and the sea, or the men who hang about them."

23. Homer's friendship with Martin is documented by Goodrich 1944, 24–25; a connection with Vedder has been suggested by Sellin 1982, 6–7. Vedder, La Farge, and Homer are said to have painted together in Newport around 1865, as has been discussed by James Yarnall, "The Role of Landscape in the Art of John La Farge" (Ph.D. diss., University of Chicago, 1981), 189.

24. Goodrich 1944, 24–25, 36; Philip C. Beam, *Winslow Homer at Prout's Neck* (Boston, 1966), 97, 108, 162, 191, 205.

25. Homer's illustration is discussed in Henry Adams et al., *American Drawings and Watercolors in the Museum of Art, Carnegie Institute* [exh. cat., Museum of Art, Carnegie Institute] (Pittsburgh, 1985), 54. Hunt's collection of Millet was also disseminated through copies made by La Farge, Vedder, and other pupils. See Ortgies and Co., New York, *Important Collection of Oil and Water Color Paintings, by John La Farge of This City*, 17 April 1884, 20, no. 65; Elihu Vedder, *The Digressions of V.* (Boston and New York, 1910), 261–262, ill. 261.

26. *The Nation*, 15 November 1866, 395.

27. Lois Fink, "American Artists in France, 1850–1870," *American Art Journal* 5, no. 2 (November 1973): 34.

28. *Cernay-La-Ville, No. 1*, and *Cernay-La-Ville, No. 2*, both dated 1868, left to the museum in 1959 by the artist's daughter, Johanna K. Hailman. For Woodwell, see Nancy Colvin, "Scalp Level Artists," *Carnegie Magazine* (September–October 1984), 14–20.

29. Sellin 1982, 7; Goodrich 1944, 39. Homer's visit to Cernay was mentioned in a letter from Mahonri Young (J. Alden Weir's son-in-law) to Maynard Walker, 1 October 1937, a transcript of which was provided to me by Lloyd Goodrich: "J. Alden Weir told me that at one time, when he was a student in Paris (sometime in the late '70s), he made a visit to Cernay-la-ville, where many Barbizon artists painted. In 1902 I visited Cernay-la-ville with my friend, Lee Green Richards, and stopped at the hotel there. The hotel had been and still was a rendezvous of artists, but we were too late to enjoy the pictures which had been, previously, on the panels of the doors and on the furniture, and disposed generally around the hotel. Corot, Daubigny, and many other men had painted there, and there had been pictures of theirs on the walls and panels of the doors, etc. I mentioned to Alden Weir that I had been to Cernay-la-ville, and he told me about some of the pictures that had been there. In particular he mentioned that on one of the panels (he didn't say whether on furniture or on the doors) there was a study of people working in a grain field which Winslow Homer had painted there on his visit to Paris in 1867. He said that even then Winslow Homer was already the Winslow Homer we know." Young suggested that the painting Weir saw was the one described in note 46, which once belonged to John La Farge and is now with Peter Davidson in New York. It seems likely, however, that Weir saw a different painting.

30. John Rewald, *The History of Impressionism*, 4th rev. ed. (New York, 1973), 168–171. Of the progressive artists, only Degas, Morisot, Whistler, and Fantin-Latour were successful with the jury.

31. Walsh 1965, 19–22, proposed that Homer might have visited Bazille, but there is no evidence to support this conjecture.

32. Wilmerding 1972, 50, proposed that *Gargoyles of Notre Dame* was based on a photograph by Charles Nègre, but this suggestion has been rightly questioned by Nicolai Cikovsky in "Winslow Homer's Prisoners from the Front," *Metropolitan Museum Journal* 12 (1977), no. 45, 166–167. *Cello Players* has often been compared with the work of Degas. "Degas and Homer," *The Fine Arts* 18 (April 1932), 33; Martha Davidson, "Two Centuries of American Paintings," *The Art News*, 5 December 1936, 16; Wilmerding 1972, 51, 82. Degas, however, does not seem to have begun painting musicians until 1868–1869, so it is unlikely that he directly influenced these works.

33. Hendricks 1979, 74.

34. *The Violet Girl* was exhibited at the National Academy of Design in 1857; *The Hurdy Gurdy Boy* was exhibited at the Boston Athenaeum in 1852, 1854, 1856, 1858, and 1859, and at the National Academy of Design in 1857. For *The Violet Girl*, see Hoppin and Adams 1979, 60; for *The Hurdy Gurdy Boy*, see Martha J. Hoppin, "William Morris Hunt: Aspects of his Work" (Ph.D. diss., Harvard University, 1974), 34 and 290, no. 125.

35. For Couture's methods, see Albert Boime, *Thomas Couture and the Eclectic Vision* (New Haven, 1980); Albert Boime, *The Academy and French Painting* (London, 1971), 65–78; Alain de Leiris, "Thomas Couture, The Painter," in *Thomas Couture, Paintings and Drawings in American Collections* [exh. cat., University of Maryland Art Gallery] (College Park, Maryland, 1970), 14–15; Anne Coffin Hanson, "Traditional Picture Construction," in *Manet and the Modern Tradition* (New Haven, 1977), 143–154; Thomas Couture, *Conversations on Art Methods (Méthode et entretiens d'atelier)*, trans. S. E. Steward (New York, 1879), 6–9, 143–148; Helen Knowlton, *Art-Life of William Morris Hunt* (Boston, 1899), 9–10.

36. I do not mean, of course, to imply that Homer was exclusively influenced by Millet, for some of his rural works bring to mind other French painters of rural subjects. For example, as John Wilmerding has pointed out, Homer's *A French Farm* (Krannert Art Museum, Champaign, Ill.) belongs to the same general type as Jean-Baptiste Camille Corot's *Church at Lormes* (Wadsworth Atheneum, Hartford) painted some twenty years earlier. Wilmerding 1972, 77.

37. Sellin 1982, 7, asserts that *Girl with Pitchfork* was painted in America, but he has told me in conversation that he now believes it was painted in France. The girl's costume and *sabots* seem clear evidence that the subject is French.

38. Henry Adams, "A Fish by John La Farge," *The Art Bulletin* (June 1980), 273. Bicknell's painting was also influenced by Ary Scheffer's *Dante and Beatrice*, then owned by C. C. Perkins of Boston. See Murphy 1979, xxviii.

39. Lois Fink first noted the importance of the Cadart and Luget exhibition and its probable influence on Homer. See her "French Art in the United States, 1850–1870: Three Dealers and Collectors," *Gazette des Beaux-Arts* (September 1978), 90.

40. Jean Gordon, "The Fine Arts in Boston" (Ph.D. diss., University of Wisconsin, 1965), 253.

41. Murphy 1979, xii. Angell wrote an informative memoir of Hunt, *Records of William Morris Hunt* (Boston, 1881).

42. "The William Flagg Homer House—661 Pleasant Street," *Belmont Citizen*, 29 March 1973. Henry Bloch of Kansas City recently purchased a painting of croquet by Manet that bears a remarkable resemblance to those by Homer and is similar in scale. It seems most unlikely that either artist was familiar with the other's work, but Robert Rosenblum has made the ingenious suggestion that Manet saw Homer's *Prisoners from the Front* of 1866, which was exhibited in Paris in 1867, and that it served as a source for his *The Execution of the Emperor Maximilian* of 1868. See Rosenblum and H. W. Janson, *19TH-Century Art* (New York, 1984), 285–287.

43. Lloyd Goodrich (see note 1) perceived the similarity between Homer's work and that of Boudin, though without citing the Cadart and Luget exhibition.

44. Philip C. Beam, *Winslow Homer at Prout's Neck* (Boston, 1966), 162. La Farge wrote three appreciations of Homer: "Speech at the Annual Banquet, American Institute of Architects, January, 1905," *American Architect and Building News*, 87, 28 January 1905, 28–29; the passage cited in note 22 (La Farge 1908); and a letter/obituary printed after his death by Gustav Kobbé, "John La Farge and Winslow Homer," *New York Herald*, 4 December 1910. In the 1905 address, La Farge described Homer as "a great American painter, as great as any in the world." Comparing Homer to "the French artist who scraped on the bones of the cave bear," he declared that Homer was "the only one who has drawn as distinctly and as well, with that firmness of touch, that far down feeling of nature" (p. 28). La Farge encouraged Homer at

various moments in his career. In 1891 he criticized Homer's dull palette, and in rebuttal Homer painted *The West Wind*; in 1892 he praised Homer's watercolors, stating that the prices were "ridiculously low"; in 1897 he persuaded Homer to exhibit *The Lookout* at the Society of American Artists (Beam 1966, 97 and 108; Goodrich 1944, 143). Early biographers tended to contrast La Farge and Homer, seeing La Farge as a promoter of foreign influences in American art and Homer as a native American figure. Downes 1911, 84, and Goodrich 1944, 36, discounted La Farge's claim that Homer was interested in French painting. Recently, scholars have been more willing to accept the notion that La Farge may have influenced Homer. Helen Cooper, for example, has compared some of Homer's watercolors to La Farge's watercolors and stained glass in *Winslow Homer Watercolors* [exh. cat., National Gallery of Art, Washington] (New Haven, 1986), 173.

45. American Art Galleries, New York, *The John La Farge Collection*, 29–31 March 1911, no. 619, *Men Working in Field*; no. 623, *Women Working in Field*; and no. 657, *Peasants Working in Field*. *Peasants Working in Field*, which was sold to A. A. Healy, is now with Peter H. Davidson, New York.

46. Novak 1969, 166, discussed the Japanese quality of *The Morning Bell*; the parallel with a specific print by Hokusai was pointed out by Adams 1985, 456. Gardner 1961, 206–207 and 210–211, suggested the other two comparisons. Apparently the first modern scholar to comment on this relationship was Allen Weller, who maintained that Japanese prints were "one of the few definite exterior influences on Homer's development" and proposed that the artist's "refinements of spacing and proportion" in such late works as *The Fox Hunt* of 1893 reflected Japanese influence. See Weller, "Winslow Homer's Early Illustrations," *American Magazine of Art* (July 1935), 412–417, 448. A Japanese painting that may have been a source for *The Fox Hunt* is More Ippo's *The White Fox*, which shows a Japanese demon fox in the snow. Homer could have seen the painting in the Museum of Fine Arts, Boston. With reference to Homer's later work, Philip Beam has stated that "Homer had examined oriental paintings, and even done some pastiche studies in Japanese style" (Beam 1966, 162).

47. Nicolai Cikovsky kindly brought to my attention what appears to be the first comparison between Homer's work and Japanese prints in "The Fine Arts of Japan," *The Nation* 7, 16 July 1868. After a discussion of the freedom, truth, and decorative qualities of Japanese drawings, the writer noted: "To compare this for a moment with our own popular art: the recently published cuts after drawings by Mr. Homer are remarkable for the freedom of drawing they display, for the vigor of gesture and general truth of action of the various figures. If one can imagine a whole race of artists taking after Mr. Homer in these good qualities of his work—for instance, the designers of the illustrations in the *Ledger* on the one hand, and those of the title-pages of popular music on the other—he can also understand that it would seem evident that some common influence would be discoverable which would sufficiently account for

the strong resemblance. And that is precisely the case in Japanese picture-making, in which manifestation of human intelligence there is to be seen a most extraordinarily diffused power over subjects of art generally considered difficult."

By the 1870s comparisons between Homer and Japanese art had become relatively common. On 17 February 1876 an anonymous reviewer for *The Nation* wrote: "It is such a beautiful thing to tell these healthful stories with all the simplicity, all that confinement to the idea, which we find in Japanese artists, that we can only mourn the loss of the fine painter Mr. Homer would be if he could give us the developed painting instead of the sketch impression." A year later, on 14 February 1877, another unsigned article in *The Nation*, devoted to the Eleventh Exhibition of the American Watercolor Society, mentioned that the year before Homer had produced "some powerful effects of the blotchy order, some abrupt eulogiums of Japanese fan painting, some cries of irreconcilable color, that excited the liveliest attention of the public." Sixteen months later an anonymous critic for the *Appleton's Art Journal* (August 1878) called Homer's painting *Upland Cotton* "a remarkable penetration of Japanese thought into American expression," and described it as "a superb piece of decoration, with its deep queer color like the Japanese, dull greens, dim reds, strange neutral blues and pinks." An article on "Artists and their Work—Pictures in the Academy," *New York Times*, 9 April 1880, 5, discussed Homer's *The Camp Fire* of 1880, now in The Metropolitan Museum of Art, saying, "What is most striking about the picture—and Mr. Homer is always sure to avoid the stupidity of mediocrity, even if he makes many misses—is the treatment of the sparks from the campfire. With a boldness which emulates Japanese draughtsmen (who sometimes make lightning proceeding from a cloud in the shape of bamboo running at right angles to each other), Mr. Homer follows the airy trail of the sparks from his campfire, and gives at length and in full, against the dark background, what the eye only sees for a moment and in motion." Albert Ten Eyck Gardner may have known of this passage when he wrote of *Camp Fire* that: "The treatment of the figures in their rustic rightness is absolutely in the style of Hokusai. The novel and daring design of the sparks flying up from the fire recalls Japanese prints of fireworks at night. The delicate pattern of weeds that lean out of the darkness towards the flames are so Japanese in feeling and yet so true to the realistic American woodsman's vision" (Gardner 1959, 53-54). On 20 June 1882, in a collection of "Art Notes," the *New York Times* juxtaposed a paragraph on the waywardness and unexpectedness of Japanese art with a paragraph on Winslow Homer.

48. *Harper's Weekly*, 22 February 1868, reproduced in Beam 1979, 157, and in Gardner 1961, 117. Homer included some whimsical Japanese elements in an undated wash drawing (Cooper-Hewitt Museum), probably made in 1876 at the time of a large display of Japanese art in Philadelphia at the Centennial Exposition. Depicting "an International Tea Party" in which Miss Japan and Mr. China entertain Mr. and

Mrs. Uncle Sam in a vaguely Japanese interior, the drawing represents a few Japanese items and is spotted here and there with imitation oriental seals and inscriptions in a manner that parodies Japanese ink paintings and prints.

49. Gardner 1959, 32; Gardner 1961, 93.

50. Walsh 1965, 15. His statements have been repeated by Novak 1969, 166 and 310 n. 6.

51. See David J. Bromfield, "The Art of Japan in Late Nineteenth-Century Europe: Problems of Art Criticism and Theory" (Ph.D. diss. Leeds University, 1977), 229-234; and Phyllis Anne Floyd, "*Japonisme* in Context: Documentation, Criticism, Aesthetic Reactions" (Ph.D. diss., University of Michigan, 1983), 111-114.

52. Ernest Chesneau declared in 1878 that "En 1867 l'Exposition universelle acheva de mettre le Japon à la mode." Ernest Chesneau, "Le Japon à Paris," *Gazette des Beaux-Arts* 18 (1878), 387. In 1868 the Goncourts confided to their journal that the taste for Japanese art had descended to the middle classes (Gardner 1961, 102). At the time of the Exposition, Chesneau wrote an important study of Japanese art that was published in three forms, in *Le constitutionel*, 14 January, 22 January, and 11 February 1868 [copy in the Library of Congress]; in *Les nations rivales dans l'art* (Paris, 1868); and in *L'art japonais—discours fait à l'Union des Beaux-Arts* (Paris, 1869).

53. Henry Adams, "John La Farge's Discovery of Japanese Art: A New Perspective on the Origins of Japonisme," *Art Bulletin* 67 (September 1985), 449-485.

54. Novak 1969, 166, maintains that "there are sufficient indications in Homer's work before 1867 that he was either already familiar with Japanese prints or had arrived, through his own printmaking experience, at similar formal solutions." Unfortunately, the example she cites, *The Morning Bell*, is now known to date from 1872 rather than 1866 (Hendricks 1979, 90). But Novak's general observation remains valid. Although Gardner cited a skating scene by Homer made shortly after his return from Paris as proof of his recent discovery of Japanese prints (Gardner 1959, 50; Gardner 1961, 115), Hendricks has pointed out that the same Japanese mannerisms occur in a similar skating scene published in *Harper's Weekly* on 13 January 1866, just before the trip to France (Hendricks 1979, 75).

55. Significantly, in two contemporary references to the Japanese character of Homer's work (note 47), it was not the composition but the unusual color harmonies that the writers singled out as "Japanese." Some of Homer's later paintings also employ color effects that specifically evoke Japanese prints. His *West Point, Prout's Neck* (Sterling and Francine Clark Institute, Williamstown), contains a sunset the intense reddish hue of which resembles the red aniline dyes that were often employed in later Japanese landscape prints.

56. John La Farge, "Japanese Art," in Raphael Pumpelly, *Across America and Asia* (New York, 1870), 201. La Farge's discussion in this same essay of the occult compositional balance found in Japanese art may

also have influenced Homer. Homer often exploited this form of arrangement, perhaps most dramatically in his late masterpiece, *Right and Left* of 1909, in which the precarious balance of the composition rests, quite literally, on the placement of the floating pin feather on the right hand side.

57. Russell Sturgis, *The Galaxy* 4 (1867), 238.

58. Curiously, these American artists shifted back to a darker palette in the 1870s.

59. Cecilia Waern, *John La Farge: Artist and Writer* (London, 1896), 11–12.

60. Royal Cortissoz, *John La Farge: A Memoir and a Study* (Boston, 1911), 112–113.

61. [George Sheldon], "Sketches and Studies, II," *Art Journal* (April 1880), 105–109, reprinted in G. W. Sheldon, *Hours with Art and Artists* (New York, 1882), 136–141. The phrasing of these remarks seems more flowing and articulate than that found in Homer's correspondence or in other interviews. Sheldon may have recast the artist's statements somewhat, drawing on notes he had made during an interview, but the substance of the remarks probably accurately reflects Homer's views.

62. The painting belonged to Mrs. Edwin S. Webster, who owned several other major paintings by Homer, including the last of his croquet scenes. Nearly all the paintings in the collection seem to have been purchased directly from the artist. This work was illustrated on the cover of the Parke Bernet catalogue of 21 April 1977, under the title "Prout's Neck," but was withdrawn shortly before the sale.

63. In my doctoral dissertation, "John La Farge, 1835–1870: From Amateur to Artist" (Yale University, 1980), 286, I attributed this painting to La Farge. The close resemblance of the painting to La Farge's work of this period makes it clear that if not by La Farge himself, it was created by an artist close to him. James Yarnall has ingeniously proposed that it was painted by Homer while on a sketching excursion in Newport with La Farge and Vedder, an episode that La Farge may have referred to in his book *Considerations on Painting*. See Yarnall, "John La Farge's 'Paradise Valley Period,'" *Newport History* 55, pt. 1 (Winter 1982), no. 185, 6–25. Yarnall does not discuss the stylistic qualities of the painting, and while it

bears a general resemblance to the work of Homer, it is not easy to cite a documented painting by Homer from the 1860s that possesses similar stylistic qualities. Perhaps the unusual qualities of the painting are related to the unusual circumstances under which it seems to have been created. The painting does not appear to be by any other artist in La Farge's circle, and thus, through a process of elimination, it should probably be attributed to either Homer or La Farge.

64. Even Homer's largest and most carefully planned paintings were often painted outdoors. Philip Beam asserts that Homer painted *The Fox Hunt* of 1893 outside in the snow (Beam 1966, 108–110). There is also strong evidence to suggest that Homer made a practice of painting outside at night, a procedure that entails enormous technical difficulties. George Sheldon stated of Homer's *Adirondack Camp-Fire* of 1880 (The Metropolitan Museum of Art) that: "He painted it out-doors. . . . The composition is a general transcript of the surroundings of a fire lighted one night while he was camping in the Adirondacks" (Sheldon 1882, 107). William Howe Downes stated that Homer's *Moonlight, Wood Island Light,* of 1894 (The Metropolitan Museum of Art), was created in "four or five hour's work," and that "like his other moonlight pictures, it was painted wholly in and by the light of the moon, and never again retouched" (Downes 1911, 173). David Tatham has brought to my attention a letter by J. Ernest G. Yalden in The Memorial Art Gallery, Rochester, New York, written on 30 September 1936, which describes Homer's watercolor *Paddling at Dusk* of 1892. According to Yalden, Homer "was particularly interested in the broad flashes of light from the paddle when under way after dark; and this picture was painted when it was almost dark. . . . It has always been a puzzle to me how he was able to get the effect he did when it was almost too dark to distinguish one color from another." Philip Beam has doubted that it would have been possible for Homer to paint at night (Beam 1966, 89–90), but the existence of several independent accounts making this claim suggests that he did so, at least to some degree.

65. "The American Section: The National Art," *Arts and Decoration* 3, 1 March 1913, 159.

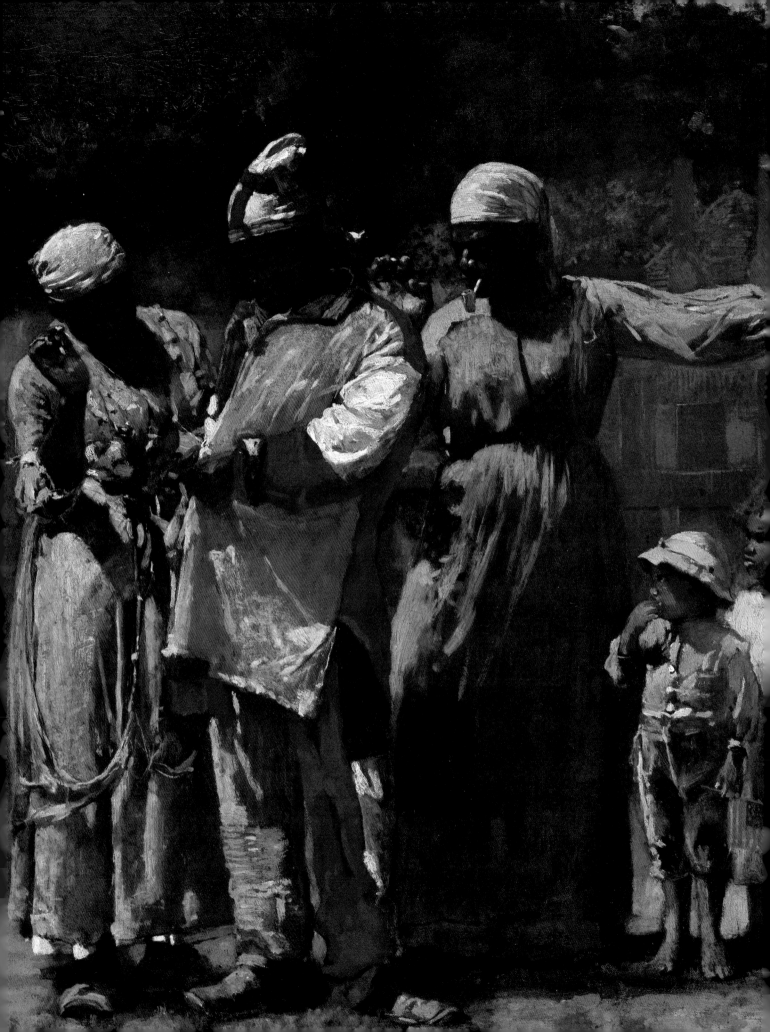

DAVID PARK CURRY
Virginia Museum of Fine Arts

Winslow Homer:

Dressing for the Carnival

Among the most complex studio oils painted by Winslow Homer during the 1870s, *Dressing for the Carnival* (fig. 1) reveals the artist's ability to create a multivalent work closely related to political, cultural, and artistic events of his day. The picture is an unusual work. Painted just at the time Homer was switching from idyllic and fashionable subjects to deeper, darker themes, *Carnival* gathers up many threads in Homer's changing oeuvre.

The central figure is a black man. While a group of children watch, two ragged women sew the final bits and patches onto the man's Harlequin costume. Homer was not the first major American artist to choose a black subject. Nor is *Dressing for the Carnival* Homer's first or last word on the matter, as numerous early prints, mature oils, and watercolors attest.[1] *Carnival* can be considered, however, a key image in Homer's post-Civil War painting campaign.[2]

Unfortunately, emancipation notwithstanding, black Americans had made little social or economic progress by the time of Homer's travels to Virginia. The status of American blacks is reflected in American art. In the well-known portrait of *Charles Calvert*, painted by John Hesselius in 1761 (Baltimore Museum of Art), young Charles is accompanied by an equally youthful but unnamed slave. Two centuries later an anonymous freeman stands in the back of the boat, providing muscle for his white companion in Thomas Eakins' *Will Schuster and Blackman Going Shooting for Rail*, 1876 (Yale University Art Gallery). Neither Hesselius nor Eakins bothered to record the black models' identities.

As might be expected, politically conscious depictions of blacks help illustrate the Civil War period. *Marching Through Georgia*, 1865 (fig. 2), is by Thomas Nast, better known for his scathing cartoons of political corruption. Histrionic gestures reduce Sherman's devastating march to the stuff of melodrama: haughty Southern belles scorn a Northern officer's polite inquiries, as grateful ex-slaves slip gifts of food and flowers to the Yankee troops. Nast recorded every type that we find in Homer's much more eloquent, understated images of the Civil War: officers, belles, blacks, even the exotically costumed Zouave.

Edwin Forbes painted *Contrabands* (private collection) in 1866.[3] The title is taken from mid-nineteenth century slang for runaway slaves. But these would-be fugitives are not running—they are shuffling. One plods forward, hands in pockets, the other slumps dejectedly on an equally dispirited mule. The only living creature with any spunk is a small mongrel dog. This dreary, monochromatic picture is compromised by the tendency toward caricature and stereotype that marred many of our Civil War images of blacks.

Detail fig. 1

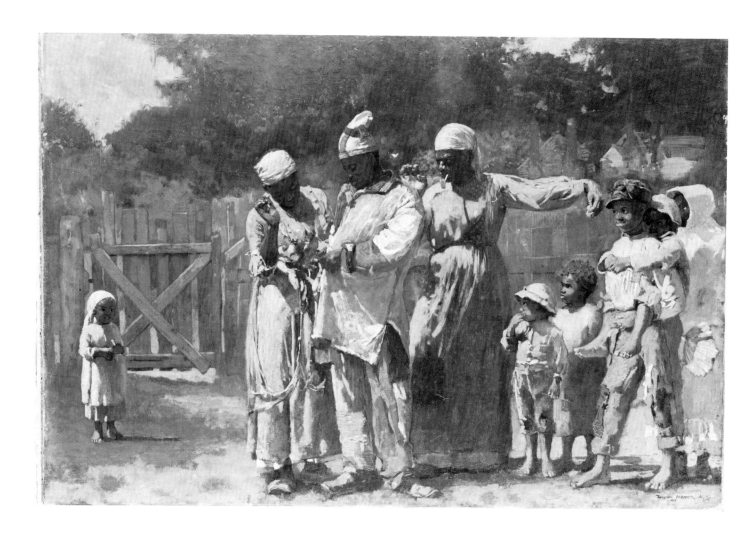

1. Winslow Homer, *Dressing for the Carnival*, 1877, oil on canvas, 50.8 x 76.2 (20 x 30)
The Metropolitan Museum of Art, Lazarus Fund

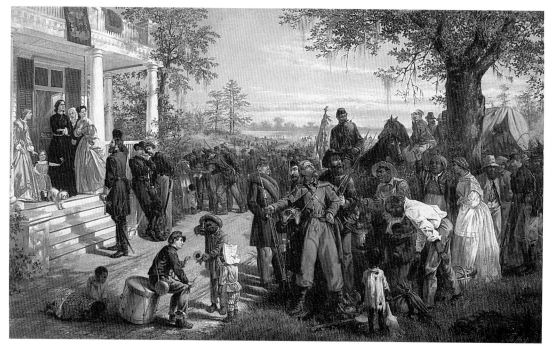

2. Thomas Nast, *Marching Through Georgia*, 1865, oil on canvas, mounted on panel, 125.7 x 201.9 (49½ x 79½)
Private collection

3. Winslow Homer, *Our Jolly Cook (Campaign Sketches)*, 1863, lithograph, published by L. Prang and Company, Boston, 27.9 x 22.5 (11 x 8⅞) National Gallery of Art, Washington, Rosenwald Collection

It is not hard to see, by contrast, why the literature credits Homer for treating his black subjects with dignity and restraint. Homer's version of *Contraband* (Canajoharie Library and Art Gallery), a watercolor from 1875, is a gentle vignette, showing a Zouave sharing a drink with a little boy. Homer used the same young black model who appears in *Taking a Sunflower to Teacher* (fig. 10). Caricature is absent, although, to be fair, we should remind ourselves that Homer did not entirely escape satirizing his black subjects. *Our Jolly Cook* (fig. 3), a lithograph made in 1863 for popular consumption, is one case in point. But more important for the

present discussion is another reminder: Homer did not see his black subjects as individuals. They are types.[4]

First exhibited in 1878, Homer's *Dressing for the Carnival* was almost immediately recognized as "remarkably strong," and an excellent study of character.[5] That year, a writer for *Art Journal* found that "total freedom from conventionalism and mannerism," a "strong look of life," and a "sensitive feeling for character" made Homer's images of blacks "the most successful things of the kind that this country has yet produced."[6]

We must take the critic's comments regarding conventionalism with a grain of salt, for Homer's work was being compared to caricaturized depictions of blacks common at the time, and as we shall shortly see, certain artistic conventions have a great deal to do with the power of this particular studio canvas. But Homer's *Carnival* is indeed sensitive and successful. It has lost none of its impact during the more than one hundred years since it was first exhibited.

When Homer undertook his midcareer series on blacks, he chose to return to familiar territory, the area around Petersburg, Virginia, where he had already sketched as a war correspondent. Petersburg was shelled in 1864 and 1865, and one of the worst battles of the Civil War took place nearby. Homer's decision to go back to an area he already knew, and to create a series of black paintings that recorded already disappearing local customs, reflected a general post-Reconstruction desire for national subjects in American art.

Homer gives us a glimpse of old slave cabins (fig. 4) in the upper right-hand corner of *Carnival*. But despite the humble setting, a festival is about to take place. A witness account of the early 1870s noted, "The Virginia negro has almost the French passion for *fête*-days."[7] Homer depicted a dying custom: Boxing Day, the day after Christmas. During the slave-holding era, Boxing Day was one of just a few annual holidays when most slaves were excused from work. Some would dress in fancy costumes and were allowed to go round to the "big houses" performing and begging for little Christmas gifts and tips. Although

such Southern customs survived the Civil War and emancipation, they were considered rural and unsophisticated. *Christmas in the South—A Suggestive Visit to the Old Family* (fig. 5) was the subject of a quaint *Harper's* illustration of 1885. The text stresses old ways and bygone days.[8]

Carnival contains figures that are emblematic of the aggressive search for "types" undertaken by mid-nineteenth-century journalists. The search is amply documented in Edward King's exhaustive series, "The Great South," which first appeared in *Scribner's Monthly* in 1873 and 1874—that is, just before Winslow Homer made his trip to Petersburg. The articles were heavily illustrated. Typical is an image of a New Orleans market, with the caption, "One sees delicious types in these markets" (fig. 6).

Types in Homer's *Carnival* include black children born after the Emancipation. Homer's treatment of black children was not significantly different from journal illustrations of the period (fig. 7). Two boys in Homer's painting carry little American flags, especially meaningful symbols of national unity following the Civil War. Made about 1880, a mechanical toy of a kneeling

4. Slave cabins
From *The Pageant of America: A Pictorial History of the United States*, vol. 3, ed. Ralph Henry Gabriel (New Haven, 1926), 150, fig. 317

black with flag and bell was called a "Freedom Bell Ringer" (fig. 8). It expresses the same patriotic sentiment as the flags in Homer's painting.

One of Homer's little flag-holders is carried by a taller lad in whose visage Homer narrowly skirts a stereotypical thick-lipped treatment of the black male. The tall boy is old enough to have been born a slave.

5. William Ludwell Sheppard, *Christmas in the South—A Suggestive Visit to the Old Family"*
Harper's Weekly, 12 December 1885

6. James Wells Champney, *One Sees Delicious Types in these Markets*, wood engraving

From Edward L. King, *The Great South: A Record of Journeys in Louisiana, Texas, The Indian Territory*, 2 vols. (Hartford, 1875), 48

7. James Wells Champney, *Peeping Through*, wood engraving

From King 1875, 453

This child could well grow up into a type despised: the "future politician" scornfully depicted by various illustrators.[9] This ignorant fellow's vote could be purchased by unscrupulous carpetbaggers, as was continually decried in the press and given graphic immediacy in such images as *Southern Types: The Wolf and the Lamb in Politics* (fig. 9), from Edward King's "The Great South."

During the 1870s, education was considered a significant antidote to the political exploitation of ignorant blacks. This is important for an understanding of *Dressing for the Carnival* within the larger context of paintings executed by Homer in that decade. Homer's black paintings coincide with another series of his—the schoolhouse series—seen by Nicolai Cikovsky as Homer's attempt to select "thoroughly national" subjects.[10] At the time Homer took up the subject, female teachers had just achieved new prominence in American

school systems. A female teacher was thought to exert a civilizing influence on her charges:

She softens the rude, encourages the dull, and teaches not only the elements of knowledge, but those habits of obedience, order, cleanliness, and propriety by which the characters of her scholars are ever afterward influenced. The children of all classes yield to her educated power. . . . The power of the teacher is greater than that of lawgivers or those who execute the laws.[11]

Cikovsky notes that the schoolhouse images "all seem to have had their source in a single experience. Where it occurred, however, or exactly when, we do not know." He adds, "the school paintings may not have been made entirely on location, but assembled later in his studio from studies and sketches."[12] Like the schoolhouse series, the black paintings seem to stem from a single experience, the details of which are somewhat vague. It seems possible, however, that Homer made just a few trips to the Petersburg area in 1874–1875.[13] As in the schoolhouse series, the central pictures of Homer's black campaign are studio works. Thus, not only the artist's general desire for national subject matter but also his working methods, as well as the specific issue of changes in American education, link these two painting campaigns.

Homer's *Taking a Sunflower to Teacher* (fig. 10) was painted in 1875. *Sunflower* shows yet another type, "the ragged urchin with his saucy face" (fig. 11). During and after the reconstruction period, liberals hoped that widespread education for blacks would be instrumental in transforming urchins into useful citizens.[14] Southern blacks had not been encouraged to read in the decades preceding the Civil War. Indeed, teaching a black to read and write was a criminal offense in Virginia between 1831 and 1865.[15]

Homer's *The Country School* of 1871 (St. Louis Art Museum) and *Sunday Morning in Virginia* of 1877 (fig. 12), both address the subject of reading. At the same time that white schools were changing, the topic of black literacy had come once more to pub-

8. *Freedom Bell Ringer,* c. 1880, painted metal, fabric, Gong Bell Manufacturing Company, East Hampton, Connecticut
Collection Bernard Barenholtz; photograph courtesy of Harry N. Abrams, Inc.

9. James Wells Champney, *Southern Types: The Wolf and the Lamb in Politics,* wood engraving
From King 1875, 784

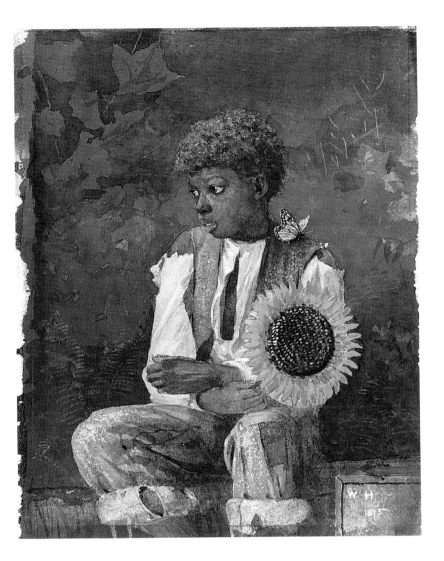

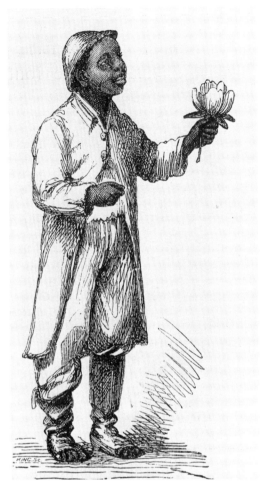

10. Winslow Homer, *Taking a Sunflower to Teacher*, 1875, watercolor on paper, 17.8 x 14.9 (7 x 5⅞) Georgia Museum of Art, The University of Georgia, Eva Underhill Holbrook Memorial Collection of American Art, Gift of Alfred H. Holbrook

11. James Wells Champney, *The Ragged Urchin with His Saucy Face*, wood engraving From King 1875, 114

lic attention. According to a journalist in 1872, "the capture of the common schools" by female teachers was "one of the most vital changes wrought by our great civil war."[16] Simultaneously, education became more widely available to blacks, and Virginia was a leader in black education.[17] Normal schools educated "Colored teachers for the Southern States." Many of the new black teachers were women.[18] A writer for *Harper's Monthly* in 1874 commented that black teachers would be "the most efficient and trustworthy [and] acceptable, missionaries to the people of their own race."[19] In Petersburg, Virginia, site of *Dressing for the Carnival*, schools were "noteworthy examples of Virginian prog-

ress since the war, and merit the warmest encomiums," according to Edward King.[20] Petersburg founded its free school system in 1868.

The benefits of education were perceived as immediate. Black students observed in a Virginia schoolhouse in 1874 were found to be "remarkably docile, orderly, and well-mannered, without a trace of the barbaric squalor and rudeness pertaining to the street-corner brat of former days."[21] The observer went on:

just after the war, they were discouragingly rude, unmannered, and disorderly, loud, coarse and given to brawling and fighting. Judicious discipline and the civilizing influence of books have already wrought a marked and radical

12. Winslow Homer, *Sunday Morning in Virginia*, 1877, oil on canvas, 45.7 x 61.0 (18 x 24)
Cincinnati Art Museum, John J. Emery Endowment

13. Winslow Homer, *Kept After School*, 1873, oil on canvas mounted on board, 23.9 x 36.2 (9⅜ x 14¼)
Private collection; photograph courtesy of Amherst College

change. A more decent, orderly, polite, and self-restrained collection of young people can not now be seen anywhere.[22]

Gradually, the rod as punishment was renounced in American education. Homer was aware of that development, and captured it in an oil painting of 1873, *Kept After School* (fig. 13). Homer made a related wood engraving as well.[23] The humane approach to the punishment of naughty children applied to black as well as white scholars, as is evident in E. L. Henry's 1888 image of a little black girl being *Kept In* (fig. 14).

Homer's political message in *Carnival* is informed by an awareness that education, finally made available to blacks after the war, would be an important path toward their eventual self-sufficiency. The picture includes a tiny girl at the far left, clutching a candy stick—certainly a holiday privilege in so poverty-stricken an environment—yet she is isolated from the rest of the group. The gate between the little girl and the rest can be considered a metaphor for choice.[24] But the gate is closed; the path is weedy. We don't know what lies beyond the gate for this solitary little girl. She may get no further than to labor in one of the many tobacco factories that made up the single most important employment source for blacks in the Petersburg area (fig. 15). Or perhaps she will have the opportunity for schooling.

Like the children, the grownups in Homer's *Carnival* are types. Two women are sewing, although they are not engaged in the fancy work of a fine lady, as sometimes depicted in eighteenth-century portraiture. The woman on the clown's left is obviously a former slave. We can deduce this from her age, of course, but also from her soft, rounded, submissive pose, with head bent down and gaze averted.

14. Edward Lamson Henry, *Kept In*, 1888, oil on canvas, 31.8 x 43.2 (12½ x 17)
New York State Historical Association, Cooperstown

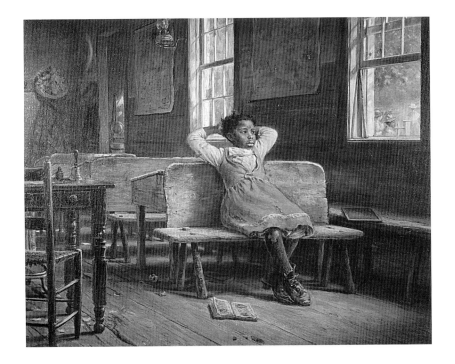

The other woman is a fearsome character. She clenches a pipe in her teeth, frowns, and stitches vigorously.[25] Possibly Homer wished only to contrast two types of former slave: strong and weak. But a high proportion of free blacks before the war made Petersburg's population atypical.[26] The free black population was predominantly female. Suzanne Lebsock wrote, "from the early part of the century through 1860, Petersburg was a town in which well over half of the free black households were headed by women." Lebsock added:

we are confronted [in Petersburg] . . . with the dual image of strength and exploitation. Women were prominent among free blacks; they outnumbered the men three to two . . . and they constituted almost half of the paid free black labor force. Yet this was all the product of wretched poverty and persistent dis-

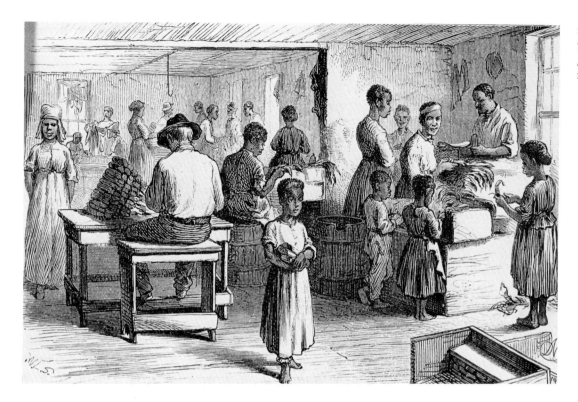

15. James Wells Champney, *Scene in a Lynchburg Tobacco Factory*, wood engraving
From King 1875, 557

crimination. The 'matriarch' and the victim, it turns out, were usually the same woman.[27]

Even in the face of new repressive measures designed to slow emancipation after 1806, a third of the slaves liberated through purchase in Petersburg, 133 out of 410, were emancipated by free blacks. These monies were hard earned indeed, and one of the most common means of gainful employment for the free black woman was sewing.[28]

In contrast to the drab clothing of the two women flanking him, the festively garbed central figure in *Dressing for the Carnival* stands out brightly. He is Harlequin, an easily recognized commedia dell'arte figure, a servant, the iconic underdog. Harlequin is a "shrewd but ignorant valet who serves lovers and cheats old men. A capering, clumsy, credulous clown, a rogue, a rake, a blundering, inept fool. Greedy, ribald, charming, impulsive, malicious, melancholy. . . . Harlequin, like his patchwork costume, is a puzzle."[29]

Surrounded by women and children in Homer's picture, Harlequin is the only adult male. He holds in his mouth a carnation, whose name derives from the same Latin root as the word "carnival." In Victorian flower symbolism, the deep red carnation signified "alas for my poor heart."[30] Alas indeed. The status of the post-Civil War black man was most precarious, as Joseph Decker's ominous picture, *Our Gang* (fig. 16), makes clear. His future was as fragile as the little flower Homer's Harlequin holds gently between his lips.

Homer has deliberately kept Harlequin enigmatic, yet we do know that his chances for gainful employment were not very good. As one journalist observed, "necessity . . . may prove a sterner master than those from whom his race have recently been liberated."[31] When Homer got off the train at Petersburg, he would have been confronted by a swarm of blacks trying to make a living by selling travelers' wares, not to mention "the hackmen who shriek in your ear" vying for business between the city's railroad stations (fig. 17). A witness account, written in 1904 about Petersburg in the 1850s, describes one of these taxi drivers:

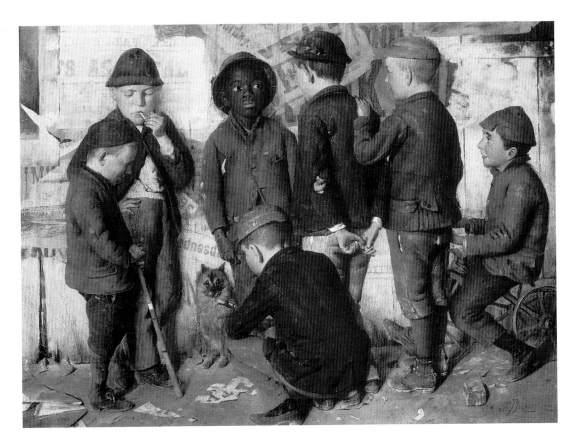

16. Joseph Decker, *Our Gang*, 1886, oil on canvas, 61.0 x 77.8 (24 x 30⁵/8) Collection, Mr. and Mrs. H. John Heinz III

17. James Wells Champney, *The Hackmen Who Shriek in Your Ear as You Arrive at the Depot*, wood engraving From King 1875, 581

The driver was one Henry, a sable personage, but a master of the reins, and with evident pride in his exalted position on the box. I have seen him recently on our streets but age and freedom have evidently not dealt very kindly with him, and one would hardly recognize in his attenuated form the stately [figure] who rattled his pampered team over our rough pavements fifty years ago.[32]

Cotton factories in the Petersburg area employed whites only, and most blacks found themselves working in the tobacco industry, or eking out livings as farmers.[33] Under the circumstances, it is little wonder that the custom of costumed Christmas begging survived into the twentieth century, particularly in the least urban areas.

Homer's black Harlequin wears an outfit that is a curious affair of strips as well as patches. The earliest engravings of Arlecchino, the original commedia dell'arte figure, show him as "a thing of shreds and patches," but by the early seventeenth century his costume was already becoming

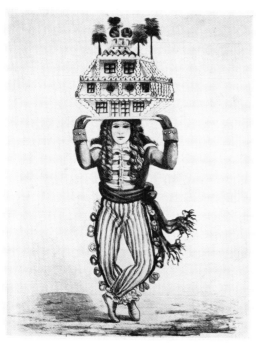

JOHN CANOE, A POPULAR CHRISTMAS MUMMER IN KINGSTON AND OTHER JAMAICA TOWNS

stylized into the now-familiar ensemble of red, blue, and green diamonds separated by narrow yellow braid and topped with a pointed hat.[34] Homer would have known the traditional costume, but the ensemble he witnessed in Virginia was not that of a purely European Harlequin. In this complicated studio picture, Homer has recorded dress in which African as well as European influences are at work.

Torn strips, worn by the tallest boy as well as the man in Homer's picture, are intended to hang and to flutter when the wearer dances. Homer's group is preparing for some kind of dancing and begging ceremony, one that had survived as discussed above, and one that quite naturally reflected an African heritage. Costumes made of rags were characteristic of Caribbean dance figures, called "Pitchy Patchy" in Jamaica, and "Pierrot Grenade" in Trinidad. The characters are also sometimes given the generic name "Rag Man." Strip costumes can be traced in part to ceremonial garb of various African tribes and

would have been brought west as a result of the slave trade.

Judith Bettelheim's exhaustive research on the subject suggests that "Caribbean vegetal costumes [that is, bunches of leaves] and their more contemporary shredded cloth variety can be viewed as a trans-Atlantic extension of at least Senegambian and Guinean ritual characters."[35] Strip costumes were recorded by the Jamaican lithographer I. M. Belisario in 1837, as part of a Christmas-season dance ceremony, the Jonkonnu or Johnny Canoe (fig. 18).[36] Although they were performed during a Christian celebration, costumed Jonkonnu dances evolved as a secular festival that planters allowed the slave class during the Christmas holidays, when work was suspended.[37] Bettelheim has traced the Jonkonnu trail to North Carolina, where it becomes somewhat cold. Variants on the tradition of costumed begging are recorded in rural Virginia, however, and the ensemble of patches and strips that Homer beheld near Petersburg are quite probably related to Jonkonnu.[38]

Costumes like the one in Homer's *Carnival*, then, are a blend of African and European tradition. "Pitchy Patchy" was also related to an ancient English character, "Jack in the Green," who appeared on May Day and was imported to Jamaica by British rulers. Bettelheim suggests, "perhaps the vegetal figure is the potent example of a parallel artistic tradition in which both the rulers and the suppressed could participate, one as a spectator, and the other as the actor. Each class felt the figure incorporated a part of its own cultural heritage."[39] Such strip costumes have survived in the Caribbean to the present day (fig. 19).

Richness of symbolism helps to invest Homer's painting with profundity. The degree to which he perceived the African-American nature of his subject is open to speculation. Yet, whether innocently or artfully, Homer filtered his ethnic data through traditions with which he was more familiar. The year before Homer painted *Dressing for the Carnival*, William Merritt Chase exhibited *Keying Up—The Court Jester*, 1875 (Pennsylvania Academy of the Fine Arts) to much critical acclaim at the

18. I. M. Belisario, *Jonkonnu Performer in Whiteface*, 1837, lithograph

From Richardson Little Wright, *Revels in Jamaica, 1682–1838* (New York and London, 1937), 19

Centennial Exhibition in Philadelphia.[40] Chase's success might have prompted Homer's choice of subject. But the dire economic and social state of the Southern black leads us to consider *Carnival* not as a painterly witticism, but as a deadly serious political statement.

Homer chose to paint black types within an art historical context. Like the urban vagrants, itinerant performers, and wandering gypsies in Manet's *The Old Musician* (fig. 20), the blacks in *Dressing for the Carnival* line up into a tableau of social misfits. Homer has masked national topicality and local subject matter with more wide-ranging references to pre-Lenten carnival and its political overtones in the post-Civil War South. During his Parisian sojourn in the late 1860s, Homer would have become acquainted with the excesses of the Parisian carnival, its masked balls and social intrigues. Colorful Arlequin and Polichinelle costumes were popular and are recorded in paintings such as Manet's *Ball of the Opera* of 1873 (National Gallery of Art), and many masked ball prints by Gavarni.[41]

19. *Pitchy Patchy*, 1975, street performer, Savanna-la-Mar Troupe, Jamaica
Photograph by Judith Bettelheim

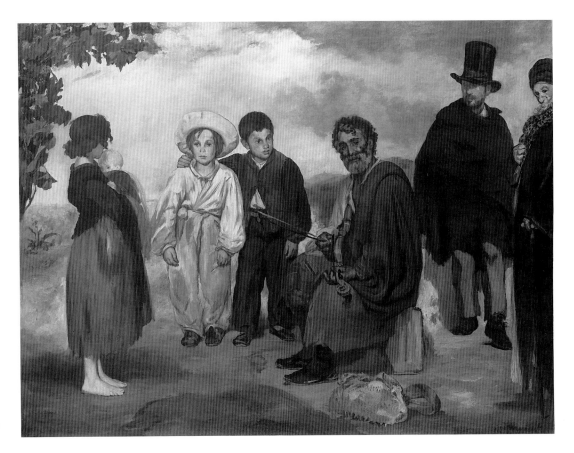

20. Edouard Manet, *The Old Musician*, 1862, oil on canvas, 187.3 x 248.3 (73³/₄ x 97³/₄)
National Gallery of Art, Washington, Chester Dale Collection

21. Honoré Daumier, *La Parade (La parade forain)*, 1860s, crayon, traces of sanguine and watercolor, 26.6 x 36.7 (10½ x 14½) Musée du Louvre, Cabinet des Dessins

In *Dressing for the Carnival* Homer recalls the "Parade," the moment before the show as captured by Daumier and other French artists (fig. 21).[42] Once the two women finish stitching his costume, Homer's black clown will be off, capering, dancing, enticing money from his more economically powerful observers. This solemn clown symbolizes a hard life.

The theme of the sad clown, a legacy from eighteenth-century French art, informs *Dressing for the Carnival*. Not surprisingly, contemporary counterparts to Homer's image exist in France.[43] Daumier's *A Saltimbanque Playing a Drum* (fig. 22) is part of his series from the 1850s and 1860s. Like the central figure in the Homer picture, the saltimbanque wears a costume that is a patched-together echo of the commedia dell'arte character, Harlequin. It has been noted recently that French saltimbanques represented "a marginal and precarious existence," which

22. Honoré Daumier, *A Saltimbanque Playing a Drum*, c. 1863, ink and watercolor, 35.5 x 25.5 (14 x 10) Courtesy of the Trustees of the British Museum

Henry James called "symbolic, and full of grimness, imagination, and pity."[44] Images of saltimbanques sometimes hid a political message. Daumier's drummer has lately been read as a "veiled attack on the French government's manipulation of elections."[45] The parallel between the French work and the American one is clear: Homer's clown can be understood partially as the Lord of Misrule, referring through Carnival symbolism to corrupt reconstruction politics in the South.

As one might surmise, Carnival in the Southern states was essentially a French transfer, particularly at New Orleans, where the papier-mâché masks were actually built in France until 1873.[46] The New Orleans Carnival, like its Parisian counterpart, had a somewhat unsavory reputation. As in France, masked balls encouraged loose behavior. In 1857, a writer for the *Picayune* admitted, "When the band was playing 'Jordan is a Hard Road to Travel' [I] took up with a female mask in the costume of Pocahontas, and found the traveling very easy."[47]

Loose behavior prompted a series of civic measures designed to exert a degree of control over the revelers. Masking by black people was prohibited as early as 1781 by legislators, who literally feared masked robbers.[48] Efforts to control, sometimes to forbid, masking in general, as well as various complicated requirements for dancing permits, mark the history of Carnival during the first half of the nineteenth century. When rules were most stringent, revelers found it expedient to proceed without license and afterwards to pay a moderate fine.[49]

A newspaper described some of the rowdy festivities in 1859. We clearly see that blacks were sometimes the victims of practical jokers during Carnivals:

All the . . . boys were out in . . . cheap harlequin and clown disguises, with bags of flour, whitening each other and the negroes, and leaving their floury tracks. . . . The grown-up jolly boys galloped . . . up the town and down, dressed and painted as Bedouin Arabs, Indians, Turks, Chinese, Venetian cavaliers, and African negroes. Groups of ludicrous maskers of all conceivable descriptions went flying around in cabs, buggies, furniture wagons, and car-riages. All the courtesans in town appeared to be out; many in male costume of all kinds, from that of the Canal Street dandy to the rollicking drunken sailor of Gallatin Street.[50]

Intimations of role-reversal and social control pervade this account. Through disguises, some whites briefly became members of ethnic groups they despised or feared. But blacks were not supposed to mask, and indeed the black face of Homer's Harlequin remains uncovered. His clown disguise will not change his social status, even temporarily.

In 1857, with the advent of the Mystick Krewe of Comus, a private club of New Orleans aristocrats, thematic parades and *tableaux vivants* became part of the New Orleans Carnival. Particularly after the Civil War, Carnival became a vehicle for expressing political discontent. Under a frankly corrupt reconstruction government, Louisiana was readmitted to the Union on 25 June 1868. The following year during Mardi Gras, "The carpet-bagger, with his newspaper and his bag, remained the favorite costume character on the streets" (fig. 23).[51]

We need not reconstruct the history of reconstruction to illuminate the political nature of Homer's painting. But it is germane to our discussion that in 1873, only a few years before Homer traveled to the South, the Mystick Krewe of Comus gained national press coverage by staging an elaborate parade titled "Missing Links to Darwin's Origin of Species," intended to satirize the excesses of the Republican party.

Masks included faithful representations of political figures—walking political cartoons. President Grant, for instance, was portrayed as "The [tobacco] grub who essays the loftiest stalk" (fig. 24). Heralded by two "cars" or floats, the Darwin pageant was divided into groups: insects, fishes, reptiles, and so on. As each papier-mâché mask was completed, the design committee was called to the studio to test it, and particularly to recognize its features. If there was any doubt as to the countenance of a political character, the mask was rebuilt.

After the parade had wound through the streets of New Orleans, the *tableaux vi-*

23. *The Cunning Fox Which Joins the Coon*, c. 1873, costume design
From Perry Young, *The Mystick Krewe: Chronicles of Comus and His Kin* (New Orleans, 1931), pl. 11

24. *The Grub Who Essays the Loftiest Stalk*, c. 1873, costume design
From Young 1931, pl. 9

vants commenced at the Varieties Theater. According to one report:

they consisted of dissolving views, introduced by lighting effects. The depths of the sea were first exhibited . . . then the waters receded and the land appeared—a great mound surrounded by fruits, flowers, rodents, and insects, reptiles occupying the summit. On the topmost peak . . . writhed the Serpent—"author of all our woes." The serpent dissolved from view and the other animals of creation formed the . . . second tableau . . . wherein Gorilla was crowned king of all creation. . . . But before the imposing throne . . . unabashed by the Great Gorilla, stood Comus [the New Orleans aristocracy] . . . a sovereignty before which the new-crowned master of the world offered impotent contrast (fig. 25).[52]

The meaning of this sharply politicized pageant was not lost on the press. One reporter noted:

Last link . . . appeared the Gorilla; a specimen . . . so amazingly like the broader-mouthed varieties of our own citizens, so Ethiopian in his exuberant glee, so at home in his pink shirt collar, so enraptured with himself and so fond of his banjo, that the Darwinian chain wanted no more links. . . . We shall not kill the effect by pinning on a moral, having a steadfast faith . . . in the Survival of the Fittest.[53]

The triumph of the Southern black male during reconstruction was short-lived at best.

Homer probably did not know Manet's politically inspired color lithograph of Polichinelle (fig. 26). About fifteen hundred copies were destroyed by French police because the clown resembled the French president.[54] But also suppressed—soon enough—was the American black male. Manet's clown holds a baton, a significant implement in the commedia dell'arte,

25. *Comus Tableau,
Darwin's Origin of Species,*
1873, wood engraving for
Harper's Weekly
From Arthur Burton La Cour, *New
Orleans Masquerade* (New Orleans,
1952)

26. Edouard Manet, *Polichi-
nelle*, 1874, color lithograph,
45.4 x 30.3 (17⁷/8 x 11¹⁵/₁₆)
National Gallery of Art, Washington,
Rosenwald Collection

symbolic of potency, the tool with which
the character retains control. As Harle-
quin's attribute, the baton is called a slap-
stick, source of our present-day word for
silly comedy.[55] But Homer's picture is far
from amusing. This Harlequin has lost his
stick. He is a powerless, impotent figure,
a sad clown.

In understanding the importance of
Homer's picture as a political statement,
it would be a mistake to lose sight of its
power as an aesthetic object—a work of
art.[56] In sharp contrast to his spontaneous
plein-air watercolors of the 1870s, Homer
has staged *Carnival* as an extremely formal
composition, marked by broad gesture and
dignified bearing. Treating his humble
genre subjects with a sculptural monu-
mentality that borders on the academic,
Homer mixed high and low artistic con-
vention to temper the then somewhat con-
troversial subject, the pathetic state of
American blacks after the Civil War, with
a measure of control. We have seen how he
drew upon an established European formal
vocabulary, particularly the theme of the

sad clown and the ethos of the street as theater, to enrich local subject matter with lasting artistic impact.

Carnival also reflects Homer's awareness of mid-century theories of color and decoration, more often associated with his activities as a member of the Tile Club. Formed in 1877, the year in which Homer painted *Carnival*, the Tile Club was a group of prominent American artists who met to discuss the latest issues in decorative art and design theory, while painting on eight-inch tiles.[57] A few tiles survive, including Homer's image of a shepherdess (fig. 27). This tile, and others executed by Homer, relate closely to his bucolic watercolors of the 1870s, but here Homer flattened the figure, stylized it a little bit, and gave it pronounced, heavily outlined contours.[58] In other words, he conventionalized the image according to current canons of decorative design.

Of course, Homer's oil paintings were not stylized to the degree that his tiles were, but he chose a planar, architectonic arrangement for the figures in *Carnival*, which in combination with his rather sculptural, hard-edged treatment, gives Harlequin and his companions the glyphic aspect of a monumental architectural frieze.[59]

Homer's various interests in the 1870s are intertwined. We have examined his awareness of black education already, but should also note that the enormous blossom featured in *Taking a Sunflower to Teacher* (fig. 10) was the quintessential symbol of the Aesthetic Movement, which hotly debated design reform in both England and America. Images of sunflowers often appear in American pictures of blacks, but our efforts at interpretation are enhanced by recalling that Aesthetic Movement advocates used the sunflower as an emblem of renewal and enlightenment.[60]

Books such as Owen Jones' *Grammar of Ornament* (1856) were surely on the Tile Club reading list. The first fourteen plates of the book are devoted to the ornament of various unfamiliar, ancient, and primitive cultures.[61] A general positivism toward primitive arts dominated mid-nineteenth-century thinking as theorists groped toward some justification of abstraction in

their own arts. Jones thought, for example, that "the more ancient the monument the more perfect the art."[62]

Homer's preoccupation with subjects reflecting a childlike state during the 1870s has recently received scholarly attention.[63] Pictures of young white children are our chief evidence. Simple geometric marks and signs chalked on the blackboard in Homer's watercolor of 1877, *The Blackboard* (fig. 28), constituted a primary or primitive lesson in drawing.[64] I would argue that the series of black paintings dovetails neatly with Homer's preoccupation of the 1870s. During Homer's lifetime, most blacks, adults or children, would have been seen by whites as living in a relatively primitive state. In "The Ornament of Savage Tribes" Owen Jones suggested, "The efforts of a people in an early stage of civilisation are like those of children, though presenting a want of power, they possess a

27. Winslow Homer, *The Shepherdess*, 1878, painted ceramic tile, 19.7 x 19.7 (7³/₄ x 7³/₄) The Lyman Allyn Museum

28. Winslow Homer, *The Blackboard*, 1877, watercolor, 48.9 x 30.8 (19¹/₄ x 12¹/₈) Collection of Jo Ann and Julian Ganz, Jr.

principally red, blue, and yellow, with black and white to define and give distinctiveness to the various colours; with green used generally . . . as a local colour. . . . Also were added both purple and brown. . . . It appears to be a universal rule that, in all archaic periods of art, the primary colours, blue, red, and yellow, are the prevailing colours, and these used most harmoniously and successfully.[66]

Jones' paragraph reads like a color diagram for *Carnival*, where indeterminate browns, purples, and greens serve as a foil for rich primary red, blue, and yellow.[67]

One might end this exegesis on a note of silence. An aspect of *Dressing for the Carnival* that sets it apart from most nineteenth-century images of blacks is the complete absence of any reference to music or musical instruments. Blacks were acclaimed for their musical gifts. These received endless comment in the press, and about the time Homer painted *Carnival*, black spirituals were being gathered together and published for the first time.[68] Some of our strongest images of American blacks include musical instruments (fig. 29). These pictures were created both before and after Homer's series of the 1870s. Homer's work is silent, somber. It offers only visual harmonies, the rhythms of elegant form. Anecdote is avoided, something we have come to expect in Homer's best work, but *Carnival* is a richly layered studio image, as complicated as any novel. By 1903 a critic noted Homer's gift for designing a painting—his "mysterious power of unerring choice." Frank Fowler averred, "It is largely their design that gives Homer's paintings their potency in memory. . . . The spots, the masses, the relation they bear to one another, stay in the memory, while the transcript of some lesser man, making slight mental appeal, soon fades from one's remembrance."[69]

Monumentality removes *Dressing for the Carnival* from the realm of caricature. Artistic convention invests it with a measure of timelessness. Historic data is subordinated to the painting as a strong visual image. Relationships between the various members of this tableau remain unstated, and Homer stitches threads of meaning into an ambiguous patchwork that invites multiple interpretations.

grace and naivete rarely found in mid-age, and never in manhood's decline."[65]

As *The Blackboard* teaches a primitive lesson in form, *Dressing for the Carnival* presents primitive color. Homer created a static, friezelike visual analogy between "primitive" subject and primary color. Jones wrote:

The colours used by the Egyptians [at that time thought to be a primitive culture] were

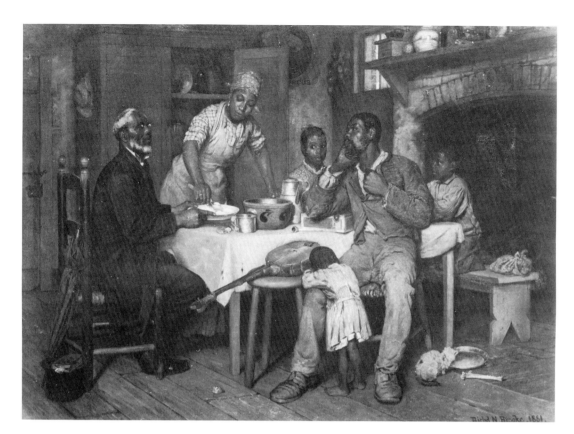

29. Richard Norris Brooke, *A Pastoral Visit*, 1881, oil on canvas, 121.3 x 167.0 (47¾ x 65¾) The Corcoran Gallery of Art, Museum Purchase

NOTES

1. I would like to express my appreciation to Jane Fudge and Virginia Stratton for their energies in gathering photographs and publication permissions for this article; to Lloyd Rule for his prompt photographic services; and to Cecelia Chin and her staff at the National Museum of American Art library for their many courtesies in helping me to accumulate research materials.

Several exhibitions have concentrated on images of blacks in American art. For an overview, see Sidney Kaplan, "Notes on the exhibition," *The Portrayal of the Negro in American Painting* [exh. cat., Bowdoin College Museum of Fine Arts] (Brunswick, Me., 1964), n.p. See also Ella-Prince Knox, Donald B. Kuspit, et al., *Painting in the South, 1564–1980* [exh. cat., Virginia Museum of Fine Arts] (Richmond, 1983); and Eleanor Swenson Quandt, *American Painters of the South* [exh. cat., The Corcoran Gallery of Art] (Washington, 1960).

2. Several scholars have examined Homer's travels to Virginia: Michael Quick, "Homer in Virginia," *Los Angeles County Museum of Art Bulletin* 24 (1978), 60–81; and Mary Ann Calo, "Winslow Homer's Visits to Virginia During Reconstruction," *American Art Journal* 12 (Winter 1980), 4–27. See also Peter H. Wood and Karen C. C. Dalton, *Winslow Homer's Images of Blacks: The Civil War and Reconstruction Years* [exh. cat., The Menil Collection] (Houston, 1988).

3. See Hermann Warner Williams, Jr., *Mirror to the American Past; A Survey of American Genre Painting: 1750–1900* (Greenwich, Conn., 1973), pl. XV.

4. Several journalists who reviewed the fifty-fifth Annual Exhibition at the National Academy of Design in 1880 praised Homer's use of black types. A reviewer for the *Nation* of 15 April 1880 said, "Mr. Homer's own turn for picturesqueness finds an excellent ally in the almost aggressive picturesqueness of negro traits and aspect. . . ." Another journalist, writing for the *New York Times* of 9 April 1880, lauded Homer as one of the few American artists to "make use of the negroes as an element of the picturesque" since "there seems no reason why the various colors and types of negroes, especially at the South, should not afford to painters excellent suggestions toward art. . . ." Both reviewers are cited in Calo 1980, 5. Later on, Homer's first biographer described *A Visit from the Old Mistress*, 1876 (National Museum of American Art), noting "the colored baby in the arms of one of the women is an interesting type." Downes 1911, 86.

5. *New York Herald*, 3 April 1879, quoted in Spassky et al. 1985, 462.

6. [George W. Sheldon], *Art Journal* (August 1878), 227; quoted in Spassky et al. 1985, 461.

7. Edward King, *The Great South: A Record of Journeys in Louisiana, Texas, The Indian Territory, Mis-*

souri, *Arkansas, Mississippi, Alabama, Georgia, Florida, South Carolina, North Carolina, Kentucky, Tennessee, Virginia, West Virginia, and Maryland* (Hartford, 1875), 580. King's articles were originally published in *Scribner's Monthly* in 1873 and 1874. For an evaluation, see introduction to new edition, eds. W. Magruder Drake and Robert R. Jones (Baton Rouge, 1972). Drake and Jones refer to a developing spirit of nationalism in literature during the 1870s that parallels Homer's nationalist paintings of the same decade.

8. The illustration's caption continues, "come to pay yo' our 'specs, sah, an' wishin' yo' Happy Chris'mus." The illustration, drawn by W. L. Sheppard, appeared in *Harper's Weekly*, 12 December 1885, 832. An accompanying text appears on page 827: "The blacks who had masters that won their affection now feel, under the tender influences of this old custom, that they are yet a part of their old masters' families." It is not hard to read between the lines for an expression of a failed social contract and a broken social order.

Opposite Sheppard's illustration, on page 831, appears an advertisement for Pear's soap. The ad shows a black man with a foolish expression holding up a bar of soap. Behind him is a handwritten testament from the white singer Adelina Patti: "Pear's soap I have found matchless for the complexion." The black man echoes, "Matchless for um Complek-shun," a cruel joke upon his desire to wash away his color.

9. For a particularly slouching illustration of the young rural black male who became easy prey for cunning, corrupt "public servants," see "A Future Politician," in King 1875, 459.

10. Nicolai Cikovsky Jr., "Winslow Homer's *School Time:* 'A Picture Thoroughly Noticed,'" in *Essays in Honor of Paul Mellon, Collector and Benefactor,* ed. John Wilmerding, National Gallery of Art (Washington, 1986), 65–66. The author notes that a critic for the *New York Evening Express* called Homer's *The Country School* "a picture thoroughly national" when it was exhibited at the National Academy of Design in 1872. He goes on to suggest that Homer was quite conscious of the "national flavor of the American school," having shown depictions of schoolhouses at the Paris Exposition of 1878. Homer also showed images of blacks. Indeed, the two series occasionally blend, as in *Watermelon Boys,* an oil of 1876 (Cooper-Hewitt Museum). In that picture, two school-age boys, one black, the other white, are eating watermelon. At the right, there is a pile of books bound with a leather strap.

11. "The New School Mistress," *Harper's Weekly,* 20 September 1873, 817.

12. Cikovsky 1986, 47.

13. Homer's exact travel schedule, and the precise number of trips taken, is still a matter of speculation. See Quick 1978, 80, n. 3. See also Calo 1980, 10, 16, and Wood and Dalton 1988, chronology, 132–133. It *is* generally agreed that Homer did not go back to the region after 1876. The actual number of trips Homer made is not particularly germane to my argu-

ments in this paper, but it is interesting to note that, despite William Howe Downes' comment that Homer "made a series of careful sketches from life" while in Virginia, few sketches survive. I know only a simple pencil drawing, *Woman Cooking at a Hearth,* 6½ x 7 in., signed and dated 1874 [Gallery Mayo, Richmond, 1989].

14. "Not only in the schools, but elsewhere, do we already observe the ameliorating influence of letters on the manners, tastes, and habits of the colored population," wrote an anonymous journalist, "On Negro Schools," *Harper's New Monthly Magazine* 292:49 (September 1874), 467.

15. Suzanne Lebsock, *The Free Women of Petersburg: Status and Culture in a Southern Town, 1784–1860* (New York and London, 1984), 92–93.

16. Anonymous journalist for *Ohio Educational Monthly* (August 1872); quoted in Cikovsky 1986, 53.

17. Edward King made several comments on the progressive attitude toward black schooling evident in Richmond. "The Richmond schools for both white and colored pupils rank among the best in the country," he wrote, adding that by 1873 Richmond had fifty-five schools for white and thirty-two schools for colored children. He concluded, "No one thinks of refusing to aid the negro in obtaining his education, although he contributes little or nothing toward the school tax." King 1875, 638.

18. For an illustration of a black school teacher writing a mathematics lesson on the board, see "On Negro Schools," *Harper's Monthly* (September 1874), 461. The image is remarkably close to Homer's watercolor, *The Blackboard* (fig. 28).

19. "On Negro Schools," 1874, 463. The need for southern blacks to serve as teachers became quickly evident as is clear in another article, "The New School Mistress," *Harper's Weekly* (20 September 1873), 817: "The courage of the school-mistress is often heroic. At the close of the rebellion a throng of accomplished women went to the Southern States to teach the coloured children, and of all the forms of 'carpetbagging' this seems to have been the most odious to the Southern chivalry. The Ku Klux of Mississippi hunted the school-mistress from her lonely cabin, threatened, slandered, and terrified her with nightly raids, and Southern women looked upon her with scorn."

20. King 1875, 581.

21. *Harper's Monthly* (September 1874), 458.

22. *Harper's Monthly* (September 1874), 462.

23. A related wood engraving, *The Noon Recess,* appeared in *Harper's Weekly* on 28 June 1873.

24. Consider, for example, Daniel Ridgeway Knight's rather obvious composition, *Rural Courtship,* undated (Thomas Gilcrease Institute of American History and Art). But the path metaphor is not, of course, restricted to an indication of sexual choice.

25. The pipe held in the teeth of this woman adds a specially resonant note of local color to Homer's picture. Writing about mid-nineteenth-century Petersburg, John Herbert Claiborne noted, "Tobacco, not

cotton was king in Petersburg in 1850. And to-day [1904], according to the reports of the Internal Revenue Office, 80 per cent of all the tobacco exported from the United States is exported from Petersburg. . . ." See "Petersburg in the Fifties," *Seventy-five Years in Old Virginia* (New York and Washington, 1904), 67.

26. Lebsock 1984, 2.

27. Lebsock 1984, 89, 90.

28. Lebsock 1984, 96, 99.

29. David Madden, *Harlequin's Stick, Charlie's Cane: A Comparative Study of Commedia dell'arte and Silent Slapstick Comedy* (Bowling Green, Ohio, 1975), 26, 28.

30. Kate Greenaway, *The Language of Flowers* (London, 1884), 11.

31. "On Negro Schools," 1874, 457.

32. Claiborne 1904, 58–59.

33. Claiborne 1904, 65. Gainful employment for the poor of both races was difficult. Claiborne notes, "The only other factories at this period of any importance . . . were the cotton factories—Matoaca, Ettrick, Battersea, Petersburg Mills, Swift Creek, and Merchants' Mills. These factories . . . employed between 800 and 1,000 hands,—white, all of them— with a monthly pay roll of about $10,000 or $12,000. . . . Manufactories in the South employing white operatives were but few, and these in Petersburg, for the few years during which they had been established, were considered a God-send to the poorer classes of white people in the city and the surrounding counties, enabling them to secure a decent livelihood which it was difficult to do by agricultural pursuits. . . ." The black man's difficulties, while unstated, are certainly implied here.

34. James Laver, *Costume in the Theatre* (New York, 1964), 69. On page 72, Laver illustrates a ragged Harlequin of 1695 compared with a much more elegant late eighteenth-century costume.

35. Judith Bettelheim, "The Jonkonnu Festival: Its Relation to Caribbean and African Masquerades," *Jamaica Journal* 10 (December 1976), 21–27. For richer detail, see Bettelheim "The Afro-Jamaican Jonkonnu Festival: Playing the Forces and Operating the Cloth," (Ph.D. diss., Yale University, 1979). A number of African tribes had strip costumes, so that tying down an exact source proves difficult. For further comments, see Judith Bettelheim et al., *Caribbean Festival Arts* [exh. cat., The St. Louis Art Museum] (St. Louis, 1988).

36. For a description and images, see Richardson Little Wright, *Revels in Jamaica, 1682–1838* (New York and London, 1937).

37. See Bettelheim 1976, 21–27. Bettelheim notes that there are various spellings for John Canoe, a leader of the black traders active in 1720 near Axim, Guinea. Canoe enjoyed a reputation as a leader and black hero who had stood up against European pressure.

38. An aged clergyman recalled a variant of the Jonkonnu ceremony for the Suffolk, Virginia *Herald* in 1880: "Before the restrictions of the law which followed Nat Turner's insurrection (1831), a band of colored minstrels were allowed to pass up and down town, playing their music and crying out at every door the state of the weather and the hour of the night. This they kept up several weeks before Christmas, and on Christmas morning the same company would bring out old Johnny Cooner, with a collecting-box, surmounted with Lady Washington. This was a great time with the children, and after playing awhile at each door and exhibiting the antics of old Johnny, the box was handed around for the pennies, which were treasured up for a great feast and high time among the colored people on Christmas night." The witness, one Reverend Riddick, recalled that the Johnny Cooner was a crude marionette or puppet. His reminiscence, originally printed 2 June 1880, reappeared with notes in Fillmore Norfleet, *Suffolk in Virginia, c. 1795–1840: A Record of Lots, Lives, and Likenesses* (Charlottesville, 1974), 43. I am indebted to Judith Bettelheim for this reference.

39. Bettelheim 1976, 25.

40. The title, *Keying Up*, was Chase's jester-like aside referring to the bright, high-keyed palette he used to create a vivid, large-scale picture intended to attract the visitor's wandering eye in a crowded exhibition space.

41. See Marilyn Brown, "Manet's Old Musician: Portrait of a Gypsy and Naturalist Allegory," *Studies in the History of Art* 8 (1978), 77–87. The examination continues in Theodore Reff, "The Street as Public Theater," *Manet and Modern Paris: One Hundred Paintings, Drawings, Prints, and Photographs by Manet and His Contemporaries* [exh. cat., National Gallery of Art] (Washington, 1982), 171–199. For Gavarni's carnival images see Nancy Olson, *Gavarni: The Carnival Lithographs* [exh. cat., Yale University Art Gallery] (New Haven, 1979).

42. The backdrop for Daumier's image is a blackman running to escape a hungry crocodile. Similar images were used to decorate floats in New Orleans Carnival parades. A float built by the Independent Order of the Moon in 1883 was titled "Mississippi in Flood." A black sits quaking on a tiny island, surrounded by snapping aligators. An illustration from *The Daily Graphic*, 14 April 1883 is in the collection of the Howard-Tilton Library.

43. The standard articles on this issue include Francis Haskell, "The Sad Clown: Some Notes on a Nineteenth-century Myth," in Ulrich Finke, *French Nineteenth-century Painting and Literature* (Manchester, 1972), 2–16; and Donald Posner, "Watteau mélancolique: La formation d'un mythe," *Bulletin de la Société de l'Histoire de l'Art Français* (1973), 345–361. See also Helen O. Borowitz, "Painted Smiles: Sad Clowns in French Art and Literature," *The Bulletin of the Cleveland Museum of Art* 71 (January 1984), 23–35.

It would appear that Homer's sources were more political, contemporary, and French than those that inspired many of his countrymen, who undertook genre scenes inspired by Dutch and Flemish "little masters" along with Murillo, the Le Nain brothers, Moreland, Hogarth, and Rowlandson. Such European

interpreters of the poor became the inspiration for many nineteenth-century genre painters in America. For a discussion, see Bruce Chambers, *Art and Artists of the South: The Robert P. Coggins Collection*, [exh. cat., Columbia Museum of Art] (Columbia, S.C. 1984).

44. Quoted in Reff 1982, 196. Henry James' comment originally appeared in *Honoré Daumier* (1893).

45. Paula Harper, "Daumier's Clowns: Les Saltimbanques et les Parades" (Ph.D. diss., Stanford University, 1976), quoted in Reff 1982, 196.

46. Perry Young, *The Mystick Krewe; Chronicles of Comus and His Kin* (New Orleans, 1931), 126. The Darwin parade of 1873 was the first to display masks built in New Orleans.

47. Young 1931, 63.

48. One historian of Carnival wrote, "During the Spanish era the control of masking was discretionary, with resultant incidents that disturbed the peace of the populace and brought about the prohibition of masquerading. A serious situation developed when certain non-Caucasians took advantage of masking to mingle under disguise with Carnival street groups, and to enter private as well as public masquerade balls. They even used mask-concealment to commit night-time robbery. The result of these infractions was the limiting of all disguises to members of the Caucasian race." Arthur Burton LaCour, *New Orleans Masquerade: Chronicles of Carnival* (New Orleans, 1952), 8.

49. Young 1931, 27.

50. Young 1931, 71.

51. Young 1931, 90.

52. Young 1931, 125–126.

53. *New Orleans Picayune*; quoted in Young 1931, 125. In 1877, Carnival goers again parodied the waning power of blacks, staging another elaborate parade, "The Aryan Race," on 13 February. LaCour 1952, 26.

On at least one occasion during the reconstruction period, the ape costume (intended to satirize blacks) was connected with Harlequin. The *Crescent* reported in 1869, "That ape had herculean proportions joined with the agility of the species which he represented. He must be one of the clowns or harlequins at the Academy." See Young 1931, 90.

54. Reff 1982, 124, n. 40.

55. Madden 1975, 60.

56. Part of the brooding power of Homer's work in general, and of this painting in particular, comes from the artist's avoidance of literal reportage. *Carnival* is, for example, a far richer work of art than Thomas Hovenden's literally reported, sentimentalized image, *Last Moments of John Brown* (Metropolitan Museum of Art), commissioned in about 1881.

57. F. Hopkinson Smith, *A Book of the Tile Club* (Boston, 1886). See also Mahonri Sharp Young, "The Tile Club Revisited," *American Art Journal* 2 (Fall 1970), 81–91.

58. Stylized shepherd and shepherdess tiles in the collection of Arthur Altschul are reproduced in Hendricks 1979, 128, fig. 192.

59. A decade earlier, Homer had painted *Prisoners from the Front*, 1866 (Metropolitan Museum of Art). As in *Carnival*, the figures in *Prisoners* are arranged in a linear, friezelike composition. There is nothing decorative about the picture, but it does seem to me that the static, formal line-up, which ultimately derives from architectural decoration, adds immensely to the monumentality of the picture.

60. On the meaning of the sunflower, see Elizabeth Aslin, *The Aesthetic Movement: Prelude to Art Nouveau* (New York, 1969), 36–51.

61. Owen Jones, "The Ornament of Savage Tribes," "Egyptian Ornament," and "Assyrian and Persian Ornament," in *The Grammar of Ornament* (London, 1868), 13–30. The book first appeared in 1856.

62. Jones 1868, 22.

63. Helen A. Cooper notes, "The novelty of watercolor as a medium for artistic expression may have suggested to Homer the need for a fresh subject as well. That he chose childhood, however, . . . is not surprising. No stage of life was so exalted in nineteenth-century art and literature, especially after the Civil War, as childhood." Cooper sees in Homer's Gloucester watercolors a merging of personal nostalgia with symbolic innocence. See Cooper 1986, 25–26.

64. Cikovsky 1986, 59.

65. Jones 1868, 14.

66. Jones 1868, 25.

67. Homer used bright primaries with a black subject again in a late watercolor, *Under the Coco Palm*, 1898 (Fogg Art Museum).

68. See, for example, "Negro Songs and Singers," in King 1875, 609–620. These songs were believed to have a kind of naive yet "correct" beauty, in much the same way that so-called primitive societies were thought to produce successful works of art without the benefit of academic theory. In a preface to a collection of songs sung by the Jubilee Singers of Fisk University, Theodore F. Seward wrote, "A technical analysis of these melodies shows some interesting facts. The . . . rhythm . . . is often complicated, and sometimes strikingly original. But although so new and strange, it is most remarkable that these effects are so extremely satisfactory. We see few cases of what theorists call *mis-form*, although the student of musical composition is likely to fall into that error long after he has mastered the leading principles of the art." Quoted in King 1875, 616.

69. Frank Fowler, "An Exponent of Design in Painting," *Scribner's Magazine* (May, 1903); quoted in Downes 1911, 96–97.

DAVID TATHAM
Syracuse University

Winslow Homer at the North Woods Club

On 23 June 1910, in failing health, Winslow Homer arrived in the Adirondacks for the last time. He had traveled by rail from Prout's Neck, Maine, to North Creek, New York, then by wagon nearly nineteen miles over rough roads to the village of Minerva and into the forest beyond. His destination was a spacious clearing with a few rustic cottages and lodges. This was the North Woods Club. He stayed twelve days. He had come to fish and restore his health, not to draw or paint. Less than three months later he would be dead.[1]

Homer had first visited this site forty years earlier, in 1870, when the clearing was a farm in the wilderness worked by the Baker family, who took in summer boarders.[2] He returned about nineteen times over four decades, spending a total of about seventy-six weeks there.[3] From these visits came a number of drawings, five wood engravings, a dozen oils, and about a hundred watercolors.[4] There is never any satisfactory accounting for the impact of place on an artist, but in Homer's case we can comprehend well enough the mix of visual, social, and sporting ingredients that, compounded early at Baker's clearing, proved to be a powerful and durable attraction to him. Some aspects of this appeal may be examined by viewing Homer's work in the context of work by artists he knew who had preceded him to the Adirondacks, by considering the relationship of his water-color technique to his subjects, and by

touching on the two drawings that were his last works at the North Woods Club.

The only location in the Adirondacks other than Baker's clearing that Homer is known to have visited for any significant time is Keene Valley, a village about thirty-five air miles north of Minerva, beyond Mount Marcy, New York State's highest peak. In 1870 and 1874 he journeyed to both the clearing and the valley, with important works executed in each place. I have treated Homer's Keene Valley work elsewhere and will say little about it here.[5] It is worth observing, however, that Homer's trips to both locales in 1870 and 1874 were made in the company of other artists, notably Eliphalet Terry, John Lee Fitch, and Roswell Shurtleff, who were, like him, sportsmen. A photograph taken at Keene Valley in 1874 shows Homer with a group of fellow guests from the Widow Beede's Cottage, disporting themselves on a nearby rock (fig. 1).[6] Among them is Shurtleff, whose friendship with Homer dated from their days as graphic artists in Boston in the late 1850s.[7] The difference between Shurtleff's dress and Homer's, the former rough and latter dapper, is instructive. By the time of Homer's first sojourn in 1870 the Adirondacks had ample though widely scattered summer hotels and inns, making it possible for tourists to spend a week or a month in stylish comfort. When Shurtleff first visited the region in the 1850s, the lodgings available were few and rudi-

Detail fig. 12

mentary, and he continued to prefer such primitive accommodations throughout his long association with Keene Valley. He had, after all, first been drawn to the Adirondacks by its reputation as the least explored mountain wilderness in the eastern United States and had been part of the first wave of artists to develop a sustained interest in the area.

The one subject in American painting that is distinctive to the Adirondacks—scenes of camp life—was invented by these artists in the 1850s. The two essential components of the subject are a group of sportsmen relaxing in a forest clearing, often accompanied by one or more guides, and a lean-to shanty or tent. No women are present, or even within miles, presumably. The "sports" are outsiders to the forest, attended by insiders, the guides; they are men from town dependent on the man of the woods. Freed from the cares of home, job, and society, and with the satisfactions of a day of hunting or fishing behind them, they take their ease. The camp scene subjects of the 1850s pictorially document the shift then underway in American thought in which a pantheistic concept of the natural world as the Almighty's hallowed residence surrendered its primacy to the more prosaic notion of nature as everyone's playground. The natural world of the camp scenes of the 1850s ministers to the body at least as much as the spirit.

Perhaps the best known example of the camp scene genre is William J. Stillman's *Philosopher's Camp* (1858; Concord Free Library). It records and idealizes the pilgrimage to wilderness of ten distinguished men from Cambridge and Boston—Ralph Waldo Emerson, James Russell Lowell, and Louis Agassiz among them—men whose natural environment was the study, library, laboratory, and lecture hall.[8] Arthur Fitzwilliam Tait painted several examples, some of which enjoyed wide popularity in lithographic reproduction. His painting *With Great Care* of 1854 (private collection) is among the earliest specimen; and his *A Good Time Coming* of 1862 (Adirondack Museum) was reproduced by Currier & Ives.[9] One of the most animated and endearing products of the camp scene genre

is Frederic Rondel's *Batkins Club in Camp* of 1856 (fig. 2). These sportsmen play cards, clean weapons, count fish, smoke, dine, and drink. Through a series of not very subtle pictorial cues, Rondel leads the eye across the canvas, figure by figure, from the yawning lean-to, to the table at the right spread sparsely with food and wine. A paint box with an oil sketch of a mountain landscape in its lid is propped open against a forward pole of the lean-to with a prepared palette and brushes resting on top. It is set between a gun and an ax for the amusement of future iconographers. The paint box presumably belongs to Ron-

1. Painters J. Francis Murphy and Roswell Shurtleff (front, left and right) with Calvin Rae Smith, Winslow Homer (second row, left and in profile with pipe), and Kruseman Van Elton (seated in back), at the east branch of the Ausable River, Keene Valley, 1874, stereopticon photograph Courtesy Peggy O'Brien

2. Frederic Rondel, *Batkins Club in Camp in the Adirondacks*, 1856, oil on canvas, 55.9 x 76.2 (22 x 30) The Adirondack Museum, Blue Mountain Lake, New York

del, who is shown seated on a stump with a pipe in his hand.

Rondel (1826–1892) and Homer both worked in Boston between 1856 and 1860. Both were lithographers in these years, and Rondel was also a painter.[10] Rondel has long been described as Homer's first and only instructor in painting, and there is no doubt a kernel of truth in this, but it is probably more accurate to think of them as friends. Rondel's association with the Adirondacks in the 1850s and 1860s contributed nothing in style or concept to Homer's later work in the area, but Homer was certainly aware of Rondel's, Shurtleff's, and Stillman's enthusiasm for the scenic beauty and robust life of New York's mountain wilderness. That enthusiasm, later reinforced by other of Homer's artist friends, including Terry, Fitch, and Homer Martin, helped form his expectations of the region.

Homer's major contribution to the camp scene genre came in 1880 with his oil *Camp Fire* (fig. 3). Stripped of the anecdotal detail found in examples of the 1850s, it stands alone as the culmination of the type, making all earlier treatments of the subject seem contrived and awkward. The somnolent atmosphere is an appropriate expression of the essential idea of relaxation after a day of hunting or fishing. The rendering of the fire and the sparks that fly from it has been admired for its naturalism since the painting's first exhibition. This canvas seems to have exhausted Homer's interest in camp scenes, however, for his later Adirondack works treat the active life of the woods, the men of the woods, and the woods alone. Indeed by 1880 the older genre was passing from popularity, to be revived briefly in the 1890s in both painting and illustration by Frederic Remington.[11]

Homer's *Camp Fire* shares with his Gloucester watercolors of the same year a keen and exploratory interest in unusual conditions of light. Light is as much the painting's subject as is camp life. Homer

3. Winslow Homer, *Camp Fire*, 1880, oil on canvas, 60.3 x 96.8 (23 ¾ x 38 ⅛) The Metropolitan Museum of Art, Gift of Henry Keney Pomeroy

may have adapted some of the composition of *Camp Fire* from his Adirondack drawings of 1874, very possibly those that had served as the basis for his *Camping Out in the Adirondack Mountains*, published as a wood engraving by *Harper's Weekly* in 1874.[12]

When Homer returned to the Adirondacks in 1889, Baker's clearing was no longer a farm but the meadowlike campus of a private club. It had been purchased in 1887 by a group of New Yorkers who had incorporated themselves the previous year as The Adirondack Preserve Association for the Encouragement of Social Pastimes and the Preservation of Game and Forests. Confusion of this name with those of other organizations, and even with the newly formed state park, led to a change in 1895 to the "North Woods Club." By this time, the club's property consisted of some 5,000 acres of mountainous forest, ponds, and streams surrounding the clearing.[13]

The literature on Homer has for many years described both him and his brother Charles as charter members of the North Woods Club, but they were not. Homer was elected to membership on 28 January 1888, in the club's second year and a month before his fifty-second birthday.[14] His first visit was the following year, and he first appears in the register in May 1889 as "the guest of George W. Shiebler," a wealthy Brooklyn manufacturer and a founder of the club.[15] Charles appears in the register only twice, in 1902 and 1904, both times as Winslow's guest.[16] Eliphalet Terry, who had been a summer boarder at the Baker farm most years since 1859, and with whom Homer had first visited the place in 1870, was a member at North Woods Club from 1887 until 1896, the year of his death.[17] He and Homer were the only artist members during this period. In 1874 Homer portrayed Terry fishing, probably on Mink Pond, and two years later presented the watercolor to the Century Association in New York, an organization to which both men belonged.[18]

Like several similar private clubs established in the Adirondacks in the 1880s, the North Woods Club offered a forest experi-

ence that was a far cry from the camp life portrayed in the paintings of the 1850s. Perhaps the most striking difference was the presence of women. In 1887, the club's first full season, four of the twenty-eight registrants were women. In 1889, Homer's first season, sixteen of seventy-two were women, not counting the club's local staff or the maids accompanying members. Most of the women were wives, sisters, mothers, daughters, and friends of members.[19]

The main lodge at the North Woods Club was rustic, but it offered far more amenities than a tent or lean-to. A dining hall was located next door.[20] By the 1890s some members, Terry among them, had built their own cottages, while still dining in common. Members came mostly from New York City and its environs, but with strong contingents also from Pittsburgh and Wilmington. In the mid-1890s through at least 1906 the annual dues were fifty dollars.[21] In the mid-1890s board was $1.75 a day, and guides were available at twenty-five cents an hour or $2.50 a day, $3.00 with a dog.[22] This rate was probably equivalent to what Homer paid those who modeled for him.

Members of the club were affluent, cultured, and, it needs hardly be added, devotees of the outdoor life, persons whose social class and interests Homer had always shared. The summer residents of Prout's Neck—his family and neighbors—were of a similar cut. By the late 1890s Henry Clay Frick was a member. Andrew W. Mellon visited in 1898, probably as Frick's guest. Frick's daughter, Helen, later the founder and benefactor of the Frick Art Reference Library, began coming to the North Woods Club in 1897 just before her ninth birthday and continued until early in the new century, although she seems never to have been at the club when Homer was.[23] She maintained an affection for the club in her later years, aiding it financially when the difficult conditions brought on by World War II threatened its existence.[24]

Homer's first visits to the club were lengthy—a total of eighteen weeks in 1889, seven weeks in 1891, and nine weeks in 1892—divided into early and late season stays, probably to allow him to spend the height of the summer at Prout's Neck and to avoid the worst of the black fly season in the Adirondacks. His later visits ranged from one to five weeks, usually in May and June. Some measure of how his fellow members viewed him is revealed in the minutes of a club meeting directly following his death in 1910, where his "singularly simple, kindly, courteous and gentle nature" is memorialized.[25]

From the club's lodge, Homer looked out on Beaver Mountain (fig. 4), with its graceful, asymmetrical rise. A dark, coniferous ridge contrasted with the lighter, deciduous cover of the rest of the mountain. He included this mountain in more than two dozen works between 1870 and 1902, constantly varying its appearance as he viewed it from different locations. He first depicted it in the background of a wood-engraving, *Trapping in the Adirondacks* (fig. 5), published in *Every Saturday* in 1870, and included it in another published in *Harper's Weekly* in 1874, *Camping Out in the Adirondack Mountains*.[26] It forms the background of his well-known *Two Guides*, 1875 (Sterling and Francine Clark Art Institute), even though the figures are from Keene Valley. Part of the mountain can be seen in his watercolor *Guide Carrying Deer*, 1891 (Portland Museum of Art, Maine), and in the oil derived from it, *Huntsman and Dogs*, 1891 (Philadelphia Museum of Art). There are suggestions of its form in his wash drawing *Landscape in Morning Haze*, c. 1892 (fig. 6). It is a prominent feature of *The Pioneer*, 1900 (Metropolitan Museum of Art), and nothing less than the primary subject of Homer's last Adirondack watercolor, his *Mountain Landscape* of 1902 (fig. 7).

Homer's varied uses of Beaver Mountain raise the question of whether he might have been alluding to depictions of Mount Fuji in the series of color prints from the 1820s by the Japanese artist Hokusai, prints that were known to many American artists by the 1870s. The allusion is possible, even though two different concepts were at work. In Hokusai's views of Mount Fuji, the direction and angle of vision constantly change, while the shape of the truly conical mountain remains the same. Homer, on the other hand, freely treated the shape of a mountain that appeared py-

ramidal only when viewed from the southwest, the direction of the North Woods Club. While some conscious or unconscious visual memory of Hokusai's prints may have played a part in Homer's repeated use of Beaver Mountain, it seems more likely that the pictorial strengths of the landform, varied by season, hour, and weather, reintroduced themselves to him virtually daily when he was in the Adirondacks and that he responded to what he saw with his usual reportorial verve.

Homer painted most of his Adirondack watercolors within a few hundred yards of the clubhouse, nearly all at locations much frequented by club members then and for more than a century afterward. He painted nothing of the club's social life but a good deal of its sporting life. In his depictions of the club's guides he pictorially reinforced the concept that they were a part of the natural environment, quite literally men of the woods.[27] These men were widely respected for their skills and character and Homer held them in high regard, just as he had earlier admired the fisherfolk of Cull-

ercoats and the deep-sea fishermen of Maine.[28] He did not portray them in a deferential relationship to sportsmen, as had the camp scene painters of the 1850s, nor did he sentimentalize or caricature them, as did many popular illustrators of the day.[29] Rather, he invested them with a dignity that was grounded in Jeffersonian and Jacksonian democracy as well as in his own personal esteem for them.

4. Beaver Mountain as seen from Mink Pond, North Woods Club
Photograph by author, 1966

5. Winslow Homer, *Trapping in the Adirondacks*, 1870, wood engraving, 22.5 x 29.5 (8 7/8 x 11 5/8), published in *Every Saturday*, 24 December 1870
Bowdoin College Museum of Art

6. Winslow Homer, *Landscape in Morning Haze, Deer at a Fence*, c. 1892, wash drawing, 36.8 x 53.3 (14 ¹/₂ x 21)
Cooper-Hewitt Museum, Smithsonian Institution

7. Winslow Homer, *Mountain Landscape*, 1902, watercolor, 36.5 x 21 (14 ³/₈ x 21)
Addison Gallery of American Art, Andover Academy

Guides, sport fishermen, fish, deer, dogs, logging—these subjects recur year after year in Homer's North Woods Club work. Indeed, they are all present in the work of his first season at the club. That year, 1889, in the course of eighteen weeks, he produced twenty-five to thirty finished sheets representing a newfound maturity in the medium of watercolor.[30] The bold and steady advances in technique he had made throughout the 1880s culminated here. The radical freedom in color and brushwork of his Gloucester watercolors of 1880, the strong draftsmanship and composition of his Cullercoats work of 1881–1882, and the brilliance of light on water and foliage that gradually emerged in his Caribbean work beginning in 1885—all converged in 1889 and, with the Club as a catalyst, burst forth in this extraordinary body of Adirondack watercolors. This was a kind of *Annus mirabilis* for Homer as a watercolorist.

Homer went to the North Woods Club not solely to paint but also, and perhaps primarily, to fish. He was an expert fly-fisherman. Some indication of his seriousness in sport-fishing survives in the club register for June 1900. There, in a list of his catch, he drew a picture of the hook he had used to catch a 6 1/4-pound pike (fig. 8), specifying size and type.

For centuries the art of sport-fishing has been placed on a higher plane than most other individual sports, and fly-fishing in some views ranks highest of all. The primacy of fly-fishing rests on the understanding that it epitomizes the union of the active and the comtemplative life. It is hardly matched among human endeavors as a means of taking the measure of one's intellectual and manual powers operating in alliance, with nothing of real import at risk. The intellectual aspect of sport-fishing derives from the need to conceptualize accurately the behavior of fish and the conditions of fishing, taking account of stillness and motion, surface and depth at the margin of land and water, while intent on capturing life in one world and bringing it into another. The image of the thoughtful fisher has a rich history in the arts, especially in books that Homer would have known at first or second hand. Izaac Walton cast his essay of practical philosophy,

8. Winslow Homer, *Fish Hook*, 1900, ink drawing in the North Woods Club register
The Adirondack Museum, Blue Mountain Lake, New York

The Compleat Angler, in the form of a conversation about fishing; John Bunyan used a metaphor of angling to justify his use of allegory in *The Pilgrim's Progress*; and Henry Thoreau introduced a self-absorbed fisher into the Concord River as he and his brothers set out on their week's journey.

Sport-fishing, and above all fly-fishing, also requires exceptional skills of manual dexterity. The selection and tying of flies, the timing, the casting, the hooking, the playing, the netting—all this depends for success on the experienced, finely tuned interplay of eye, hand, and mind. So does painting in watercolors. Homer doubtless saw parallels between what he did as a watercolorist and what he did as a fly-fisher.

Homer's exceptional powers of observation coupled with an extraordinary command of the watercolor medium produced between 1889 and 1900 a group of paintings of fish and fishing that are among the wonders of American art. His *Jumping Trout* (fig. 9), *Mink Pond* (fig. 10), and *Casting. A Rise* (fig. 11) are representative. They have nothing to do with the by-then old subject of camp life, and everything to do with Homer's sensibilities as fisherman and painter. But while they capture with remarkable authenticity the behavior of fish and the experience of fly-fishing, as sport-fishermen have attested for nearly a cen-

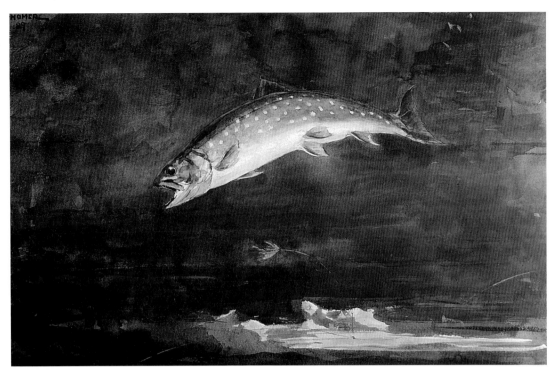

9. Winslow Homer, *Jumping Trout*, 1889, watercolor, 35.6 x 50.8 (14 x 20) The Brooklyn Museum, in memory of Dick S. Ramsay

tury, they also attract a far greater number of viewers who know or care little about fishing. Part of the appeal surely comes from Homer's bravura technique.[31]

Consider the watercolor *Casting. A Rise* (fig. 11). Homer drew the serpentine line of the fisherman's cast by cutting through the washes of color with a point to reveal the white paper beneath. He did this in a single rapid gesture in which any miscalculation, hesitancy, or rush would have ruined the illusion that the line is cast toward the viewer. The multiple washes are complex in their sequence and manipulation. The composition is to a significant extent the result of cropping. Although the work had its origins in keen observation and rapid execution, its completion required deliberate and close calculation. It is one of Homer's great achievements that he not only preserved the spontaneity of his original watercolor sketches as he "finished" them in his studio at Prout's Neck, usually some weeks after his original work, but actually heightened their sense of immediacy. Having brushed, soaked, blotted, scraped, touched, and trimmed, he seems to have taken pride in these watercolors as hand-crafted objects. The tenor of the

times would have encouraged this.

We can understand something of that tenor through the manual training movement. Though it has been largely forgotten in the twentieth century, the movement was a vital aspect of American culture during Homer's lifetime. It was based on the simple premise that manual skills and intellectual skills are linked and interdependent. Manual skills represent nonverbal, spacial thinking that is not inferior in kind to verbal, linear thinking, and a full development of one's native abilities is attainable only through the mastery of both.[32] The movement began with the Jacksonian era's reaction against the dominant ideal of a classical literary education, and it gained support from mechanics' societies and others with a stake in the development of technology. It was also promoted by utopian communities, especially those envisioning wholesale social reorganization. It was, for example, a vital idea at Brook Farm. After the Civil War it flourished as a movement concerned with the social and aesthetic issues William Morris had struggled with in England, but it had a more pragmatic and democratic outlook. Though it shared certain ideals with the

arts and crafts movement, its greatest impact on American life was felt in the reform of public school curricula and architecture.

In the early decades of the twentieth century the movement collapsed. The concept of manual training as a correlative of intellectual training deteriorated into the practice of vocational training of a utilitarian and even anti-intellectual kind. But during Homer's career the movement was in its heyday and had elevated the mastery of complex manual skills expressive of serious and original thought to a level of respectability never previously enjoyed in America. In doing so, it had created a mystique for hand-crafted objects. The figures in Homer's Adirondack watercolors—flyfishermen, loggers, and guides—who often carry rods, nets, axes, oars, and pikes, live by their hands and by a profound, highly specialized, and not easily verbalized knowledge of complex tasks. Homer's admiration for others' mastery of manual skills seems implicit in his use of his own mastery in portraying them.

Such a reading illuminates a watercolor that is distinctive among Homer's Adirondack works, not only in its style and subject but also in the extent of its documentation. *Paddling at Dusk* (fig. 12), with its richly soaked background, is an unusually bold and flat composition, and Homer's treatment of the surface of the pond is among his strongest in watercolor. The subject is unique in that the trimly dressed figure sitting high in the small boat is not a guide or a fisherman but a fellow member of the North Woods Club. Homer inscribed the watercolor to the man at upper right: "Winslow Homer to Ernest J. G. Yalden/August 27, 1892."[33] Forty-four years later, in 1936, Ernest Yalden recalled in a letter the circumstances of the painting, revealing some of Homer's reasons for undertaking the subject.

"Paddling at Dusk" . . . was painted some time during the summer of 1892. Mr. Homer and myself were members of the Adirondack Preserve Association at the time; and this picture was made at Mink Pond on the preserve. It is a canoe built by myself which interested Mr. Homer on account of its portability for it weighed only 32 lbs. He was particularly inter-

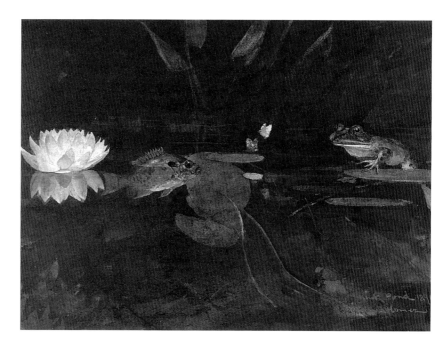

ested in the broad flashes of light from the paddle when under way after dark; and this picture was painted when it was almost dark. The canoe built of mahogany was based on the model of a Canadian bateau, was 12 [feet] long and 18 inches beam. It has always been a puzzle to me how he was able to get the effect he did when it was almost too dark to distinguish one color from another.[34]

In the last paragraph of his letter Yalden wrote: "I have a number of interesting photographs of Homer that I made when with him for several summers, and I should be glad to show them to you at any time you might care to run out here." These photographs have never been found.

Homer painted Yalden sometime between 18 June and 28 July 1892, the inclusive dates of the first of the artist's two visits that season. He dated the watercolor 27 August when he completed work on it at Prout's Neck. In selecting a talented craftsman and his hand-built boat as a subject, Homer paid a compliment to Yalden's special combination of intellectual and manual skills and in so doing gave expression to what he valued in himself.

One measure of how comfortably Homer's mature watercolor style fit the taste for hand-crafted objects can be found in

10. Winslow Homer, *Mink Pond*, 1891, watercolor, 35.2 x 50.8 (13 7/8 x 20) The Harvard University Art Museum, Fogg Art Museum, bequest of Grenville L. Winthrop

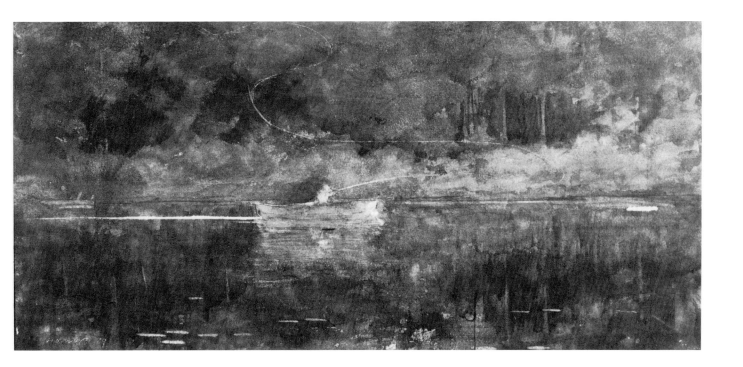

11. Winslow Homer, *Casting. A Rise*, 1889, watercolor, 22.9 x 49.2 (9 x 19 ³/₈) The Adirondack Museum, Blue Mountain Lake, New York

the list of works of the first exhibition of the Society of Art and Crafts in Boston in 1897. The lithographer Louis Prang exhibited his studio's hand-drawn, multiple-stone color reproductions of two of his

friend Homer's watercolors, including one Adirondack subject of 1894, *Playing Him, or The North Woods* (Currier Gallery of Art).[35] The print was, in essence, one hand-crafted object's homage to another. Homer

12. Winslow Homer, *Paddling at Dusk*, 1892, watercolor, 38.1 x 53.3 (15 x 21) Memorial Art Gallery of the University of Rochester

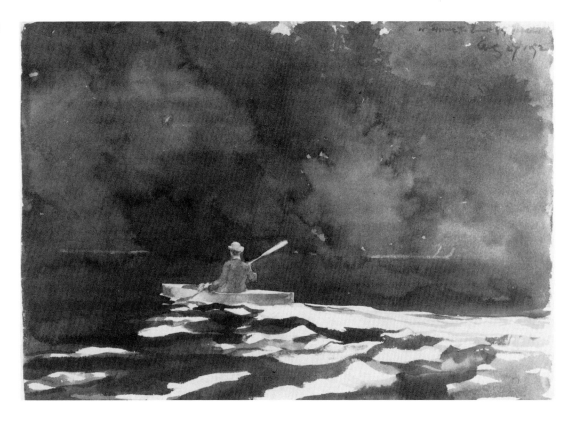

took the trouble to critique a proof. There is much more to be found in Homer's Adirondack watercolors than evidence of the manual training movement, but these ideas form a part of the context within which Homer developed his elaborate technique, and they help explain why technique and subject—hand and mind—mesh so thoroughly in his work.

Though Homer was an avid fisherman at the North Woods Club, he seems not to have been an active hunter. Indeed, the register's list of game shot by members includes only one entry for him.[36] On 24 June 1908, about five weeks after suffering a minor stroke at Prout's Neck, Homer arrived at the club for his penultimate visit. The extent to which he had advanced toward recovery is clear not only from his strong signature in the register but also from what happened the next day when he joined a few fellow members on an excursion into the forest. The party had stopped for a break when a bear chanced on the scene and paused to study the group from the far side of a fallen tree. Homer seized a rifle and shot it. He then made two drawings of the incident. One (fig. 13), showing the configuration of the party and the appearance of the unwelcome guest, was aided by his memory of what had happened some minutes earlier. The other (fig. 14), which depicted two guides carrying his bear away, was made from life.

The first of these drawings is an echo of the Adirondack camp scene genre of half a century earlier. It lacks a tent or lean-to, though it includes the forest setting and the group of sportsmen and guides taking their ease, and it gains, through the bear, an element of drama usually alien to the genre. The second drawing, in Homer's characteristic energetic line, shows his reportorial eye undiminished and his hand as expressive as ever. These last works of Homer's at the North Woods Club remind us that his art, from first to last, had at its core a hot-blooded reaction to something seen.

The extent to which Homer's visual intellect could elevate an idea beyond its reportorial origins can be found in his later treatment of the link missing in the sequence of events depicted in these two

13. Winslow Homer, *Sportsmen and Bear, North Woods Club*, 1908, pencil drawing, 10.8 x 14.0 (4 1/4 x 5 1/2) North Woods Club

14. Winslow Homer, *Guides Carrying Bear*, 1908, pencil drawing, 10.4 x 23.5 (4 1/4 x 9 1/4) The Adirondack Museum, Blue Mountain Lake, New York

drawings—the gunshot itself. That emotionally charged moment emerged early the next year, 1909, transformed in Homer's oil *Right and Left* (fig. 15).[37] He adapted the concept from his earlier watercolor, *A Good Shot* of 1892 (fig. 16), bringing to it

15. Winslow Homer, *Right and Left*, 1909, oil on canvas, 71.8 x 123.0 (28 1/4 x 48 3/8)
National Gallery of Art, Washington, Gift of the Avalon Foundation

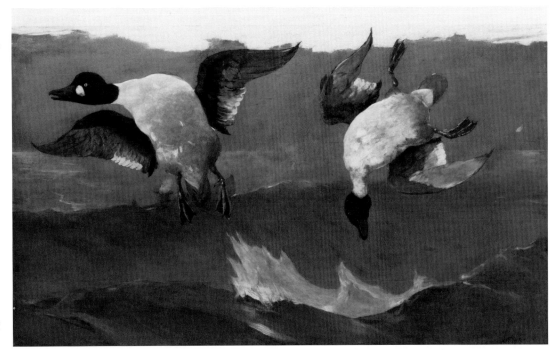

16. Winslow Homer, *A Good Shot: Adirondacks*, 1892, watercolor, 38.2 x 54.5 (15 1/16 x 21 11/16)
National Gallery of Art, Washington, Gift of Ruth K. Henschel in memory of her husband, Charles R. Henschel

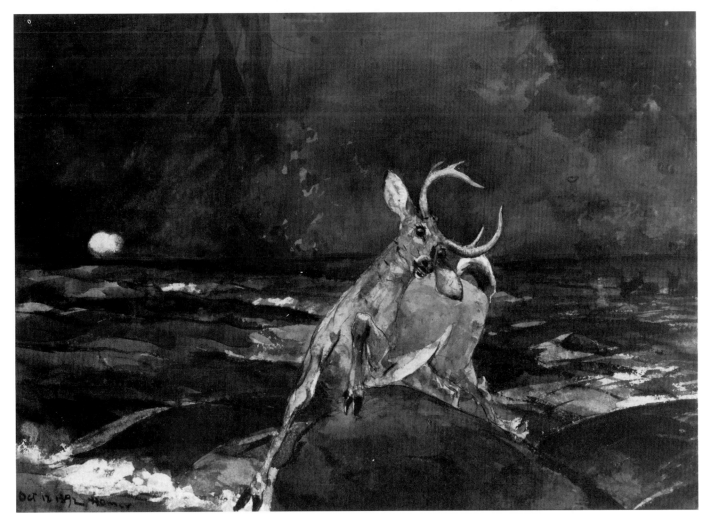

his experience of duck and goose hunting at Prout's Neck. But the scale and intensity of the oil painting may have roots in Homer's surprise meeting with the bear the previous summer. As in *A Good Shot*, the vantage point is that of the hunted rather than the hunter, but the locale is the coast of Maine rather than the Adirondacks, and the prey ducks rather than bear.[38]

This intensification of experience might have led to further Adirondack works if Homer had regained his health, but his accomplishments were in no way incomplete. He had transformed a minor American subject of the 1850s—Adirondack camp life—into the most mature and brilliantly expressed portrayal of man at home in the forest that we know. He had succeeded more than any other artist of his time or since in conveying the excitement that wilderness arouses in Americans. And he did this in a series of works—his North Woods Club watercolors—that from their first showings to the present have seemed so truthful, so eloquent, and so moving in what they say, and how they say it, that they have no peers.

APPENDIX

Winslow Homer's Visits to the North Woods Club

1889	May 6–July 13
	Oct. 1–Nov. 24
1891	June 9–July 31
	Oct. 1–?
1892	June 18–July 28
	Sept. 17–Oct. 10
1894	June 3–July 8
1896	May 15–June 15
1899	July 17–July 22
1900	June 7–June 28
1901	May 4–May 22
1902	May 21–June 10
	(Charles Homer May 21–June 26)
1903	May 23–June 8
1904	May 31–June 27
	(Charles Homer May 31–June 4)
1905	June 27–?
1906	June 28–?
1908	June 24–(c. mid-July)
1910	June 23–July 4

Source: North Woods Club Register, Adirondack Museum, Blue Mountain Lake, N.Y. Homer also visited the site in 1870 and 1874, before its purchase by the club.

NOTES

1. North Woods Club register, Adirondack Museum, Blue Mountain Lake, New York. For the dates of Homer's visits to the North Woods Club between 1889 and 1910 as recorded in the register, see appendix. In traveling from Prout's Neck to Minerva, Homer may have broken his journey to spend a night or more in Boston or Albany, places where he changed trains. An alternative route by which he may have returned to Prout's Neck on one or more occasions was by rail from Lake George north to Montreal and then to Portland.

2. For a comprehensive history of this site, including its years as the Baker farm, see Leila Fosburgh Wilson, *The North Woods Club, 1886–1986* (privately printed, 1986); James W. Fosburgh, "Winslow Homer in the Adirondacks," *Winslow Homer in the Adirondacks* [exh. cat., Adirondack Museum] (Blue Mountain Lake, N.Y., 1959), 11–17, and his "Homer in the Adirondacks," *Portfolio* (winter 1963): 72–87, 111–112. See also *Minerva, a Town in Essex County* (Minerva, N.Y., 1967), 124–126. At least three of Homer's artist friends had preceded him to the Baker farm: Eliphalet Terry summered there from 1859 until his death in 1896, except from 1875 through 1878; John Lee Fitch visited in the summers of 1868, 1870, 1873, 1874, 1880, and probably others; and John Karst, the wood engraver, delayed his visit in 1869 to complete his work on the block of Homer's *On the Beach at Long Branch* for publication in *Appleton's Journal* (21 August 1869). See the Juliette Baker Rice Kellogg papers (MS 83-18), Adirondack Museum. Terry's oil painting *Baker's Farm* is reproduced in Fosburgh 1959, 65. The clearing was first cut in the early 1850s to accommodate a lumbering operation and became a farm in 1854 when Thomas Baker moved his family there. The Baker property was commonly known as "The Woods" before its purchase in 1887 for use as a sporting club.

3. See appendix. In 1893, 1895, 1897, 1902, and possibly 1894 Homer fished at Lakes Tourilli and St. John, both in Quebec. See Lloyd Goodrich, *Winslow Homer* (New York, 1944), 146–149, 184; and Gordon Hendricks, *Life and Works of Winslow Homer* (New York, 1979), 220–225, 231–234.

4. The most comprehensive list of Homer's work in the region is Lloyd and Edith Havens Goodrich, "Adirondack Works by Winslow Homer," in Fosburgh 1959, 21–27.

5. David Tatham, "The Two Guides: Winslow Homer at Keene Valley, Adirondacks," *American Art Journal* 20, no. 2 (1988): 20–34.

6. The identification of certain of the figures, and the year, are specified in Peggy O'Brien, "Shurtleff," *Adirondack Life* (November/December 1979), 43.

7. O'Brien 1979, 40.

8. Reproduced in Hans Huth, *Nature and the American: Three Centuries of Changing Attitudes* (Berkeley, 1957), pl. 35. For a key to the figures in Stillman's painting, see Edward Waldo Emerson, *Early Years of the Saturday Club, 1855–1870* (Boston, 1918), 170–172.

9. Warder Cadbury and Henry F. Marsh, *Arthur Fitzwilliam Tait, Artist in the Adirondacks* (Newark, Del., 1986), 130, 166–167.

10. David Tatham, "A Drawing by Winslow Homer: 'Corner of Winter, Washington and Summer Streets,'" *American Art Journal* 18, no. 3 (1986): 40–50. Among Rondel's lithographs is an Adirondack subject, *View on the Raquette River, N.Y.*, printed by F. F. Oakley, Boston, c. 1858; impression, Adirondack Museum.

11. *Artist in Residence: The North Country Art of Frederic Remington* [exh. cat., Frederic Remington Art Museum] (Ogdensburg, N.Y., 1985) reproduces several examples.

12. See Natalie Spassky et al., *American Paintings in the Metropolitan Museum of Art* (New York, 1985), 2:466–468; and *Harper's Weekly*, 7 November 1874, 920. For Beaver Pond as the site of *Camping Out*, see H. Leroy Whitney, "North Woods Club," *Angler's Club Bulletin* (1948), 4–5, where Thumb Pond, also part of the North Woods Club preserve, is specified as the site of Homer's oil *Waiting for a Bite* (1874) and the wood engraving of the same subject and title published in *Harper's Weekly*, 22 August 1874. Whitney specifies the inlet to Mink Pond as the site of *Trapping in the Adirondacks*, published in *Every Saturday*, 24 December 1870.

13. For a concise history of the North Woods Club, see Leila Wilson, *The North Woods Club, 1886–1986* ([Minerva, N.Y.], 1986). See also *Minerva* 1967, 125.

14. North Woods Club minute book, vol. 1, Minerva, N.Y. It is possible that Homer and his brother participated in the discussions that led to the founding of the club.

15. Club register, Adirondack Museum.

16. Club register, Adirondack Museum.

17. Club minute book, vol. 1.

18. A. Hyatt Mayor and Mark Davis, *American Art at the Century* (New York, 1977), 54.

19. Club register, Adirondack Museum.

20. A photograph showing both buildings is reproduced in Hendricks 1979, 87.

21. The 1897 figure is cited in *Minerva* 1967, 126. In 1908 Homer wrote a check for dues of $100, but he may have been paying for two years. Homer to Edwin S. Townsend, 10 February 1908, private collection.

22. *Minerva* 1967, 126.

23. Club register, Adirondack Museum.

24. Wilson 1986, 21.

25. Club minute book, vol. 4, entry for 27 October 1910.

26. *Every Saturday*, 24 December 1870, 849; *Harper's Weekly*, 7 November 1874, 920.

27. Goodrich 1944, 114–115; Fosburgh 1959, 15.

28. Among the guides portrayed at Baker's farm and the North Woods Club were Michael ("Farmer")

Flynn, Charles Lancaster, and Rufus Wallace. For an important note concerning these guides, see John R. Curry, "Some of Homer's Adirondack Models," in Fosburgh 1959, 19. For Orson Phelps and Monroe Holt, whom Homer knew at Keene Valley, see Tatham 1988.

29. For caricatures, see Edward Comstock, Jr., "Satire in the Sticks: Humorous Wood Engravings of the Adirondacks," in *Prints and Printmakers of New York State, 1825–1940*, ed. David Tatham (Syracuse, 1986), 163–182.

30. Goodrich and Goodrich, in Fosburgh 1959, 23–24.

31. See Helen A. Cooper, *Winslow Homer Watercolors* [exh. cat., National Gallery of Art, Amon Carter Museum, Yale University Art Museum] (New Haven, 1986); and Marjorie B. Cohn, *Wash and Gouache* [exh. cat., Fogg Art Museum] (Cambridge, Mass., 1977).

32. The essential primary source for the movement is Calvin M. Woodward, *The Manual Training School* (Boston, 1887). See also Cleota Reed, "William B. Ittner and Henry C. Mercer: The Architecture and Art of the Erie Public Schools, 1915–1920," *Journal of Erie Studies* 11 (fall 1982): 32–53.

33. Homer transposed one of the initials. Yalden's standard usage was J[ames]. Ernest G[rant]. Yalden. Homer's watercolor *The Return to the Camp* (private collection), also dated 1892, is similar in composition but depicts a guide in a canoe.

34. Yalden to Robert McDonald, 30 September 1936, Memorial Art Gallery, Rochester, N.Y. At the time Homer painted him, Ernest Yalden was twenty-two years old. He had been born to a well-to-do family in England in 1870 and had come to the United States as a child. His father, James Yalden, a prominent accountant and civil servant, was a founding and very active member of the North Woods Club. Ernest Yalden received his bachelor of science degree in civil engineering from New York University in 1893, the year after Homer painted him. He joined the Carnegie Steel Company in Pittsburgh, married in 1895, and soon after returned to New York at the invitation of the Baron de Hirsch Fund to design a school with an innovative curriculum in manual and vocational training for the children of immigrant families. He established the school and directed it with great success for a quarter of a century. Yalden was also accomplished in several avocations. He became perhaps the foremost American amateur astronomer of his time, working from an observatory he built on the grounds of his home in Leonia, New Jersey. He designed, built, and collected sundials, and wrote a treatise on them. He designed and built boats ranging in size from canoes to sea-going yachts. As part of the war effort in 1916–1918 he taught modern systems of navigation and on one occasion piloted a steamer from New York to Bermuda by dead reckoning to demonstrate that it could be done by someone with expert astronomical knowledge. He published scholarly papers in several fields, organized a civic orchestra in Leonia, playing clarinet when not conducting, and was a skillful photographer who designed and built his own cameras.

For a concise summary of Yalden's life and accomplishments, see the New York Community Trust's pamphlet *J. Ernest Grant Yalden, 1870–1937* (New York, n.d.). Among the several published obituaries, those in *Popular Astronomy* 45 (1937): 296–298, *Science* 85 (1937): 325–326, and *Monthly Notices of the Royal Astronomical Society* 98 (1938): 262–273, have supplied most of the information given in the present text.

35. *First Exhibition of the Arts and Crafts, Copley Hall* [exh. cat.] (Boston, 1897), 216. Prang also exhibited a chromolithographed reproduction of Homer's *The Eastern Shore*. The prints apparently were not published. Proofs from 1895 exist in the Metropolitan Museum of Art.

36. The entry, in Homer's hand, reads "June 24— One Bear." The date is probably incorrect, since Homer dated his two quick sketches of the bear 25 June. Though Homer is not credited with any deer in the register, he depicted scenes of deer hounding in 1889 and 1892 in at least four watercolors and one oil. See Cooper 1986, 174–185. In this type of hunting, guides and dogs drove a deer into a pond and kept it from shore, exhausting and drowning it. By taking deer this way and transporting them by boat to a lakeside camp, guides avoided an arduous carry through the forest. The deer hounding season at the North Woods Club was a short one—ten days in 1892. In that year six deer were taken. North Woods Club register, Adirondack Museum.

37. Homer probably began *Right and Left* in the autumn of 1908, but certainly no later than 8 December of that year, when he mentioned the painting in a letter to his brother Charles. He dated the painting 7 January 1909. This sequence is summarized in John Wilmerding, "Winslow Homer's *Right and Left*," *Studies in the History of Art* 9 (1980): 61–62.

38. The essential subject of both works is not so much the death of the animals but the excitement felt by a hunter at the moment of firing and hitting his target. It takes time to comprehend this subject, for it requires first the recognition of the gunshots depicted in the background and then making a connection between the distant hunter and the falling animal close to the picture plane. At the point of comprehension, the violence of the subject and all the associations we bring to it add to the power of the work. But the work has an arresting quality of another kind, at least for those who are drawn by the forms, colors, and textures of the surface, by the apparent motion of the ducks and the waves, and by Homer's autographic manipulation of the medium. The composition and treatment of the surface allow viewers, indeed encourage them, to intellectualize the violence of hunting and to distance themselves from it—though not necessarily from the vicarious excitement—while attracting them to the formal qualities.

The balance Homer reached in these things explains as well as anything the wide popularity of his North Woods Club watercolors. Since their first showings, they have been highly esteemed by fanciers of sporting pictures on the one hand and connoisseurs of fine art on the other, two populations who, in America, otherwise share few tastes in art.

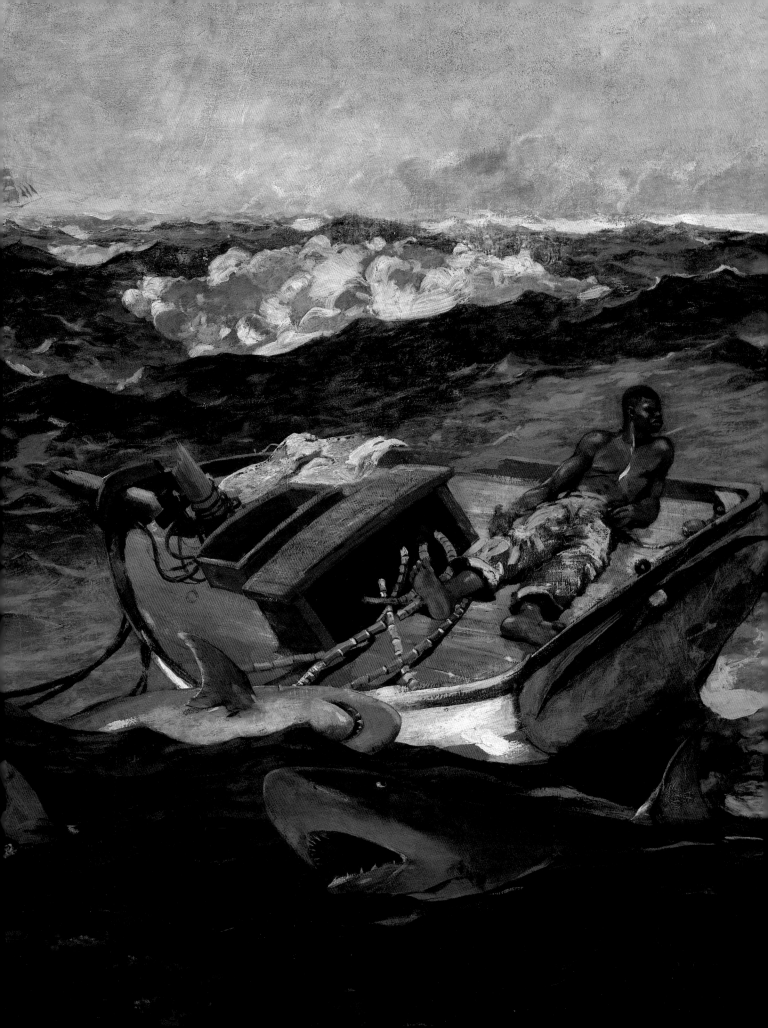

NICOLAI CIKOVSKY, JR.

Homer Around 1900

In 1900 Winslow Homer was almost sixty-five years old, had painted professionally for about thirty-five years, and had ten more years to live. There were signs about this time that his creative energies were diminishing: he painted sporadically (except in watercolors); he tended to rework earlier paintings almost as much as he made new ones; and the new ones, as we will see, were often made from older materials, ideas, and experiences. His artistic career was no doubt coming to its end. Yet about 1900 Homer painted some of the most moving and complex, probing and alert works of his entire life.

I am going to speak very literally about Homer "around" 1900: about the two great paintings that bracket that year, *The Gulf Stream* of 1899 (fig. 1), and *The Searchlight* of 1901 (fig. 25). This is a particularly good time to consider them, because although they are paintings that compel attention in any case, both have recently been discussed in the new volume of The Metropolitan Museum of Art's catalogue of its American paintings, where virtually all of the relevant material on both of them is presented in entries that are models of thoroughness.[1] If something more remains to be said about *The Gulf Stream* and *Searchlight*, it is not because the catalogue is in any way deficient but because the paintings are exceptional in their richness and complexity. I want to speak of them too, however, because they are exemplary paintings, works that are especially informative about the nature of Homer's artistic enterprise, his method and mentality, in the last years of his life.

Critical feeling lately has been that *The Gulf Stream* is too narrative, that it is pictorially too crowded—that, on the whole, its success as art has been sacrificed to the overly explicit telling of a story.[2] It has seemed an obvious painting. Just the opposite is true.

We have begun to understand it not simply as a narrative picture, but, despite its public scale and subject matter ("No one would expect to have it in a private house," Homer admitted[3]), as an exceedingly private one.[4] It is private not because its meaning is hidden from general understanding—the painting is clearly about human mortality, about man's lonely confrontation with death—nor is it an abstract or philosophical consideration of mortality as the common certainty of humanity. It is private because it is the expression of Homer's own thoughts of death and destiny. To the degree that those thoughts were complex, contradictory, in their very nature mysterious and enigmatic, the painting is the same. If the painting is densely filled, it is for the purpose of expressiveness, inclusiveness, and completeness, and even, perhaps, for the precision of allegory; also because through its pictorial form its elements are put before us with (for Homer) unusual urgency.

Homer visited Nassau and Florida from December 1898 into February 1899. That visit, with its passage through the Gulf Stream (Homer said later that he crossed the Gulf Stream ten times in his life[5]), was the immediate stimulus for the painting; he probably began it soon after his return in 1899. But that visit was not its source. Its roots lay more deeply in Homer's past, in other art, in legend,[6] and within himself.

The painting did, however, originate in first-hand experience. In December 1884, as relief from the hard winters at Prout's Neck, Maine, where he had been living since 1883, Homer made his first visit to the Bahamas, Cuba, and Florida, and the

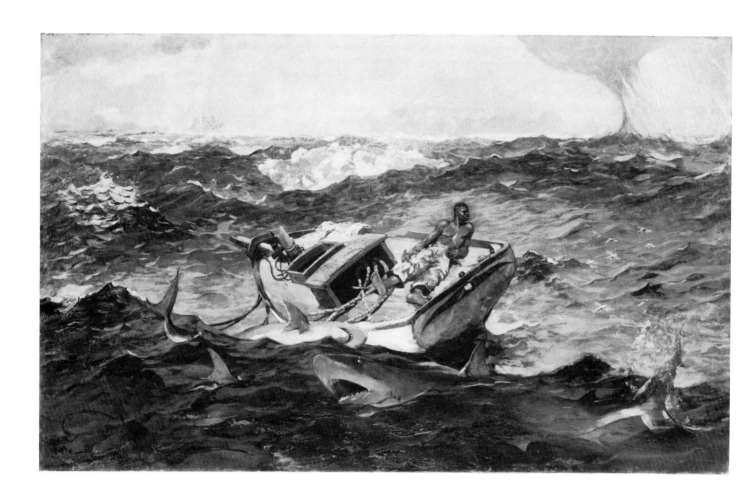

motif he would use many years later in *The Gulf Stream* occurs in the work made on this first trip to the Caribbean.

The development of the motif proceeded through several stages. Its first dated appearance is an 1885 watercolor (fig. 3) of a derelict boat and sharks (there were more derelicts in the Gulf Stream than in any other place in the North Atlantic, and Homer probably saw this one on his trip to or from the Caribbean[7]). But although this is the first *dated* study, it may already be a stage in the artistic transformation of the subject. A pencil drawing (fig. 2), while of uncertain date, makes a plausible claim for consideration as the earliest of the studies for *The Gulf Stream* (although at this point Homer probably did not have its ultimate use in view). Two things suggest this. First, it is of sketchbook size and rapidly drawn

in pencil, as though a quickly made notation of a directly observed transient event. All the other *Gulf Stream* studies, like the 1885 watercolor, are comparatively larger, more completely realized, and more carefully studied. Second, the jury-rigging of the mast and the distress flag—details that this drawing and no other study for *The Gulf Stream* depicts—correspond more realistically to steps that would have been taken in circumstances of distress. The passive resignation of the figure in the later stages and final version of the image, while perhaps more compelling as art, is less probable as fact. In a watercolor dated 1889 (fig. 4), Homer clarified and consolidated what he had recorded in the pencil sketch and the 1885 watercolor. And finally, in the work closest in its details and size to the finished painting—and therefore, one may

1. Winslow Homer, *The Gulf Stream*, 1899, oil on canvas, 71.4 x 124.8 (28 1/8 x 49 1/8)
The Metropolitan Museum of Art, Wolfe Fund

2. Winslow Homer, sketch for *The Gulf Stream*, c. 1885, pencil drawing
Collection of Lois Homer Graham

3. Winslow Homer, *Sharks*, 1885, watercolor, 36.8 x 53.0 (14 1/2 x 20 15/16)
The Brooklyn Museum, Gift of the Estate of Helen B. Saunders

assume, closest to it in date—Homer made a large watercolor of the forward part of the boat (fig. 5).

No other painting by Homer underwent the same development. No other single motif preoccupied him for as long a time, and to no other motif did he return as often. *The Gulf Stream* was painted when Homer was sixty-three, in the year following the death of his father, who was his surviving parent (with whom he had a close but distinctly ambivalent relationship), and in the last year of the century. In that potent blend of circumstances it is not remarkable that Homer would feel alone and think of his own mortality. Neither is it remarkable that such crowding thoughts and feelings would infiltrate his

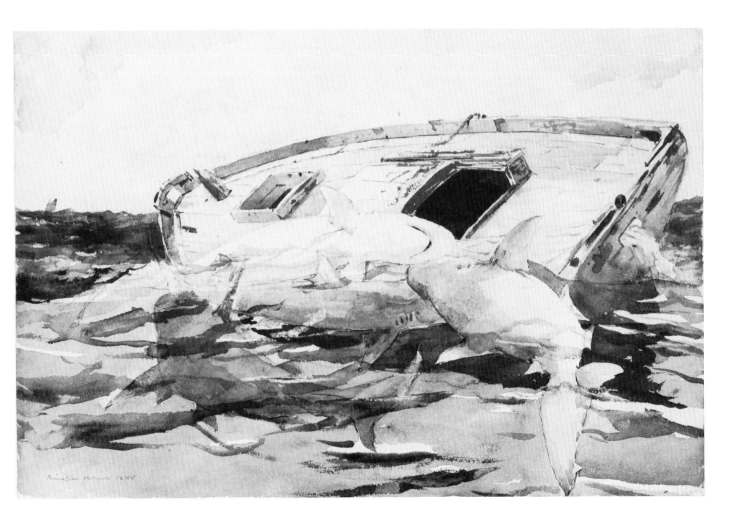

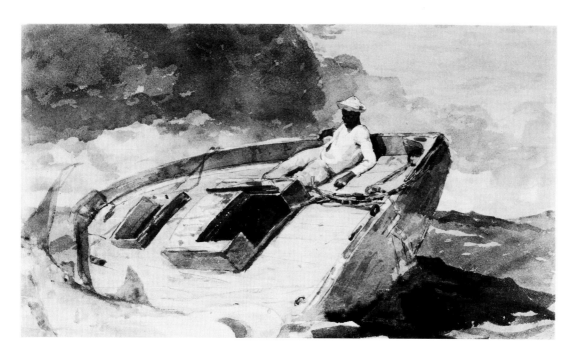

4. Winslow Homer, *The Gulf Stream*, 1889, watercolor, 28.9 x 50.8 (11 3/8 x 20)
The Art Institute of Chicago, Mr. and Mrs. Martin A. Ryerson Collection

art. But why those thoughts and feelings took this form, why they occupied this particular subject, is not so clear.

It cannot be a complete coincidence that the motif made its first appearance shortly after the death of Homer's mother in April 1884. Henry Adams has reminded us of Homer's closeness to his mother and of some of the ways her death affected his art.[8] It is not far-fetched to think that an abandoned and beleaguered boat could have assumed particular meaning for Homer at this time. And perhaps that association—the private charge of meaning and memory that attached itself to the motif because of the circumstances in which he first experienced it—gave it a special place and value in Homer's creative imagination, explaining his almost obsessive return to it. It might suggest why that motif might be recalled by the recent death of his father and his sense of his own mortality.[9]

The Gulf Stream, as its development shows, depended on resources of memory and revived experience for its form and an essential element of its meaning. Those resources were not confined to its development of motif alone, however, for *The Gulf Stream* reached even more deeply and widely into Homer's past.

Something in one of his first watercolors, *A Basket of Clams* of 1873 (fig. 6), connects it with *The Gulf Stream. A Basket of Clams* is Homer's first consideration of the inevitable and inseparable relationship between life and death, here in death's intrusion into youthful innocence as two boys come upon a dead shark on the beach.

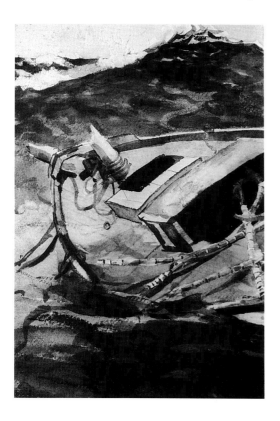

5. Winslow Homer, study for *The Gulf Stream*, c. 1899, watercolor, 29.8 x 62.5 (11 3/4 x 24 5/8)
Cooper-Hewitt Museum, Smithsonian Institution, Gift of Charles Savage Homer

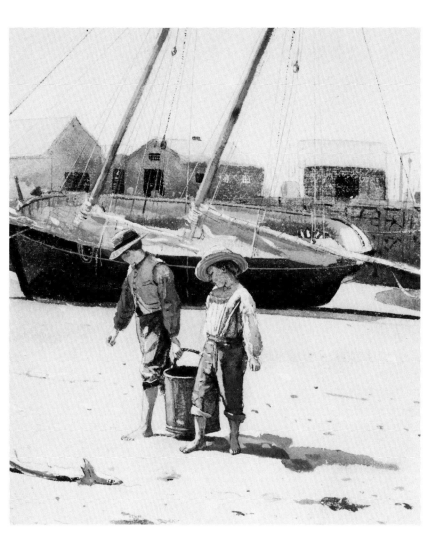

6. Winslow Homer, *A Basket
of Clams*, 1873, watercolor,
29.2 x 24.8 (11 ½ x 9 ¾)
Mr. and Mrs. Arthur G. Altschul

of the Medusa of 1819. But the first three
have a particularly salient relationship to
Homer's painting. They are not merely
works that Homer *might* have known, or
that *The Gulf Stream* happens to recall;
they are not just works that belong to what
we sometimes too loosely call a tradition.
On the contrary, each can be confidently
located within Homer's experience. Tur-
ner's *Slave Ship*, Cole's *Voyage of Life*, and
one of Delacroix's studies for the *Barque
of Dante* (or *Dante and Virgil Crossing the
Styx*, as it was called) were all at one time
in the John Taylor Johnston collection in
New York. Johnston's was one of the larg-
est and finest American collections at the
middle of the nineteenth century, and
when it was sold late in 1876, the sale at-
tracted widespread attention and public-
ity.[10] For these reasons alone Homer would
have been aware of the Johnston sale. But
he had an especially keen and vested inter-
est in it for another reason: one of his own
works, at the time his most famous paint-
ing, *Prisoners from the Front*, was among
the works to be sold.

The Johnston sale, therefore, was a no-
table incident in Homer's early artistic life,
and his personal stake in it might have
made other paintings in Johnston's collec-
tion particularly memorable. Even so,
would Homer's memory of those paintings
have been clear and active enough when he
painted *The Gulf Stream* more than twenty
years later to justify thinking of them as
direct sources of its inspiration? It seems
improbable. And yet it is somehow harder
to believe that the sharks in *The Gulf
Stream* did *not* have something to do with
the unforgettable group of damned souls in
the *Dante and Virgil*; that the foreboding,
almost apocalyptic sea and sky of Turner's
Slave Ship and the searingly memorable
image of the drowning slave in its fore-
ground were not resurrected in *The Gulf
Stream*;[11] or that Homer would not recall
Cole's *Voyage of Life* when, in his old age,
he painted his own reflection on human
mortality. If we remember that *The Gulf
Stream* derived from studies Homer had
begun fourteen years before and that he
obsessively returned to the motif, and if
we regard *The Gulf Stream* as a summary
painting—as its complexity and ambition

They turn from it with a mixture of revul-
sion and revelation. That the shark (in vir-
tually the same "pose") and a listing boat
should recur as principal parts of *The Gulf
Stream* suggests a relationship that, how-
ever deep and distant, is nonetheless real.

No one can fail to notice *The Gulf
Stream*'s relationship to the succession of
beleaguered figures in boats in nineteenth-
century painting. There is, for example,
Delacroix's *Barque of Dante* of 1822 (fig. 7),
or Turner's *Slave Ship* of 1840 (fig. 8), or
Thomas Cole's most popular work, his
four-part series *The Voyage of Life*, which
he painted in two versions of 1840 and 1842
(see figs. 9a, b). Other works belong in this
succession too, such as Copley's *Watson
and the Shark* of 1778 and Géricault's *Raft

7. Eugène Delacroix, *The Barque of Dante (Dante and Virgil in Hell)*, 1822, oil on canvas, 199.1 x 246.1 (78 3/8 x 96 7/8) Musée du Louvre (cliché des Musées Nationaux)

8. Joseph M. W. Turner, *The Slave Ship (Slavers Throwing Overboard the Dead and Dying, Typhoon Coming On)*, 1840, oil on canvas, 91 x 138 (35 3/4 x 48) Museum of Fine Arts, Boston, Henry Lillie Pierce Fund

insist that we do—that reached into and drew upon experiences of a lifetime, then the possibility that Homer's memory supplied images from other works of art is not unlikely after all.

Perhaps what made these works most vividly pertinent to Homer when he was painting *The Gulf Stream* was not their particular effect or configuration of form, but the theme or meaning they shared. In some way all are about life and death, or the passage between them. And if it was their common meaning that made them most memorable, perhaps they enable us to see more exactly what *The Gulf Stream* is about. It is not, melodramatically, about death and dying, but more profoundly and personally, about death and destiny.

I have been speaking of these paintings as sources for *The Gulf Stream*. But maybe

9a, b. Thomas Cole, *The Voyage of Life: Youth* and *Manhood*, 1842, oil on canvas, 134.3 x 194.9 (52 7/8 x 76 3/4) and 134.3 x 202.6 (52 7/8 x 79 3/4)
National Gallery of Art, Washington, Ailsa Mellon Bruce Fund

they are more correctly thought of not as sources from which Homer borrowed but as images to which he referred—canonical images of mortality residing in the public domain that Homer did not so much imitate as invoke. While they enriched his painting, they also explained it. Their meanings were added to his and supplied clues for its interpretation. If, for example, *The Gulf Stream* invokes Cole's *Voyage of Life*, as I think it does very forcefully, it makes clear that Homer's painting, too, is an allegory of life, in which the derelict boat with its helpless passenger is borne to its fate through the perils of existence by the inexorable, and for the nineteenth century still mysterious, flow of that "river in the ocean," the Gulf Stream, as Lieutenant Matthew Maury called it in his well-known book on oceanography.[12]

The Gulf Stream drew on thoughts and ideas apparent in Homer's work as early, perhaps, as 1873, and definitely on the series of studies that originated in 1885. But

the larger state of mind in which *The Gulf Stream* was conceived, a deepened, more pervasive and persistent consciousness of mortality, was more recent. It appeared only in the early 1890s, poignantly in the Adirondack watercolors and oils (see Tatham, fig. 16) and on a plane of high tragedy in *Fox Hunt* of 1893 (fig. 10).

10. Winslow Homer, *Fox Hunt*, 1893, oil on canvas, 96.5 x 174.0 (38 x 68 1/2) The Pennsylvania Academy of the Fine Arts, Temple Fund Purchase

11. Winslow Homer, *The Signal of Distress*, 1890–1896, oil on canvas, 62.2 x 97.2 (24 1/2 x 38 1/4) Thyssen-Bornemisza Foundation, Lugano, Switzerland

12. Winslow Homer, *The Wreck of the Iron Crown*, 1881, watercolor, 51.1 x 74.0 (20 ³/₁₆ x 29 ¹/₈) Mr. Carleton Mitchell

in the boat in the distance. Originally the boat was under full sail; in the revised version it is an unpowered and uncontrollable derelict without sails or masts, bearing a tattered flag of distress but showing no sign of life. The first painting recalls Homer's *Wreck of the Iron Crown* of 1881 (fig. 12). Like it and other works of the middle 1880s, such as *The Life Line* (fig. 13) and *The Undertow*, originally *Signal of Distress* was conceived as a heroic rescue. In its altered version the fate of the boat has been decided beyond the power of human agency to influence it.

The Signal of Distress is also notable for the state in which Homer left it. Although Homer frequently rethought and revised his paintings after they were finished and exhibited, no painting of such ambition is left as unresolved. It remains a visible record of struggle, and the way Homer dated it, "1892–6," tells less of its completion than of its incompletion. Homer did not finish the painting, he simply ended it. His difficulties with *The Signal of Distress* may have been technical or they may have been formal. But their essence lay in a profound change of spirit and outlook he experienced at the time, one that corroded the

If that consciousness is marked by any single painting, it would have to be *The Signal of Distress*, which Homer began, finished, and exhibited in 1890. A few years later, however, he extensively reworked it (fig. 11).[13] The change that most affected the painting's essential meaning was made, as a sketch for the original shows,

13. Winslow Homer, *The Life Line*, 1884, oil on canvas, 73.7 x 114.3 (29 x 45) The Philadelphia Museum of Art, The William L. Elkins Collection

14. Winslow Homer, study for *The Signal of Distress*, 1881 or 1883, pencil drawing
Cooper-Hewitt Museum, Smithsonian Institution, Gift of Charles Savage Homer

ravaged boat, where the promise of hope was literally dismantled—was Homer's sense of death and destiny compellingly embodied. The battered boat is the closest precedent, in type and time, for the central motif in *The Gulf Stream* and may even have had its source in the same experience recorded in fig. 2.

The Signal of Distress is the precedent for *The Gulf Stream* in another way as well. Two components of *The Signal of Distress* originated much earlier: the lifeboat, sketched on a trip to or from England in 1881 or 1882 (fig. 14); and the figures rushing to answer the distress signal, related to several English drawings in which Homer explored the same dramatic idea. In other words, when first planned in 1890, *The Signal of Distress* reached back nearly a decade for its main elements. It was Homer's first distinctly retrospective painting. The use of earlier sketches was not unusual for Homer, but never before had the distance been as great between a painting and experiences upon which it drew. The same reflective condition of mind and method, only now more complex, produced *The Gulf Stream*.

heroic confidence of the painting's original conception but could not, despite extensive alterations, satisfactorily reshape its form and subject. It remained for Homer's next great oil, *The Gulf Stream*, to accommodate his new state of mind. Only in one detail of *The Signal of Distress*—the storm-

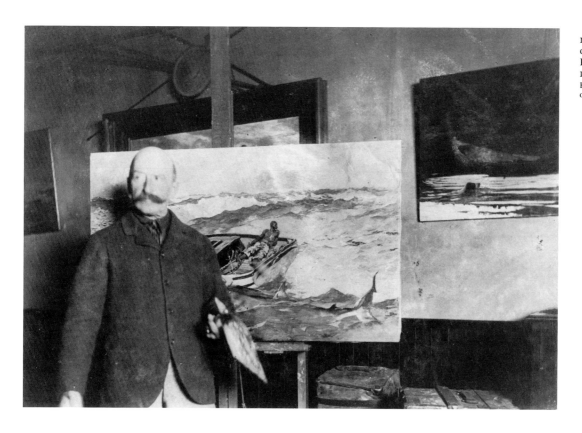

15. Homer standing in front of *The Gulf Stream* in his Prout's Neck studio, about 1899, photograph
Bowdoin College Museum of Art, Gift of the Homer Family

16. Winslow Homer, *Hound and Hunter*, 1892, oil on canvas, 71.8 x 122.2 (28 ¼ x 48 ⅛)
National Gallery of Art, Washington, Gift of Stephen C. Clark

17. Winslow Homer, *Lost on the Grand Banks*, 1885, oil on canvas, 77.5 x 125.4 (30 ½ x 49 ⅜)
Los Angeles County Museum of Art, Lent by Mr. and Mrs. John S. Broome

A photograph of Homer in his studio at Prout's Neck (fig. 15), the only known photograph of Homer at work, shows how literally *The Gulf Stream* was developed in the presence of his earlier art. One of the paintings in the studio at the time was *Hound and Hunter* of 1892 (at the right; see also fig. 16). Another, of which only a small part is visible in the photograph (at the left), seems to be *Lost on the Grand Banks* of 1885 (fig. 17). (It is not possible to identify the third with confidence.) It is, of course, unwise to make too much of the largely unplanned and impermanent relationships among objects in photographs. Yet there is a distinct thematic resemblance among the three identifiable paintings. All depict figures in boats. An element of peril, ranging from risk to mortal danger, is central to all. And *The Gulf Stream*, the latest of the three, is in a way a merger or summation of the two earlier paintings—of the desperate helplessness of *Lost on the Grand Banks* and the candid violence and cruelty of *Hound and Hunter*.[14]

The interconnectedness of the three paintings is probably not completely accidental or ad hoc. Just at this time, about 1900, Homer began to organize his paintings into sets or suites for exhibition, to explore how paintings of different dates and sometimes different subjects might oper-

18. Winslow Homer, illustration from a letter to Thomas B. Clarke, 11 December 1900
Winslow Homer papers, Archives of American Art, Smithsonian Institution

West Point

Eastern Point

Breaking on the Bar

Cannon Rock.

ate together thematically and aesthetically (fig. 18).[15] A similar kind of thinking, an almost editorial consideration of thematic and aesthetic relationships among his paintings, may have been at work in the act of painting *The Gulf Stream*—and in

Homer's decision to exhibit *The Gulf Stream* and *Hound and Hunter* together at the fifth Carnegie annual in 1900.

Of all of Homer's paintings, the one closest to *The Gulf Stream* is *Breezing Up* of 1876 (fig. 19). They are, of course, dia-

19. Winslow Homer, *Breezing Up*, 1876, oil on canvas, 61.5 x 97.0 (24 1/8 x 38 1/8)
National Gallery of Art, Washington, Gift of the W. L. and May T. Mellon Foundation

metrically different in mood and meaning. *Breezing Up* is, with almost symbolic clarity, an image of hopefulness and futurity. *The Gulf Stream*, with the same clarity, is an image of utter hopelessness. Perhaps the relationship is simply one of motif, a borrowing by Homer of an appropriate formal configuration, or prefiguration, from within his own art. Or perhaps in a more complex and less conscious way *Breezing Up* was an unstated term of meaning in *The Gulf Stream*. *Breezing Up* was first exhibited in 1876, the year of the Johnston sale. The experience of that sale, as I have suggested, contributed crucially, many years after it occurred, to the imagery and meaning of *The Gulf Stream*. Homer's most important work of that year (and his most admired painting since *Prisoners from the Front*), *Breezing Up* may have become associated in his memory with one of the works in the Johnston sale that influenced the conception and meaning of *The Gulf Stream*: Cole's *Voyage of Life*. The relationship within Homer's art between *Breezing Up* and *The Gulf Stream* is

so very like that between *Youth* and *Manhood* (figs. 9a and b) in Cole's *Voyage of Life* that it is possible to read in it a similar allegorical meaning.

Another early source for *The Gulf Stream*, made at the time of the first study for it, is *Shark Fishing* of 1885 (fig. 20). From it Homer appropriated one of the sharks for *The Gulf Stream*. This is yet another case of Homer's retrospection, but one that also provides a measure of the change in Homer's style between 1885 and the mid-1890s. *Shark Fishing* shares with other works of Homer of the mid-1880s—*The Life Line* (fig. 13), *The Herring Net* (fig. 21), *The Fog Warning*, *Undertow*, and *Eight Bells*—a monumental density of form. Large and almost lithic figures in single, solid, centrally placed compositional geometries of pyramids, cubes, and spheres dominate the picture space. These paintings are classical in style and heroic in effect. *The Gulf Stream* is very different. It is, as befits its subject, without their heroic strength and conviction of form. Elements of the composition are distributed

21. Winslow Homer, *The Herring Net*, 1885, oil on canvas, 74.3 x 120.2 (29 ¼ x 47 ¼)
The Art Institute of Chicago, Mr. and Mrs. Martin A. Ryerson Collection

across the painting surface, and though it does have an emphatic center, *The Gulf Stream* is organized chiefly in horizontal planes or bands that tend toward overall flatness. This property of style is visible in nearly all of Homer's late oils: *Cannon Rock* of 1895, *West Point, Prout's Neck*, of 1900 (fig. 22), *Kissing the Moon* of 1904 (see Adams, fig. 26), and *Right and Left* of 1909 (see Tatham, fig. 15). It is the essential formal attitude of Homer's late style.

Homer's art, like much other late nineteenth-century art, is expressive, and flatness was the stylistic mechanism that released his art from the obligation to descriptiveness and illusionism and equipped it to register feeling and assert meaning. The parts of Homer's late paintings lie upon or tend toward the surface not from calculations of design, but from some internal pressure, as though to press out—literally to express—what they con-

tain and to bring that content before the viewer with as little mediation (like the distancing required for successful pictorial illusion) as possible. The late paintings even seem to transgress the conventional barrier of the picture plane and to place, almost to empty, their meaning—what they seem literally to contain—before the viewer, as in *On a Lee Shore* of 1900 (fig. 23); or to make the viewer the object of their pictorial address in the most expressively direct and almost shocking way, as in *Diamond Shoal* (fig. 24), and *Right and Left*.

In 1901, two years after *The Gulf Stream*, Homer painted *Searchlight, Harbor Entrance, Santiago, Cuba* (fig. 25). It represents the blockade of the Spanish fleet in Santiago harbor by ships of the American navy during the Spanish-American War of 1898, emphasizing the most distinctive aspect of that blockade, the use of ships'

22. Winslow Homer, *West Point, Prout's Neck*, 1900, oil on canvas, 76.4 x 122.2 (30 1/16 x 48 1/8) Sterling and Francine Clark Art Institute, Williamstown, Massachusetts

23. Winslow Homer, *On a Lee Shore*, c. 1900, oil on canvas, 99.1 x 99.1 (39 x 39) Museum of Art, Rhode Island School of Design, Providence, Jesse Metcalf Fund

searchlights to illuminate the harbor's mouth at night to prevent the Spanish from escaping under cover of darkness.

Searchlight, by comparison—or possibly by deliberate contrast—with *The Gulf Stream*, painted in the last year of the old century, takes its meaning from the present rather than the past. It was prompted specifically, we can be quite certain, by the court of inquiry convened in the fall of 1901 to determine which of the two commanders at Santiago, Admirals Sampson or Schley, should be credited with the victory. Described as "the most remarkable judicial procedure of the new century"[16] and widely reported and heatedly discussed, the court of inquiry brought the events of the recent war vividly to public attention. Homer clearly wanted to capitalize on that attention. He began and finished the painting in the early winter of 1901, and in a letter to his dealer urged him "to show [the] picture as the subject is now before the people."[17]

Opportunism alone, however, cannot account for a painting of such profundity, or

24. Winslow Homer,
Diamond Shoal, 1905,
watercolor, 34.3 x 54.0
(13 1/2 x 21 1/4)
Collection IBM Corporation, Armonk,
New York

such uningratiating seriousness. The Schley-Sampson court of inquiry may have triggered it, but something greater inspired it.

Searchlight is a modern painting. The new century inspired it—not some event of 1901, but 1901 itself—the year, as many people reckoned, in which the new century actually began. This painting crystallizes the sense of discontinuity between past and present, the ungraded meeting of old and new, the competing claims of memory and modernity, all of which occupied a distinct and disquieting place in early twentieth-century consciousness. Homer's *Searchlight* belongs with Childe Hassam's *The Hovel and the Skyscraper* (Mr. and Mrs. Meyer Potamkin), George Bellows' *Lone Tenement* of 1909 (fig. 26), Alfred Stieglitz's *Old and New New York* of 1910 (fig. 27), or Giorgio de Chirico's early paintings in which Renaissance architecture and modern locomotives are juxtaposed as an image of that modern consciousness.[18]

Old and new met in actual combat in the naval battle at Santiago, and the Spanish fleet was no match for the modern American navy. Pathetically outnumbered and outgunned, all it could manage, as it steamed to certain destruction from Santiago harbor, was heroism. The American navy had newer and larger ships, more powerful guns, heavier armor, and a device new to naval warfare—the most luminous symbol of its modernity—the searchlight.[19]

Homer did not depict the battle of Santiago itself. He invented a more powerful and more poignant image of the meeting of old and new than a conventional battle scene could possibly be. The event as a whole is distilled into the contrast between the sixteenth-century castle with its obsolete cannon and the modern searchlights piercing the night sky, a contrast expressed pictorially by emphatic differentiation of brilliant light and shadowy obscurity. In this extraordinarily terse, reductive—and in these respects, peculiarly modern—image, Homer addressed several aspects of meaning.

The searchlight symbolized modern enlightenment, illuminating and dispelling the darkness of the past. Santiago's Morro

25. Winslow Homer, *Search-light, Harbor Entrance, Santiago de Cuba*, 1901, oil on canvas, 77.5 x 128.3 (20 ¹/₂ x 50 ¹/₂)
The Metropolitan Museum of Art, Gift of George A. Hearn

Castle was described at the time as "a cesspool of iniquity [and] the last stronghold of medievalism on American soil."[20] It also derided romantic sentimentality by challenging its chief symbol, the light of the moon, with its incisive artificial brilliance. And it impugned nature with technology in the same way the futurist Giacomo Balla did in *Street Light* of 1909 (fig. 28), and for the same purpose of demonstrating, as Balla said, "that the romantic moonlight had been supplanted by the light of the modern electric lamp."[21] This sort of thinking was not foreign to Homer's contemporaries. A passage in Admiral Sampson's account of the blockade expresses the same modern contempt of nature: "Every night, when the ship came up to her position and turned the light on, and I saw the harbor illuminated, I felt entirely secure. I looked at it many times during the night, always with the same feeling; and there it was night after night, with no

variation. After we arrived we had the friendly aid of a brilliant moon, and as the moon waned we became very anxious; but after we had the searchlight we reviled the moon, because we could not see as well with the moon as without it."[22]

Homer had no direct experience of the Spanish War, as he had of the Civil War. He knew of it only through what he read in contemporary newspaper reports and later accounts such as the one by Admiral Sampson. Sampson's mention of the moon, a detail Homer could only have known through a literary source, suggests that Homer was familiar with this text. The press played a special role in the Spanish War, reporting on it with unprecedented thoroughness and avidity, and it seems fitting that Homer knew about the war in this singularly modern way.

Other accounts of the blockade of Santiago mentioned the severe emotional and physical strain that the use of the search-

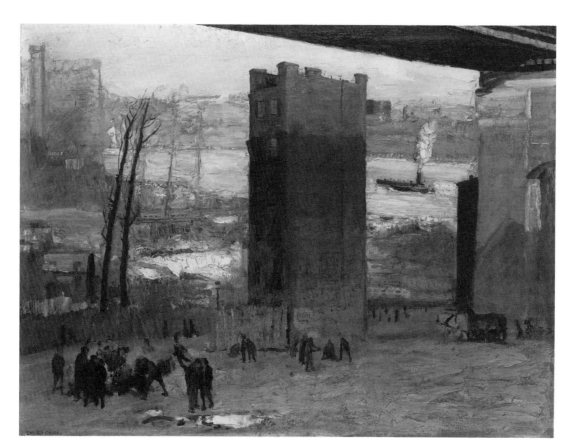

26. George Bellows, *The Lone Tenement*, 1909, oil on canvas, 91.8 x 122.3 (36 ⅛ x 48 ⅛) National Gallery of Art, Washington, Chester Dale Collection

light produced. Its "steady glare," it was said, "tried the souls of the Spanish sailors and soldiers," and the American sailors who manned the searchlight and kept it steadily aimed at the harbor's mouth felt it too.[23] This tension is established—almost induced—in Homer's painting by the stabbing beams and cold, harsh brilliance of the light, by the contrasts of light and dark, and by the expressive strategem, similar to that used in other late paintings, of positioning the viewer not as a passive or detached observer but as the focus of the searchlight's beams.

Not only the searchlight, but electricity itself at the turn of the century was an explicit attribute or exemplification of modernity. Homer knew this well before he painted *Searchlight* in 1901. Eight years earlier electricity had been his subject in *The Fountains at Night, World's Columbian Exposition* (fig. 29). What Homer depicted was not the sculpture of the fountain or even the fountain itself but "the lofty jets to either side . . . converted to leaping rainbows, glowing, fantastical, mystical," by the "splendors of electricity." But the Columbian Exposition was described as "all an electrical exhibit," and it may have been there in Chicago that Homer experienced what he did not see for himself in Santiago, the effects of searchlights at night. The Chicago fair featured "magnificent searchlights that sweep the horizon with shafts of flame . . . as if the earth and sky were transformed by the immeasurable wands of colossal magicians." The anachronistic imagery of the metaphor conveys the awesomeness of this electrical display, a novelty so great that it strained the conventional resources of language to describe it.[24] In 1901, the year in which Homer painted *Searchlight*, the Pan-American Exposition in Buffalo, "The City of Light," offered an even more dazzling display of the "modern miracle" of electrical

27. Alfred Stieglitz, *Old and New New York*, 1910, photogravure, 33.3 x 25.7 (13 1/8 x 10 1/8)
National Gallery of Art, Washington, Alfred Stieglitz Collection

28. Giacomo Balla, *Street Light*, 1909, oil on canvas, 174.6 x 114.9 (68 3/4 x 45 1/4)
Collection, The Museum of Modern Art, New York, Hillman Periodicals Fund

29. Winslow Homer, *The Fountains at Night*, 1893, oil on canvas, 40.6 x 63.5 (16 x 25)
Bowdoin College Museum of Art, Bequest of Mrs. Charles S. Homer

30. Winslow Homer, study
for *Searchlight*, 1885,
graphite pencil
Cooper-Hewitt Museum, Smithsonian
Institution, Gift of Charles Savage
Homer

illumination: "Since the world began, this is the first time that human eyes have beheld such floods of artificial light. . . ."[25] At the close of the 1900 Paris exposition, Henry Adams wrote John Hay, "It's a new century, and . . . electricity is its god."[26]

A report of an incident during the blockade of Santiago suggests another dimension of Homer's painting, another turn of its meaning: "For six minutes . . . the [American] ships fired without reply from land, and then a gun on the parapet of the old Morro belched flame and smoke, and hurled a big round shell far out over the sea, where it exploded more than fifty feet in the air. We laughed heartily at that display of fireworks—at the idea of firing an old smooth-bore at a modern battle-ship—but later we felt like taking our hats off to the gunner who did it."[27] Modernity in Homer's understanding, this reminds us, was not absolute. The present did not erase the past but, on the contrary, was inseparable from and simultaneous with it. In the cannon and architecture of Homer's painting, thoroughly redolent of age and obsolescence, there is an element of nobility, dignity, valor, and humanity, very different from the cold, evanescent beams of the modern searchlight. This corresponds to the heroic gesture of defiance by the gunner who fired from the Morro. It is the same assertion of the past in the face of the present.

Different though they undoubtedly are, *The Gulf Stream* and *Searchlight* have important things in common. They are similarly retrospective, though *Searchlight*, looking back three years to the Spanish War, takes its subject more from public than personal history. Homer reached into the history of his art for the motifs in which he cast both *Searchlight* and *The Gulf Stream*. In fact, he used a drawing (fig. 30) for *Searchlight* made at the very time—in the same year and on the same trip to the Caribbean—that he made the first study for *The Gulf Stream*.[28]

Homer seems to have recognized an element of commonality between *The Gulf Stream* and *Searchlight*. In 1902 he wrote his dealer to say, "If my *Gulf Stream* ever comes home [from exhibition], it is the same size as that *Gun* picture, and [they] would look well together in some show."[29] Saying they "would look well together" suggests that Homer felt the paintings were somehow aesthetically compatible. But he surely sensed a deeper compatibility than

that. Perhaps he recognized their sources in the same events of his experience and the associative meanings they shared. Perhaps he did not—because by his closeness he could not—see that each painting, positioned on opposite sides of the boundary between the old century and the new, explored in its way a similarly profound and momentous passage, between life and death, and new and old.

NOTES

1. Natalie Spassky et al., *American Paintings in the Metropolitan Museum of Art* 2 (New York, 1985), 483–496.

2. See, for example, Oliver W. Larkin, *Art and Life in America* (New York, 1949), 274; Barbara Novak, *American Painting of the Nineteenth Century* (New York, 1969), 187; Roger B. Stein, *Seascape and the American Imagination* (New York, 1975), 112: "melodramatically overstated and terribly derivative in both its symbolism and its structure. . . ."

3. Quoted in William Howe Downes, *The Life and Work of Winslow Homer* (Boston and New York, 1911), 149.

4. Henry Adams, "Moral Themes: Winslow Homer," *Art in America* 71 (February 1983), 121.

5. Letter to M. Knoedler & Co., 17 February 1902 (quoted in Spassky et al. 1985, 484).

6. "The inspiration for the watercolors, and ultimately for the painting, may have been the well-known Bahamian tale of 'McCabe's Curse,' an account of which Homer had clipped from a local newspaper and pasted inside his copy of *Guide to the Bahamas*." Helen A. Cooper, *Winslow Homer Watercolors* (Washington, 1986), 143.

7. See Theodore Waters, "Guarding the Highways of the Sea. The Work, Records, and Romances of the Hydrographic Office," *McClure's Magazine* 13 (September 1899), 442. See also the illustration "Dangerous Derelicts in the Track of Ocean Commerce," *Frank Leslie's Illustrated Newspaper* 77 (27 July 1893), 54, for an image suggestively close to the *The Gulf Stream*.

8. Adams 1983, 117.

9. "It is hard to measure the degree of personal grief and artistic release that his father's death brought to the constrained New England painter, but there may been considerable subconscious identification with the isolated sailor who has survived a sudden storm and is now adrift in familiar but dangerous waters." Peter H. Wood, "Waiting in Limbo: a Reconsideration of Winslow Homer's *The Gulf Stream*," in *The Southern Enigma: Essays in Race, Class, and Folk Culture*, ed. Walter J. Fraser, Jr., and Winfred B. Moore, Jr. (Westport, Conn., 1983), 88.

10. See, for example, "The Johnston Collection," *New York Tribune*, 5 November 1876.

11. Homer's memory of Turner's *Slave Ship*, as Natalie Spassky has suggested, may have been revived or reinforced by its acquisition by the Museum of Fine Arts, Boston, in 1899, the year he painted *The Gulf Stream*. Spassky et al. 1985, 486.

12. Matthew Fontaine Maury, *The Physical Geography of the Sea* (Cambridge, Mass., 1963 [first edition 1855]), 38. Homer knew, or knew about, Maury's work, and presumed his audience might; in a letter of 17 February 1902 to his dealer, Knoedler, he wrote: "You ask for a full description of my picture of the 'Gulf Stream'. I regret very much that I have painted a picture that requires any description. The subject of this picture is comprised in *its title* & I will refer these inquisitive schoolma'ams to Lieut. Maury." Quoted in Spassky et al. 1985, 484.

13. See Lloyd Goodrich, *Winslow Homer* (New York, 1945), 120–121. A photogravure of 1891, known to Goodrich but which I have not seen, recorded the painting's original appearance.

14. "It is less fantastic than cruel. . . ." *New York Sun*, 27 December 1906; quoted in Spassky et al. 1985, 487.

15. Letters to Thomas B. Clarke, Scarborough, Maine, 11 December 1900 and 31 December 1900.

16. "The Schley Court of Inquiry," *Leslie's Weekly* 93 (7 September 1901), 211. "Never before in the history of the navy has an issue been presented of such supreme and universal interest, not only to the navy, but to the general public. . . ." *Boston Evening Transcript*, 12 September 1901.

17. Letter to M. Knoedler & Co., Scarborough, Maine, 30 December 1901.

18. See also the juxtaposition of older sailing boats and the modern skyscraper city in an illustration in Jesse Lynch Williams, "The Water-Front of New York," *Scribner's Magazine* 26 (October 1899), 389.

19. See Lieutenant W. S. Hughes, "Electricity in War. I. In Naval Warfare," *Scribner's Magazine* 6 (October 1889), 415–417.

20. Stephen Bonsal, "With the Blockading Fleet off Cuba," *McClure's Magazine* 11 (June 1898), 124.

21. Letter to Alfred H. Barr, Jr., Rome, 24 April 1954, in Virginia Dortch Dorazio, *Giacomo Balla, an Album of His Life and Work* (New York, [1969]), n.p. Cf. F. T. Marinetti, ". . . turbines transformed the rushing waters into magnetic pulses that rushed up wires, up high poles, up to shining, humming globes. So it was that three hundred electric moons cancelled with their rays of blinding mineral whiteness the ancient green queen of loves." From "Let's Murder the Moonshine" [1909], in *Marinetti: Selected Writings*, ed. R. W. Flint (New York, 1972), 51. "The painter has dared to face the realistic features of his subject without reservation, relying, indeed, upon the force of their actuality as contrasted with the tender mystery of the moonlit sky." "Among the Galleries: American Pictures at the Union League Club," *New York Sun*, 10 January 1902.

22. Rear Admiral William T. Sampson, U.S.N., "The Atlantic Fleet in the Spanish War," *The Century* 55 (April 1898), 902.

23. W.A.M. Goode, "The Inner History of Sampson's Campaign," *McClure's Magazine* 12 (November 1898), 95.

24. Murat Halstead, "Electricity at the Fair," *The Cosmopolitan* 15 (September 1893), 577–578. See also "Electricity at the Fair," *Harper's Weekly* 36 (16 July 1892), 692–693; and Julian Ralph, "Nine Acres of Electrical Exhibits," *Harper's Weekly* 36 (3 September 1892), 847.

25. David Gray, "The City of Light," *The Century* 62 (September 1901), 675.

26. Paris, 7 November 1900, in *Letters of Henry Adams (1892–1918)*, vol. 2, ed. Worthington Chauncey Ford (Boston and New York, 1938), 301.

27. John R. Spears, "The Chase of Cervera," *Scribner's Magazine* 24 (August 1898), 148.

28. In a later sketch (Cooper-Hewitt Museum), surely preparatory to the painting, he included the searchlight beams, which, of course, he had not seen in 1885.

29. Letter to M. Knoedler & Co., Scarborough, Maine, 24 January 1902.

Notes on Contributors

Henry Adams is a graduate of Harvard University and obtained his Ph.D. from Yale University, where he received the Frances Blanchard prize for the best doctoral dissertation in art history. In 1985 he received the Arthur Kingsley Porter Prize of the College Art Association. He currently serves as Samuel Sosland Curator of American Art at the Nelson-Atkins Museum of Art in Kansas City. He has produced about a hundred publications, including most recently two books on Thomas Hart Benton and an article in *The Burlington Magazine* on Winslow Homer's "Mystery Woman."

Nicolai Cikovsky, Jr., became curator of American art at the National Gallery of Art in 1983 after a long career in college teaching (his last position was as chairman of the art department at the University of New Mexico). At the National Gallery he has been responsible for exhibitions on George Inness, Ansel Adams, William Merritt Chase, Raphaelle Peale, Childe Hassam, John Twachtman, and the Manoogian Collection. Among his publications are books, exhibition catalogues, and articles on Inness, Chase, and Peale as well as on Sanford Gifford, Samuel F. B. Morse, Winslow Homer, Thomas Eakins, and aspects of nineteenth-century American landscape painting. In 1990 he assumed concurrent responsibilities as deputy senior curator of paintings at the National Gallery.

David Park Curry is the deputy director for collections and curator of American art at the Virginia Museum of Fine Arts, and was formerly curator of American art at the Denver Art Museum and curator of American art at the Freer Gallery of Art. He has a background in American studies and a Ph.D. in art history from Yale University. He has written on Winslow Homer, James McNeill Whistler, American folk art, nineteenth-century American and European architecture, and a variety of decorative arts subjects. He organized the recent exhibition and wrote the catalogue for *Childe Hassam: The Island Garden Revisited* (New York, 1990).

Lucretia Hoover Giese wrote her doctoral dissertation on Winslow Homer as a painter of the Civil War (Harvard University, 1985). She has published additional articles on Homer and other painters of the nineteenth and early twentieth centuries. She is on the faculty of the department of art history at the Rhode Island School of Design.

Roger B. Stein is currently professor of the history of art at the University of Virginia. His early study of Ruskin's influence in

the United States has been followed by studies of American seascape and landscape and of the American aesthetic movement as well as essays on John Singleton Copley, Charles Willson Peale, and Winslow Homer, among others.

David Tatham is professor of fine arts at Syracuse University. He is the author of books, exhibition catalogues, and articles on painting and the graphic arts in nineteenth-century America and England, including many that relate to Winslow Homer.